# The **Media**
# and **Communication**
# DICTIONARY

This book is part of the Peter Lang Media and Communication list.
Every volume is peer reviewed and meets
the highest quality standards for content and production.

PETER LANG
New York • Washington, D.C./Baltimore • Bern
Frankfurt • Berlin • Brussels • Vienna • Oxford

# SHARON KLEINMAN

# The **Media** and **Communication** DICTIONARY

## A Guide for Students, Educators, and Professionals

PETER LANG
New York • Washington, D.C./Baltimore • Bern
Frankfurt • Berlin • Brussels • Vienna • Oxford

**Library of Congress Cataloging-in-Publication Data**

Kleinman, Sharon.
The media and communication dictionary: a guide for students,
educators, and professionals / Sharon Kleinman.
p. cm.
Includes bibliographical references and index.
1. Mass media—Dictionaries.  2. Communications—Dictionaries.
I. Title.
P87.5.K64    302.2303—dc23    2011018238
ISBN 978-1-4331-0651-4

Bibliographic information published by **Die Deutsche Nationalbibliothek**.
**Die Deutsche Nationalbibliothek** lists this publication in the "Deutsche
Nationalbibliografie"; detailed bibliographic data is available
on the Internet at http://dnb.d-nb.de/.

The paper in this book meets the guidelines for permanence and durability
of the Committee on Production Guidelines for Book Longevity
of the Council of Library Resources.

© 2011 Peter Lang Publishing, Inc., New York
29 Broadway, 18th floor, New York, NY 10006
www.peterlang.com

Printed in the United States of America

Dedicated with love and admiration to my parents,
Arthur R. Kleinman (1926–2008)
and Elaine Caplan Kleinman

# Contents

# Illustrations

\* All photographs by Jean Bronson Galli

# Preface

Communication, an essential human activity, is dynamic. This dictionary provides explanations of its inventive and evolving language, theories, and technologies and is designed to be a handy reference resource for students, educators, and professionals in many fields. A comprehensive index enables readers to quickly find the information needed. The entries are also cross-referenced. "See also" terms at the end of many entries point to related entries.

*The Media and Communication Dictionary: A Guide for Students, Educators, and Professionals* is my third book with Peter Lang Publishing (www.peterlang.com). The two previous works are *The Culture of Efficiency: Technology in Everyday Life* (2009) and *Displacing Place: Mobile Communication in the Twenty-first Century* (2007). Like many things in life, one project led to another. All of them have been labors of love. The goal of this dictionary is to help people understand the latest developments in our media rich environment as well as fundamental and historically significant terms and concepts from the communication field. Many of the terms have additional meanings outside of the domains of communication and media. Due to the focused nature of this dictionary, those definitions are not included in the entries. In this volume, over 800 technical and colloquial terms are defined, many of which are not in other dictionaries of this type. While this book was being written and published, new words, tools, and technologies have been introduced that will gain traction and further transform our lives and our world. Your comments and ideas for

updating and enhancing a future edition are welcomed enthusiastically. Please send them to sharon.kleinman@quinnipiac.edu. Thank you!

# Acknowledgments

I am grateful to Mary Savigar, Patricia Mulrane Clayton, Bernadette Shade, Valerie Best, and the entire staff at Peter Lang for their guidance and support for this project.

I am thankful for the wonderful support from my colleagues at Quinnipiac University. Special thanks to Michele A. Moore, Edward Kavanagh, Mark Thompson, John Lahey, Jean Husted, Danielle Reinhart, Jennifer Burns, Rich Hanley, John Gourlie, Grace Levine, Larry Levine, Raymond Foery, Margarita Diaz, Paul Janensch, Edward Alwood, Alexander Halavais, Ewa Callahan, Kent Golden, Karin Schwanbeck, Bill Schwanbeck, Vicki Todd, Cynthia Gallatin, Lauren Erardi, Robin D'Errico, John W. Morgan, Janet Waldman, Angela Mattie, Michele Hoffnung, Carol Marro, Angela Bird, Rosa Nieves, Aileen Moran, Janet Valeski, Robert Young, June DeGennaro, Kathy Cooke, David Valone, Jill Fehleison, and Bernard Grindel.

Jean Bronson Galli took the fabulous photographs that illustrate entries throughout this book.

Ellis Perlswig, M.D., Harvey Jassem, Mary Mayer, Brenda Berkelaar, Frances Rowe, Brian Salerno, Ti Badri, Bertram Bradley, and Nathalie Durand reviewed entries, generously sharing their time and expertise.

Krystin Barnett, my graduate research assistant, provided terrific research assistance.

I thank my students, colleagues, and friends for sharing ideas.

I am grateful to my loving family, Elaine Caplan Kleinman, Yale Asbell, Audrey Asbell, Sara Asbell, and Bernice Bradley, and my fantastic friends, Joan Bombalicki, James Williams, Katie Tranzillo, Jerry Saladyga, Daniel Pardy, Tucker Sweitzer, Jerry Boryca, Theo Forbath, Alison Roberts, Alex Heonis, Nita Maihle, Jennifer Jacobs, Colleen Sexton, Mary Zihal, and Dena Miller, M.D., for their encouragement and support.

Lastly, I am thankful to be part of the community at Fresh Yoga in New Haven. Namaste.

*Sharon Kleinman*
*Woodbury, Connecticut*

**Abstract** A brief summary of a research paper, book chapter, grant proposal, or any written communication that precedes the body of the piece, providing the reader with an orienting overview. Abstracts of published research articles are included in online library databases. People researching a topic can read an abstract to determine if the article or other work that the abstract summarizes is relevant to their investigation before locating the full text of the piece online or in hard copy. Most research article abstracts are 150 or fewer words long, formatted in one paragraph. See also teaser

**Academic Journal** See peer reviewed journal

**Academy Awards** Also called the Oscars, annual awards from the Academy of Motion Picture Arts and Sciences, which has about 6,000 members who cast votes for awards that recognize outstanding cinematic achievement in over two dozen categories, including acting, cinematography, directing, costume design, makeup, music, foreign language film, animated feature-length film, short film, sound effects, visual effects, screenplay adaptation, original screenplay, film editing, sound editing, and documentary. More than 2,700 gold-plated, 13½ inch tall, 8 ½ pound Oscar statuettes, officially named the Academy Award of Merit, have been conferred. The first Academy Awards were presented at a ceremony in 1929. The Academy Awards

have inspired similar recognition shows for creative achievements in music and theater in the United States as well as in other countries. See also cinematography, movie

**Acknowledgment** In media productions of all types, the creator's expression of appreciation for assistance and contributions. Books typically include an acknowledgments page. See page xiii of this dictionary for an example.

**Acoustics** In physics, the science of sound. The ancient Greeks and Romans were champions in acoustics. The architecture of their ancient amphitheaters made it possible to hear presentations without amplification. Microphones and speakers were not invented until the 19th century. One of the most famous amphitheaters is the 2,500-year-old Epidaurus Amphitheater in Greece, which seats 14,000 people and has 55 tiers. Astoundingly, when a person drops a coin in the middle of the dirt stage, the sound of its hitting the ground can be heard clearly from any place in the theater. In music, the acoustic (singular) music genre is natural or close to natural sounding. Acoustic instruments, such as acoustic guitars, contrast with electric versions developed later that have built-in pick-ups (microphones) for sound amplification, like the solid-body electric guitar designed and popularized in the 1940s by American guitarist and inventor Lester William Polsfuss (1915–2009), better known by his stage name, Les Paul. See also retronym

**Acquisitionist** Also called an acquisitions librarian or collection specialist, the library employee responsible for ordering materials for a library collection.

**Acquisitions Editor** In book publishing, the person responsible for obtaining and reviewing manuscripts from authors for publication.

**Acronym** A word constructed using the initials and sometimes additional letters from other words, such as PAW for "parents are watching," DIY, for "do-it-yourself," WYSIWYG, for "what you see is what you get," FAQ for "frequently asked questions," VIP for "very important person," ASAP for "as soon as possible," DNA for "deoxyribonucleic acid," KISS for "keep it simple, stupid" and "keep it short and simple," FYI for "for your information," F2F for "face-to-face," SKU for "stock keeping unit," and LOL for "laughing out loud." An acronym that is appropriate for the context in which it

is typically used is called an apronym, for example, BASIC, which stands for the computer language "Beginner's All-purpose Symbolic Instruction Code." An anacronym is an acronym that few people know or remember the words to which it refers, such as RADAR, which stands for "radio detection and ranging," and LASER, which stands for "light amplification by stimulated emission of radiation." People frequently use acronyms in their short message service (SMS) text messages and in their Twitter postings (tweets) in order to efficiently communicate their thoughts and feelings because text messages and tweets are limited to 140 characters, which is about the length of a typical postcard message. However, long before the advent of mobile phones, text messages, and Twitter, people abbreviated language. Telegraph messages were shortened for efficiency reasons, since each signal needed to be decoded by a telegraph operator and senders were charged by the word. Shorthand stenography was abbreviated, because secretaries had to transcribe quickly in order to keep pace with their bosses' dictation. Acronyms are also commonly used in chat rooms and in personal advertisements posted in newspapers and online. The seemingly innate human tendency to communicate as efficiently as possible by compressing phrases into acronyms and words into abbreviated utterances (vocal sounds) was identified in the 1930s by American linguist George Kingsley Zipf (1902–1950). He called this tendency the Principle of Least Effort. It is surprising that Zipf's Law is not referred to as POLE! See also neologism, pseudonym, retronym, short message service, synonym, telegraph, Zipf's Law

**Active Audience** According to the media theory of uses and gratifications, people use and interpret any kind of media text actively and for their own purposes. See also polysemic

**Actuality** Also called *actualité,* movies of real events as they are happening, such as a train pulling into a station, a couple dancing, or a person sleeping. The early silent films in the late 19th and early 20th centuries were very short actualities. The genre of actualities was a precursor to documentaries, non-fiction movies that typically feature real people at real locations rather than actors on constructed movie sets. In French, *actualité* means a piece of news, and *actualités* is the news. See also documentary, movie, short, silent film

**Ad Nauseam** Latin expression that means "to a sickening degree." For clarity, use English words rather than Latin expressions or abbreviations *ad nauseam!* See also e.g., et al., etc., i.e.

**Address** In an email system, an address is structured as name@mydomain. The part after the "@" is the domain name. It identifies the server. Many users' mailboxes can be hosted on a single server. The part before the "@" is the username, which must be unique within each domain name. Usernames are often composed in one of these formats: firstname.lastname, firstnamelastname, or initialletterlastname. For instance, jane.doe, janedoe, or jdoe. Email addresses are not case sensitive. It is helpful to use plain letters rather than language-specific letters in an email address so that the address can be typed from any computer in the world. For instance, andre rather than andré for a username. See also domain name, email, server, uniform resource locator

**Administrative Research** Empirical research conducted by institutions and businesses to answer specific questions.

**Adult Entertainment** A euphemism for pornography. See also censorship, euphemism, obscenity, rating system

**Advance** Money paid to writers and musicians by publishers and record labels before their creative works are made available for sale to the public, and sometimes even before the works are created. These payments are advances of expected royalties, so they are votes of confidence in the creators. Sometimes the sales of the creative works do not ultimately generate enough royalties to cover the advance payment. See also royalties

**Advance Copy** A copy of a media product made available to a limited number of people, including reviewers and journalists, prior to the official release.

**Advanced Research Projects Agency Network** (ARPANET) The first decentralized network of interlinked computers. It was developed as a U.S. military project in the late 1960s so that the then-scarce computing resources could be shared by researchers working on projects for the U.S. Defense Advanced Research Projects Agency (DARPA) from different locations. The ARPANET was the precursor to the Internet, which is a global network of networked computers designed

in the 1970s that is not owned by anyone. See also computer, email, Internet, network

**Advertisement** Also shortened to ad, any form of paid public promotion of services or goods for sale. Examples include: television commercials, posters, billboards, bumper stickers, newspaper inserts, pop-up advertisements on websites, pre-roll ads that run before online video productions such as news clips, and post-roll ads that run after them. Ads are designed strategically to attract potential and existing customers' attention and to persuade them that they desire or need the object or service being promoted. Ads take various approaches for this persuasion. Some ads inform people about the features and benefits with a rational argument that differentiates one particular item from similar ones on the market. Others work more subtly, stirring desires and feelings in potential consumers through imagery, words, music, or a combination of these elements. Subliminal advertising conveys messages that are communicated in a manner so that they are below the normal level of people's conscious awareness of them. Although people are unaware that they perceive these hidden messages, they are stimulated by them nevertheless. Subliminal messages, such as the word "sex" embedded in ice cubes in a glass in a beverage advertisement, can influence people's thoughts, actions, beliefs, and behaviors, leading them to desire a certain brand of alcohol, for instance. Advertisements sometimes feature famous people in order to associate products with elite status. This approach implies that if a consumer uses a product, such as a particular brand of shampoo, they will live an enviable life like the celebrity. Advertisements often leverage the power of cultural symbols, such as the U.S. flag, to communicate the values and characteristics of a brand. Almost anywhere a person looks, advertising can be found. Ads are on take-out coffee cup sleeves, subway station walls, public transit buses and trains, pens, t-shirts, baseball hats, cycling jerseys, and golf balls. They line the inside perimeter walls of sports stadiums on large digital screens, which are visible not only to the live audiences, but also, importantly, to audiences viewing televised events. The media depend on advertising for revenue, which is why there are frequent breaks for commercials during television and radio shows and a multitude of print ads on magazine and newspaper pages. Goods are also advertised in movies and television shows through product

placement and/or product integration, which has been paid or bartered for. When actors in movies or on television shows are shown with a specific product, for example, drinking a Coca-Cola, wearing a Rolex watch, texting on a Verizon mobile phone, or driving a Jeep, it is typically because a company has paid for the product to appear on the set or has arranged a barter agreement. Product placement/integration can be construed as subliminal advertising too, because people do not realize that they are being pitched and stimulated to desire certain products. The latest trends in advertising are to leverage the power of social media to publicize brands and products. When a YouTube video that showcases a company's product goes viral, it becomes highly visible, effective, and cost-efficient advertising. The company that does the most advertising in the world is Procter & Gamble. Global advertising revenue was projected to exceed $544 billion dollars (U.S.) in 2010. See also association principle, banner advertisement, billboard, blipvert, brand, cultural symbol, persuasion, pop-up advertisement, poster, product placement, social media, viral marketing

**Advertising Agency** Business that designs, coordinates, and administers advertising campaigns for its clients. Advertising agencies obtain or conduct marketing research, handle the creative aspects of designing ads and the business aspects of placing them, and evaluate the effectiveness of their campaigns, making sure that the target customers are being reached. Boutique advertising agencies typically focus on producing creative work for one niche industry, such as tourism. They are often founded by account executives who previously worked at larger, full-service advertising agencies. In the United States, advertising agencies employ more than 182,000 people. There are about 26,000 advertising agencies worldwide. See also advertising campaign, client

**Advertising Campaign** Coordinated efforts for promoting a product or service through advertising. A campaign usually runs for a specific amount of time, repeating advertisements multiple times to ensure customer recognition. See also advertisement

**Advertising Council** Nonprofit organization in the United States founded in 1942 to design and spread public service announcements (PSA).

See also public service announcement, social marketing, video news release

**Adware** Invasive means for online advertising using software that is installed on computers through a variety of creative means, including through hyperlinks in messages posted to legitimate social networking websites like Facebook, to the microblogging service Twitter, and also via fake newspaper advertisements that point people to the addresses of spoof websites. Adware sometimes includes spyware, software that collects computer users' private information and browsing behavior without their knowledge and disseminates it to others for commercial or criminal purposes. Adware is also distributed by cybercriminals known as affiliates connected with global cybercrime rings that develop illegal computer viruses. Once adware is installed on a computer, it causes pop-up advertisements to open on users' computer screens for products and services, including ads for fake and ineffective antivirus software, called scareware or rogueware. Affiliates are paid large commissions on the scareware sold through adware they installed on computers. The prosecution of cybercriminals for theft and fraud is spotty in different parts of the world. See also computer virus, pop-up advertisement, scareware, spoof website, spyware

**AEJMC** See Association for Education in Journalism and Mass Communication

**Aesthetics** The appearance of something, especially in terms of its beauty. Aesthetics also refers to the study and philosophy of taste.

**Affiliate Station** A local television or radio station that is associated with a national network. Affiliates have contracts with a network or networks that enable them to broadcast network programs. Affiliates also have the ability to air local shows and local news in specific time slots. See also network, program, radio, television

**Agenda Setting** Theory about media effects that argues that whatever issues, events, and people that the media focus on are put on the public's radar screen. By emphasizing certain issues and backgrounding or ignoring others, the media inform and shape news audience members' perceptions of the relative importance of things. American media scholars Maxwell Elbert McCombs (1938–) and Donald Lewis Shaw (1936–) coined the term agenda setting and introduced their

groundbreaking theory about it in 1972, influenced by American writer and political commentator Walter Lippmann's (1889–1974) ideas about public opinion. See also audience, framing, gatekeeping, news, public opinion, theory

**Air Card** Also called a connect card or data card, a device that can be plugged into a computer to enable a wireless connection to a computer network and/or the Internet. See also computer, Internet, network

**Airplay** The radio or television broadcast of a sound or audiovisual recording. The number of times that a recording is aired as well as the venues in which it is aired is tracked by performing rights organizations such as: American Society of Composers, Authors, and Publishers (ASCAP); Broadcast Music, Incorporated (BMI); and SESAC, which collect licensing fees on their artists' behalf and distribute royalties to them. The amount of airplay that a recording gets is one measure for determining if it is a hit. See also American Society of Composers, Authors, and Publishers; Broadcast Music, Incorporated; copyright; hit; radio; recording; royalties; SESAC; soundtrack

**Album** Music recording issued on a vinyl LP (long playing) or a compact disc (CD). The music can be a recorded in a studio or during a live performance or a combination of both. See also compact disc, MP3, music, recording

**Alignment** In printed materials such as letters, books, and magazine articles the placement of the lines of text (sometimes called copy) and/or the images on a page. The text in most English documents is aligned to the left side of the page, which is called left aligned, left justified, or flush left. This gives each page a neat left edge. Sometimes the lines of text on a page are justified, which gives neat edges to both the right and left sides by adjusting the spacing of the words on each line so that they spread across the entire line. Flush left but unjustified lines of text have a ragged right edge, called a ragged margin or ragged right. Quotations are sometimes aligned to the right, which is called right aligned, right justified or flush right; or they are sometimes centered. Almost all of the text in this dictionary is flush left and justified. The exception is on the dedication on page v, where all of the text is right justified. In page design, there is also vertical alignment. For instance, a caption below an image can be aligned

with the left edge of the image or two images can be aligned one on top of the other.

**Alternative Media** See independent media

**Amazon.com** The largest online retailer in the world. Founded by American Internet entrepreneur Jeffrey Bezos (1964–) in 1995 as an online bookseller, amazon.com first earned a profit in 2001. It now sells more e-books than it does conventional books on paper, and also sells products in an enormous range of categories. It has strategic partnerships with many individuals and companies. The proliferation of mobile devices, especially smartphones, continues to support the e-commerce explosion in which amazon.com is an important leader with its innovative sales techniques and worldwide customer base. See also e-book, e-commerce, Internet

**Ambiance** Also spelled ambience, the character or atmosphere of a place. Ambient music is background music. Ambient lighting surrounds something but does not shine directly on it as a spotlight would. Ambient music and lighting can be used inventively and strategically to help create the desired tone for an environment. See also diagetic space, music, noise

**American Dream** According to the American Dream, everyone in the United States, natives and immigrants, can purportedly achieve a comfortable lifestyle through dedication and hard work. Today this comfortable lifestyle is typically characterized as being gainfully employed, owning a home, car, other commodities, and having money for discretionary spending. The American Dream is a recurring theme in U.S. television shows, movies, literature, music, art, political speeches, and memoirs. Evidence of the widespread diffusion of this optimistic narrative lies in the fact that for well over a century some people from outside the United States have raved that the streets are paved with gold in this land of opportunity. See also memoir

**American Psychological Association** (APA) An academic and professional organization for psychologists in the United States founded in 1892 at Clark University in Worcester, Massachusetts, and based in Washington, D.C. It has more than 150,000 members. Among its many activities, the APA updates and publishes the guidelines for the APA style, which is the standard format for research papers in the

social sciences. Like other academic organizations, such as the Modern Languages Association (MLA), which publishes the style guidelines for research papers in the humanities, the APA hosts academic conferences where scholars and educators meet to discuss research in their fields and sponsors academic journals and books in which scholarship is published. The APA is one of the largest publishers of scientific research in the world. APA is also the acronym for other organizations, such as the American Psychiatric Association. See also Association for Education in Journalism and Mass Communication, International Communication Association, Modern Languages Association, National Communication Association

**American Sign Language** (ASL) Also called Amelsan, a system of communication used by many people with hearing and speech impairments in the United States and Canada in which hand gestures are employed to communicate letters and words. ASL was developed by American educator, writer, and minister Thomas Hopkins Gallaudet (1787–1851), who could hear. Gallaudet traveled to Europe in the early 19th century to learn about education techniques for people with hearing and speech impairments and subsequently established in Hartford, Connecticut, the first school for the deaf in the United States. For ASL, Gallaudet and his collaborators drew on symbols that were already in use by deaf people in the United States, as well as on other symbolic communication systems, such as French Sign Language. Gallaudet University in Washington, D.C., is named in Gallaudet's honor. See also code, symbol

**American Society of Composers, Authors and Publishers** (ASCAP) Formed in New York City in 1914 by a group of music creators, this member-owned organization tracks the public performance of musical works in concert halls, on the radio, on the Web, and in other venues, and it collects and distributes performance royalties to those music creators who are ASCAP members. Music composers and publishers pay a one-time fee to join ASCAP. The organization's focus on the establishment of music licensing agreements, copyright protection initiatives, and legislative lobbying on copyright issues concerning music is particularly significant today because the remixing and file sharing of copyrighted work is so easy and common. See also

advance; airplay; bootleg; Broadcast Music, Incorporated; copyright; performance royalties; piracy; publisher; royalties; SESAC; taper

**AM/FM** Radio broadcast transmission systems. The acronym is short for "amplitude modulation" and "frequency modulation." FM radio has a clearer signal than AM but typically a smaller geographic broadcast area, depending on the power and location of the station and atmospheric conditions. See also radio, satellite radio

**Analog** Electronic devices that use continuously varying voltage for data transmission. Digital systems are replacing analog ones in television and radio. In analog recordings, sound is captured on the grooves of a vinyl record or on the continuous band of a magnetic tape. In contrast, in digital recordings, such as those on compact disc (CD) and in MP3 files, sound waves are translated into binary (on-off) pulses of numerical code. See also digital

**Anchor** See news anchor

**Animation** A technique in which the illusion of motion is created by showing line drawings, puppets, clay models, or other inanimate objects in a sequence. By the late 20th century, computer technologies advanced the art of animation to new heights. *Toy Story* (1995) was the first fully computer-generated animated feature film. It contains over 114,000 frames of animation, which took approximately 800,000 computer hours to create. *Toy Story* was critically acclaimed for its cultural, historical, and aesthetic achievements. It was produced for $30 million and had a $20 million advertising budget. *Toy Story* and its two sequels, *Toy Story 2* and *Toy Story 3,* became blockbuster hits.*Toy Story 3* earned over $1 billion worldwide in box office receipts. *Shrek* (2001) was the first animated feature film awarded an Academy Award for Best Animated Feature. It was produced for $60 million and became a huge box office hit. Japanese animation is called anime. See also Academy Awards, anime, blockbuster, cartoon, hit, movie, short, video game

**Anime** Japanese cartoon style used in animations and comic books that may be targeted to adults or young audiences, depending on the content. Anime is a popular form of entertainment in Japan. It includes dramas, thrillers, science fiction, and pornography. See also animation, cartoon, comic book

**AP** See wire service

**APA Style** See American Psychological Association

**Aphorism** Also called a maxim, adage, or proverb, a saying that conveys generally accepted knowledge in a succinct way, such as this one attributed to the Chinese philosopher Confucius (551 BC–479 BC): "Your eyes are always bigger than your stomach."

**Apple** A U.S. corporation based in Cupertino, California, that designs, manufactures, and sells innovative desktop and portable computers, computer peripherals, software, and digital media devices. Apple was founded in 1977 and had its initial public offering (IPO) on December 12, 1980. The chief executive officer (CEO), American entrepreneur Steven Paul Jobs (1955-), co-founded the company with American computer scientist and electrical engineer Steven Gary Wozniak (1950–), and American entrepreneur Ronald Wayne (1934–), who left the company shortly after its founding. Apple sells its own products as well as third-party Apple-compatible accessories and media products such as music, games, books, videos, television shows, podcasts, and applications through its online store, in the company's retail locations, and through other retailers. As of the beginning of 2011, there had been approximately 10 billion downloads from Apple's online store, commonly called the app store. There are 317 bricks and mortar Apple stores, 233 in the United States, and 84 in other countries. The company employs approximately 46,600 full-time employees and 2,800 temporary employees. In 2010, its revenue was approximately $65 billion, representing an increase of 34% from 2009. Apple's net income in 2010 was $14 billion, representing an increase of 41% from 2009. See also application, computer, iPad, iPhone, iPod, iTunes, software

**Application** Typically shortened to app, this is a small computer program. Apps have propelled the popularity and commercial success of mobile information and communication technologies (ICT) such as the iPhone, BlackBerry, and other mobile phones and smartphones. Apps are available in the following categories: news, entertainment, tools, travel, education, weather, sports, fitness, and online shopping, banking, and investing. Each device has apps that were specifically developed for it. Some are free, some have a cost, and some have a monthly subscription fee. App development is a growing industry.

Location-based applications are mobile apps that leverage the global positioning system (GPS) capabilities of smartphones to direct location-relevant information and advertising to users. A killer application, or killer app, is one that is so widely relevant and desirable that it becomes a truly transformative technological innovation. For example, email was a killer application in the 20th century. Many people who had never used computers were motivated to learn how to use them and to purchase personal computers (PC) for their homes when they recognized how useful email could be. In October 2010, the U.S. Patent and Trademark Office granted Apple a trademark for the slogan "there's an app for that," which Apple first used in a television commercial promoting the iPhone in 2009. The slogan pays homage to the more than 250,000 apps for the iPhone, iPad, and iPod available from the Apple App Store. See also Apple, computer, diffusion of innovations, email, global positioning system, jailbreak, location-based application, mobile phone, program, smartphone

**Applied Research**  Study undertaken to solve an immediate real-world problem as contrasted with basic research, which is undertaken to expand knowledge and understanding about something but not necessarily to solve a problem or create something. See also basic research

**Arbitron Ratings**  Reports of radio listening data prepared by Arbitron, a U.S. radio rating company founded in 1949 and headquartered in Columbia, Maryland. Radio stations use Arbitron data to decide what to broadcast. Like media audience research firm Nielsen, Arbitron sells its rating reports to broadcasters, advertisers, and advertising agencies. Arbitron used to track television viewership also, but no longer does. Both Nielsen and Arbitron have a method for selecting a sample of media consumers, collecting data about their media consumption, and generalizing to the population of a specific region, known as the market, based on the data. See also audience, Nielsen ratings, radio, sample

**Archive**  To backup (as in a computer data backup), store, and conserve something for later or just-in-case use. Also, the collection or repository of data, files, documents, and/or artifacts that have been stored. An archivist is a person responsible for maintaining an archive for a library, agency, or organization. Archives can be in print and/or electronic formats. In electronic formats, the challenge is to ensure

that the file type and storage media will be readable in the future. Some storage technologies have become obsolete quickly. Zip drives and zip discs were popular in the late 1990s and early 2000s, but they were superseded by newer technologies with enhanced capacities and performance. See also cloud computing, compact disc-read only memory, data, Wayback Machine

**A-Roll** Camera footage that focuses on the main subject of a story. If more than one camera is used to shoot the footage for a story, the A-roll footage is that from the main camera. B-roll is secondary footage taken by another camera. B-roll footage is edited into the final production to add context and spice.

**ARPANET** See Advanced Research Projects Agency Network

**Art House Cinema** Movie theater that typically plays independent, unconventional, experimental, and/or avant-garde (leading edge) movies aimed at niche moviegoing audiences rather than mainstream audiences. See also avant-garde, independent media, movie

**ASCAP** See American Society of Composers, Authors and Publishers

**Aspect Ratio** The relationship between the width and height of an image projected on a screen, such as a television, computer, or cinema screen. High-definition television (HDTV) has a widescreen 16x9 aspect ratio, which means 16 units wide by 9 units high. This is close to the aspect ratio of a cinema screen. Standard television has a 4x3 aspect ratio.

**Associated Press** (AP)  See wire service

**Association for Education in Journalism and Mass Communication** (AEJMC) Founded in 1912, this academic and professional organization is dedicated to promoting excellence in journalism and mass communication education and practice. AEJMC hosts conferences where scholars, educators, and practitioners meet to discuss research in their fields, and it sponsors academic journals in which scholarship is published. See also International Communication Association, National Communication Association

**Association Principle** In advertising, showing a product in a setting that connects it to a positive cultural value even when no real connection exists between the product and the value portrayed. An example is

linking a product that is environmentally hazardous to the value of environmental sustainability. The advertising technique of association is a soft sell approach; a hard sell approach uses factual information rather than vague associations to persuade potential customers. See also advertisement, persuasion

**Astroturfing** Also called Astroturf lobbying, it is lobbying by corporations, organizations, or the public relations (PR) firms representing these entities, that disguise themselves as grassroots movements in order to further the corporations' or organizations' political and/or economic agenda with lawmakers. Lloyd Bentsen (1921–2006), former U.S. senator and former U.S. Secretary of the Treasury, coined this term. It is a clever, powerful, and humorous expression because Astroturf, which is a trademarked brand of artificial grass used on sports fields, is substituted for grassroots, which refers to something that is real, fundamental, and common. Grassroots lobbying refers to activism that grew from an authentic groundswell of common citizen sentiment about a particular issue. See also public relations, viral marketing

**Asynchronous Communication** Exchange of messages or information that happens at different times, not in real time. See also real time, synchronous communication

**Attribution** In journalism, the indication of the source of information in a story, which could be the name of a person, a wire service, or another media outlet that originated the story. See also source, wire service

**Audience** Everyone who experiences any kind of performance, such as a political speech or rock concert, or who reads any type of text, such as a sports magazine, billboard, book, or blog, is part of the audience. Audience members can be located in the same place, such as in a theater or concert hall, or in different places, such as in cars listening to the radio or at home watching television. Audience members do not necessarily interpret and evaluate identically the meaning of the messages in performances or texts. Though there might be a widely accepted or dominant reading of a particular message, audience members can have their own interpretations and evaluations based on individual background, values, perspective, and personal experiences. This notion of the possibility of multiple meanings is called polysemy. An example of polysemy is when a satirical movie its

creators intended to be funny is interpreted as humor by most viewers, but taken literally by some viewers who are not savvy enough to understand the jokes. Another example is when some audience members interpret works that are fictional as being real. A text can also have little or no meaning for particular audience members because it does not resonate with anything that they know. This is called neutrosemy. Audiences vary in size, and sometimes an audience is just one person. The creator of a text or performance needs to know the characteristics of the audience in order to appropriately and effectively communicate the intended message. For example, audiences can be defined in terms of demographics, such as age, neighborhood, and income level, or psychographics, which are personality and lifestyle characteristics, such as outdoorsy or artistic. An educator speaking about the risks of sexting would not use the same vocabulary, examples, or speaking style to an audience of elementary school students as to an audience of college students. See also Arbitron ratings, audience agency, demographics, Nielsen ratings, psychographics

**Audience Agency** Argument that audience members actively seek out media products and actively appropriate the messages and values embedded in them. A differing viewpoint is that audience members are passive and vulnerable receivers of media products. At face value, these two arguments seem to be mutually exclusive, but audiences can be active consumers and interpreters of media content and nevertheless manipulated by it. See also audience, polysemic, receiver

**Audience Studies** Cultural studies research approach that focuses on the audience of a text, such as the fans of a particular television show, rather than on the media product itself, in order to interpret meanings that the text has for the audience and how the text fits into their lives. See also Arbitron ratings, audience, cultural studies, fan, Nielsen ratings, text

**Audiotape** Magnetic tape used for sound recordings.

**Audiovisual/Information Technology** (AV/IT) **Integration** The increasingly seamless convergence of audio, video, and networking technologies in a myriad of contexts. Examples of AV/IT integration include the now common event of using video teleconferencing equipment to hold business meetings virtually, saving both time and travel expenses, and less familiar uses such as robot-assisted telesurgery,

robot digitization of U.S. government video records, and virtual reality training simulations, such as those used by medical students to learn surgical techniques and by pilots to practice flying. See also convergence, digitization, virtual reality

**Audition** A try-out for a role in a media production.

**Augmented Reality** (AR) **Technology** Software and hardware that overlays geographic location data (longitude and latitude) with images, information, reviews, and so forth. With AR technologies, mobile device users have real-time access to annotations of their physical location. AR technologies leverage global positioning systems (GPS), location-based applications, and the aggregated, collectively contributed resources of Web 2.0. See also global positioning system, location-based application, Web 2.0

**Auteur** Director of a movie that puts his or her characteristic mark on it even if the director did not write the screenplay. In French, *auteur* means author. See also director, movie, screenplay

**Author's Alteration** (AA) Also called author's correction, an author's significant change to a typeset galley that is not a typographical error correction. Publishers sometimes charge the author for each alteration.

**Autobiography** A person's life story written by that person. Autobiography writers are often famous people of whom readers are already interested. In contrast, a memoir is an autobiographical account pertaining to one aspect of the writer's life. See also biography, biopic, ghost, memoir

**Auto-Takedown** Software that detects and automatically removes copyrighted content from websites such as the video hosting site YouTube, regardless of compliance with fair use doctrine guidelines. See also copyright, Creative Commons, Digital Millennium Copyright Act Safe Harbor, fair use doctrine

**Avant-Garde** Cutting edge and innovative cultural product such as a movie, painting, or musical composition that pushes the boundaries of a mainstream art form and can over time become part of the mainstream. Some theaters specialize in showing avant-garde movies or plays. See also art house cinema

**Avatar** A digital representation of a person in a virtual context, such as in a multiplayer game like *World of Warcraft* (WOW) or in an immersive

online environment such as Second Life. *Avatar* (2009) is also the title of Canadian-born American director James Cameron's (1954-) blockbuster 3-D (three-dimensional) science fiction movie. In this film, which has achieved the highest worldwide sales ever, a spectacular array of special effects are used in order to tell a story in which humans create avatars as surrogate selves and use them in innovative and thought-provoking ways. See also digital, persona, pseudonym

**Back Issue** Also called back copy or back number, an edition of a periodical published prior to the current issue. A collection of back issues of a periodical is called a back file. Back issues can be purchased from a publication's back issue department.

**Back Matter** The material at the end of the body of a book, which may include an index, bibliography, glossary, notes, and one or more appendices. See also book

**Backgrounder** A briefing document often prepared by a public relations (PR) or public affairs professional that is more detailed than a press release. Backgrounder also refers to a briefing session by officials in an organization. See also press release

**Backlist** Books that are still in print but not actively promoted by a publisher. See also book, publisher

**Backpack Reporter** See video journalist

**Bakelite** The world's first synthetic plastic with the chemical name polyoxybenzylmethylenglycolanhydride. A dense and durable manufacturing material, it was developed in 1909 by Belgian chemist Leo Baekeland (1863-1944), for whom it is named. It was used in early radio sets and telephone casings as well as in other electronics, toys,

jewelry, cameras, and machine guns. Many Bakelite items from the early 20th century are highly sought after by antique collectors and dealers. Bakelite continues to be manufactured for use in some consumer goods, including saucepan handles, electrical plugs, and electric iron parts.

**Balloon Boy Hoax** See pseudo-event

**Bandwagon Effect** Advertising strategy that conveys that everyone is on-board with the product or service being promoted in an attempt to persuade potential customers to get on-board too by purchasing the product. See also advertisement, persuasion

**Bandwidth** In radio and analog television, the range (band) of frequencies measured in hertz (Hz) that are used by a communication channel for transmissions. In computing, the rate that data can be transmitted over a network from one point to another measured in kilobits per second (Kbps) or megabits (millions of bits) per second (Mbps). As the bandwidth is increased so is the speed of data transmission over a computer network. That is why fast Internet connections are called broadband Internet. See also data, frequency, hertz, Internet, network

**Banned Book** See book challenge, censorship, First Amendment, obscenity

**Banner Advertisement** Advertisement that stretches across the top of a Web page. By clicking on the banner, the user gets directed to a website with information about the advertised product or service and details for how to purchase it. Companies using banner advertisements usually pay a fee to the website that hosts/shows the banner. This is how some websites generate revenue while operating for free for users.

**Bard** A synonym for poet. British writer William Shakespeare (c. 1564–1616) is often referred to as the bard. See also poem

**Bars and Tone** Before transmitting program material, television stations typically transmit an SMPTE (Society of Motion Picture and Television Engineers) color bar image along with a continuous 1,000 Hz audio tone. This test pattern was developed in the 1970s and has since been updated so that it works for 4x3 aspect ratio standard definition video signals as well as 16x9 aspect ratio high-definition television (HDTV) signals. Receiving stations use these test patterns to calibrate their equipment. Also, television program producers typically record the color bars and tone at the beginning of a recording so that

the playback gear can be adjusted appropriately. This was a routine process for analog NTSC transmissions and recordings and is still used today with digital technologies. See also analog, digital, NTSC

**Basic Research** Study undertaken to increase general knowledge or understanding about something but not necessarily to solve an immediate real-world problem or create something. See also applied research

**BBC** See British Broadcasting Corporation

**Beat** In journalism, the geographic territory or subject matter that a reporter covers.

**Beat Generation** A youth movement in America in the 1950s and early 1960s whose counter-culture ideology was epitomized in the writing of Allen Ginsberg (1926–1997) and Jack Kerouac (1922–1969). See also obscenity

**Bell Curve** Also called the normal curve or normal distribution, the graphical representation of data points in statistics and science in which the average point is in the middle with symmetrical slopes downward on either side. The curve literally has the shape of a bell. Many naturally occurring variables are normally distributed, and many statistical tests are based on the assumption that the data have a normal distribution. See also data

**Bias** In journalism, partiality or prejudice. In social research, a systematic error.

**Bibliophile** A person who loves books.

**Billboard** An outdoor advertising sign. In the United States today, $7 billion is spent on billboard ads per year, and there are 450,000 billboards. Also the name of a weekly entertainment industry trade publication renowned for the highly influential *Billboard* charts it produces that list the most listened-to music in multiple genres based on radio airplay, sales, streaming, and even mobile phone ringtone downloads. See also trade publication, weekly

**Biography** The story of a person's life written by someone else, a biographer. When the person who is the subject of the story or that person's estate if the person is deceased cooperates and shares information with the biographer, the book is called an authorized biography. In contrast, an unauthorized biography is the account of someone's life written

without this cooperation or permission. A biopic is a biography in movie format. This term is a blend of "biography" and "picture." A profile or profile piece is a short biography. See also autobiography, ghost, memoir

**Biometric Verification** Process for confirming someone's identity before allowing access to a place or computer system by measuring and comparing a unique physical attribute of the person's body with information about this attribute stored in a database. The fingerprint of any finger is a commonly used attribute. Some computers and other devices have built-in equipment for fingerprint verification. Other forms of biometric verification include measuring a person's vocal characteristics or voiceprint (called voice authentication or voice ID), signature, DNA, iris and retina pattern, and hand and earlobe geometry. The characteristics of a person's keystrokes on a keyboard can also be used for biometric verification. An application measures a user's typing speed and the length of time that keys are depressed and converts the data into a biopassword. See also cybercrime, database, logon

**Biopic** A blend of "biography" and "picture." An account of someone's life in movie format. See also autobiography, biography, ghost, memoir

**Bit** A blend of "binary" and "digit." The smallest possible unit of computer data, either 0 or 1. There are eight bits in a byte. See also byte, data

**Bit Player** An actor employed for a small role with some dialogue that is called a bit part or bit role.

**Biz** Slang for business. The entertainment industry is often called show biz.

**Black Hat** The quintessential bad guy in the American western movie genre. The good guy wears a white hat. See also genre, white hat

**BlackBerry** A brand of smartphone developed by the Canadian company Research in Motion (RIM) (see Figure 1 on page 23). BlackBerry smartphones use push technology for email that forwards all emails received in a person's mailbox to the device. This is different from all other email systems, which use pull technology instead, meaning that users have to access their mailboxes and retrieve messages. BlackBerry's push technology made it a strong competitor in the smartphone market. Also, the BlackBerry was one of the first smartphones to include a fully developed keyboard (QWERTY in Anglo-Saxon countries

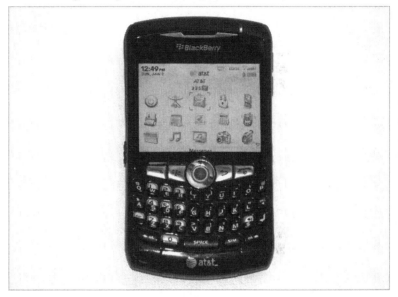

and AZERTY in French-speaking countries). Travelling business-people were early adopters of the BlackBerry and still constitute the majority of the users. BlackBerry smartphones are sometimes wryly called crackberries because many users become somewhat, or a lot, addicted to using them. This can happen with other smartphones, too. See also application, crackberry, early adopter, Internet addiction disorder, mobile phone, push technology, QWERTY, screen-sucking, smartphone

FIGURE 1. A BlackBerry smartphone.

**Blacklist** List of people who are excluded from participating in something. Blacklisting is meant to reflect badly on the person, typically for political reasons. In computing, a list of email addresses that send undesired messages or spam. Messages from blacklisted addresses are isolated into a junk mail folder so that users do not have to lose time and energy reading them. See also junk mail folder, spam, whitelist

**Blah, Blah, Blah** Boring, longwinded, and/or meaningless talk or jargon. See also jargon, verbose

**Bleep Out**  To delete a lewd or offensive word from a television or radio broadcast. See also censorship, First Amendment, outtake, seven dirty words

**Blend Word**  Also called a centaur word in reference to the half-man/ half-horse creature in Greek myths or a portmanteau word, a blend word combines other words to make a new one, such as tweaching, a combination of "Twitter" and "teaching," spamouflage, a combination of "spam" and "camouflage," and sitcom, a combination of "situation" and "comedy." See also neologism

**Blind Carbon Copy**  Also called blind courtesy copy, when the email address or addresses of one or more email message recipients are invisible to other people that receive the message. The "Bcc:" address line is used for blind carbon copies. Blind carbon copies are typically sent when people want to keep others informed about something in a confidential way. Overuse of carbon copies and blind carbon copies in email can be poor netiquette. Sometimes recipients feel that they are being bombarded with too many extraneous messages that take time to read, and they wonder why they are receiving them. The reason often boils down to the popular business acronym CYA, also known as CYOA, which is the organizational practice of being careful about "covering your own ass." See also netiquette

**Blind Interview**  In journalism, an article or broadcast in which the interviewee's identity is not revealed to the audience. See also journalist shield laws, source

**Blind Review**  A review of a scholarly or creative work in which neither the reviewers nor the creator(s) are told one another's identities in order to promote an impartial evaluation. See also peer reviewed journal

**Blipvert**  Compressed, concentrated, high-speed advertisement that lasts from less than one second to five seconds. Miller Brewing Company's one-second beer commercial during the 2009 Super Bowl football game in the United States is an example. See also advertisement

**Blitz**  In advertising and marketing, a short, intensive media campaign.

**Blockbuster**  A tremendously popular and financially successful movie, such as Canadian director, producer, and screenwriter James Cameron's (1954-) *Avatar* (2009); book, such as all of those in British writer J.K. Rowling's (1965-) seven-volume Harry Potter book series (1997-2007);

or play, such as British producer-composer Andrew Lloyd Webber's (1948–) *The Phantom of the Opera* (1986), which has grossed over $5 billion, and Walt Disney Company's musical theater adaptation of its animated movie *The Lion King* (1997), which has grossed more than $3 billion. Blockbusters typically benefit from big budgets, heavy promotion, and coordinated merchandise tie-ins, like toy action figures. The term comes from the early era of the movie industry when movies were generally distributed to theaters in groups, known as blocks, while blockbusters were singled out for individual booking because of their extraordinary revenue potential.

**Blog** Short for Web logs, blogs range from sporadic, single-authored online diary entries to periodic, collectively authored, professional online publications. Blogs allow readers to respond to the original posting as well as to other readers' comments. However, readers cannot alter the original entries or others' comments on the entries the way they can on wikis, such as on Wikipedia, the well-known, collectively authored online encyclopedia. Blogs are organized chronologically with the most recent entry appearing first. They focus on topics ranging from the personal to the political to the corporate, and from the mundane to the quirky—hobbies, health issues, travel, celebrities, fashion, and so on. Some blogs are publicly accessible while others restrict access through the use of password protection. Blog audience sizes vary widely. Some blogs have just a handful of readers and others have thousands. The blogging phenomenon began in the 1990s and has grown exponentially. Thousands of new blogs are created everyday with easy-to-use blogware, though many are short-lived enterprises. Blogs typically include hyperlinks to other online resources, including websites and other blogs. Readers use blogs as supplements or alternatives to mainstream media (MSM) news outlets. Mainstream media professionals read blogs for information and story ideas and in some cases author personal or professional blogs. Blogs, like podcasts, often serve as outlets for alternative viewpoints from traditional mass media. Blogs are an exemplar of prosumption on Web 2.0, as American sociologists George Ritzer (1940–) and Nathan Jurgenson (1982–) have described them, because users produce as well as consume blog content. The interactivity and bottom-up nature of the blogosphere contrasts with activities on Web 1.0, which is comprised of those online contexts that are more top-down in structure, where users consume content that is developed and updated by specialists.

On Web 1.0-type websites, specialists do not build-in features that allow users to easily augment, alter, or respond to content. See also blogosphere, citizen journalism, Twitter, video blogs, Web 2.0, wiki

**Blogger** A person who authors or contributes to one or more blogs. Someone who reads blogs but does not contribute to them is called a blurker, a blend of "blog" and "lurker."

**Blogosphere** The online universe of blogs.

**Blooper** In movies, television, and other performance contexts, a person's unintentional and sometimes embarrassing mistake or slip of the tongue. Bloopers are sometimes added to an on-demand show or DVD as a special feature to attract viewers. See also malapropism, outtake, political tracker, wardrobe malfunction

**Bluetooth** Technology that allows a device such as a mobile phone to communicate wirelessly over a short distance with another device such as the audio system in a car.

**Blu-Ray Disc** High-density, 5-inch optical disc for digital data storage that looks like a compact disc (CD) or DVD. A Blu-ray disc can hold high definition video and large amounts of data. A single-layered disc can store 25 GB of data and a dual-layered disc can hold 50 GB. Twenty-layered discs with ten times the capacity of dual-layered discs are under development. The name comes from the blue color of the laser ray that writes to and reads from the disc. In contrast, a red laser writes to and reads from a DVD. The Blu-ray disc is a successor technology to the DVD, and a CD or DVD player cannot read a Blu-ray disc. However, a Blu-ray player that has the appropriate red laser can read a CD or DVD. See also built-in obsolescence

**Blurb** Brief paragraph typically written in a compelling style that summarizes something for promotional or informational purposes. An author's biographical sketch on a book jacket and a movie plot overview on a DVD cover are examples.

**BMI** See Broadcast Music, Incorporated

**Body Language** See kinesics

**Bogart the Wi-Fi** The practice of monopolizing a Wi-Fi resource by making the network password protected so that others who do not know the password are unable to access the Internet through the network

connection. In June 2010, someone anonymously posted in the lobby of a Brooklyn, New York, apartment building a list of the nicknames of nearby password protected Wi-Fi networks, requesting that the owners of these networks "stop bogarting the Wi-Fi." Because the owners of these networks pay for their connections through monthly subscription fees, and because the speed of data transmission is reduced when multiple computers simultaneously use a network connection, the person who accused the network owners of not freely sharing their Wi-Fi was perhaps overly optimistic about getting a positive response. Bogart in this saying refers to 20th century American actor Humphrey Bogart (1899–1957). He can be seen smoking cigarettes down to the nubs in movies and never sharing them. In one film, *The Roaring Twenties* (1939), American actor James Cagney (1899–1986) offers his cigarette to Bogart to share and Bogart smokes the whole cigarette. Bogart's sexy, cool manner of handling and smoking cigarettes in his movies and off screen helped popularize smoking in the United States in the early and mid-20th century. Bogart died of esophageal cancer that was likely caused by his smoking. Several American bands, including Fraternity of Man, Country Joe and the Fish, and Little Feat, recorded "Don't Bogart Me" (1968), better known as "Don't Bogart That Joint." The song's lyrics about not hogging a marijuana cigarette reference Humphrey Bogart's style of cigarette smoking. Fraternity of Man recorded the original version, which was subsequently popularized on the soundtrack of the hit movie *Easy Rider* (1969). See also Internet, network, wireless fidelity

**Bollywood** A blend of "Bombay" (now called Mumbai) and "Hollywood" that refers to the center of the Hindi language movie industry in India. See also Hollywood

**Book** A bound volume of printed text on individual pages that may also contain illustrations and graphics. Book pages are sandwiched between a front and back cover and held together by a binding on one side. The material included on the first page or first several pages of a book before the actual body of the contents begins is called the front matter. The front matter includes a title page with information about the author, publisher, illustrator, copyright holder, and publication data and may include additional pages such as: an illustration page called a frontispiece, table of contents (see page vii), list of illustrations (see page ix), preface (see page xi), foreword, dedication page (see page v),

and acknowledgment page (see page xiii). The material at the end of a book is called the back matter. It can include an index (see page 231), bibliography, glossary, notes, and one or more appendices. Hand-copied texts (called manuscripts) inscribed on materials such as dried tree leaves, vellum (animal skins), stone, and paper using a variety of tools existed in many civilizations around the globe for several centuries before the global diffusion of papermaking techniques and the printing press with movable type in the 15th century. Printing presses were developed in Asia in the 11th century, preceding those developed in the West by several hundred years. Early manuscripts were not readily accessible to the masses because it took a long time for scribes to reproduce them, and they were rare and precious. The printing press revolutionized reading, education, religion, and science, as texts could be reproduced identically, relatively inexpensively, and disseminated more efficiently than ever before to mass audiences in their vernaculars. All of this encouraged more and more people from all social classes and occupations to learn to read. The first substantial book printed on a press with movable type in the Western world was the *Gutenberg Bible,* printed by German inventor Johann Gutenberg (c. 1400–1468) in Mainz, Germany, around 1455. It is 1,286 pages long and bound into two volumes. It includes ornate initial letters and decoration that were added by hand after the book was printed. Of the approximately 200 copies printed, only 22 complete copies are known to exist today. Only five complete copies exist in the United States. In the 20th century, there were further innovations in books in terms of formats, such as books on cassette tape and then books on compact disc (CD), with the words read out loud by professional actors or sometimes by the authors themselves. In the 21st century, the book industry is undergoing another major transformation with the advent and diffusion of digitized volumes, or e-books (electronic books), that are available for instantaneous purchase and download from the Web to computers and portable technologies such as the Apple iPad tablet computer, and e-book reading devices such as the amazon.com Kindle and Barnes and Noble Nook. E-books are more affordable as well as more ecological than print versions: no trees are chopped down to make them. They are more portable than printed books, too, because they can store thousands of e-books as well as magazines and newspapers for readers' enjoyment anytime, anyplace. Although not all authors or publishers have agreed to make their books

available for digital downloading, e-book publishing is the current industry trend. As the physical book market continues to decrease from annual sales in the United States of about $21 billion in 2010 to an estimated $19 billion in 2014, more and more textbooks, trade books, newspapers, and magazines are being made available in digital formats for purchase or rental, and e-book reading devices like the Kindle and Nook as well as digital book applications for other mobile devices are proliferating. See also diffusion of innovations, e-book, information overload, mass media, printing press, publisher

**Book Challenge** Formal complaint lodged with authorities to have a book removed from a public or school library, classroom, or bookstore. In the United States, the American Library Association tracks book challenges and publishes lists of banned and challenged books on their website. See also censorship, First Amendment, obscenity

**Boom** Movable microphone stand with a telescoping metal pole called a boom pole that allows for adjustments in the placement of a microphone used for radio and television broadcasts and filmmaking. A boom can be positioned so that a microphone is outside of the frame of a camera, either suspended above a scene or to the side.

**Bootleg** Copy of a musical recording in any format (e.g., cassette tape, compact disc [CD], DVD, MP3), movie, concert, or another event that is typically made without obtaining permission from the copyright holder or performer. Bootlegged copies are sometimes shared or sold, especially online. Counterfeit audio or video copies of manufacturer recordings of music, movies, and so forth are those that are made with the intention of selling them without compensating the copyright holders. The dissemination of these copies ultimately benefits the copyright holders, according to some researchers, because they cultivate audience members' desires for additional similar products. On a related note, there are people called tapers who record live concerts with performers' and copyright holders' permission and share their recordings with one another. Performers grant this permission because they benefit from the exposure that they and their music get when the music is shared. People who hear tapers' recordings might buy tickets to the artists' concerts or purchase the artists' "merch" (merchandise), including official releases (manufacturer recordings on CD and MP3) and clothing with the artists' names or logos on it. The iconic American jam band *Grateful Dead,* which performed

approximately 2,300 concerts from 1965 to 1995, pioneered the practice of arranging special taper areas in concert venues where people with tickets that designated them as tapers could set up their equipment near the sound board and could sometimes even plug into it, which yielded especially clear recordings. See also copyright, Creative Commons, piracy, recording

**Boutique** See advertising agency

**Bowdlerize** To censor, edit, or change any work, such as a book, film, or theatrical production (broadly referred to as a text), by scrubbing it clean of sex, obscenities, and/or political content deemed too bawdy or controversial. The resulting edited version is called a bowdlerization of the original. The term is an eponym. Thomas Bowdler (1754–1825), a British physician, produced sanitary volumes of William Shakespeare's (c. 1564–1616) work in the early 19th century that were titled *The Family Shakespeare* because they were appropriate for all members of the proverbial family. See also censorship, double entendre, obscenity

**Box Office** Also called a ticket booth, a small office where tickets for movies, concerts, theater, and other types of performances are sold.

**Braille** A tactile writing system that uses embossed raised dots to represent characters that people with visual impairments can read by running their fingers over the dots. Braille is the primary communication system for people with visual impairments worldwide. In Europe, some packaging for food and medicine includes a section in Braille to help people with visual impairments to identify it. Braille is an eponym. Louis Braille (1809–1852), a blind teacher, musician, and inventor from France, developed the system in 1824, when he was 15 years old. Three years later, he published a book that taught Braille. He went on to teach at the school for the blind in Paris where he had studied, *l'Institut National des Jeunes Aveugles* (National Institute for Blind Youth), one of the first of its kind in Europe. He also collaborated on the development of dot-matrix printing machines. See also code, language

**Brand** A collection of concepts, images, words, and fonts that in combination convey distinctively the identity of a person, company, or organization, or a portion of an identity, such as a product line. For

instance, Evian is a brand of the Danone Group. See also advertisement, logo, public relations, slogan

**Breaking News** In journalism, a news story that is currently unfolding. See also Cable News Network, crawl, news, twenty-four-hour news

**Bricked Device** A handheld electronic device that has been damaged to the extent that it is as useless as a brick.

**Bricolage** The remixing of cultural objects to create something new. See also mashup, montage, remix

**British Broadcasting Corporation** (BBC) An autonomous, highly respected U.K. media organization headquartered in London that was formed in 1922 and granted its first Royal Charter in 1927 to provide broadcasting in the public interest. Sir John Reith (1889–1971) was its first Director-General. The BBC is the largest broadcasting organization in the world. It receives funding from the public via licensing fees paid by U.K. households as well as government funding. Its television and radio stations and website, which offers news and analysis in 32 languages, increasingly compete with other media outlets for market share worldwide.

**Broadband Internet** A robust communication channel with bandwidth capable of many transmissions at once and fast Internet connectivity. Broadband is supported by cable, digital subscriber line (DSL), and satellite connections, among others. Cable and DSL allow for data transmission at approximately the same speed. DSL uses a conventional landline telephone that is always on (as compared with a dial-up connection) to provide high-speed access. Broadband can also be supported with utility power lines. This technology has several names: broadband over power lines (BPL), Internet over powerlines (IOP), power line communication (PLC), and power line telecommunication (PLT). Data can be transmitted at speeds approximately equal to that of cable and DSL using this technology, which is not yet widely implemented in the United States due to concerns about interference. Wireless services using wireless fidelity (Wi-Fi) and other similar technology standards such as worldwide interoperability for microwave access (Wi-Max) also support broadband Internet connectivity, which can be used in a stationary place or on-the-go with many portable devices such as a smartphone. The predecessor to broadband Internet was a dial-up connection using a personal computer (PC)

with a modem connected to a landline telephone not on a dedicated line, meaning that the phone line is not used exclusively to connect to the Internet and it is not an always-on connection. Basic dial-up is still in use. It provides a painfully slow connection in comparison to broadband Internet, typically 56 Kbps or less. See also bandwidth, data, digital divide, Internet

**Broadcast Music, Incorporated** (BMI) Organization founded in 1939 that collects licensing fees on behalf of composers, songwriters, and publishers and distributes royalties to the copyright holders when music is performed in concert venues or music recordings are broadcast or used in movie or television soundtracks. In 2010, BMI distributed approximately $800 million in royalties to the copyright owners it represents. See also American Society of Composers, Authors and Publishers; copyright; royalties; SESAC

**Broadcasting** The communication of sounds, in the case of radio, or sounds and images, in the case of television, via radio waves on a specific frequency to reach as many people as possible. The term originated in agriculture to describe the way that seeds are sown in fields. Radio waves are measured in cycles per second known as hertz (Hz), which is an eponym. German physicist Heinrich Rudolph Hertz (1857–1894) was the first to demonstrate that radio waves could be varied and projected. Regular radio broadcasts began during World War I, though there were earlier experimental transmissions by inventors and corporations. Regular television broadcasts began in the United States in 1928, though at that point they were largely experimental. Radio and television shows are called broadcasts. Likewise, when a pop-up message is sent to an entire computer network, it is a broadcast. See also cable television, radio, satellite, television, wireless communication

**B-Roll** See A-Roll

**Browser** See Web browser

**Built-In Obsolescence** Also called planned obsolescence, a limited usage life, which is an intrinsic but lamentable characteristic of many media and communication technologies. New, superiorly featured, and typically faster operating versions of all sorts of devices are developed in ways that not only supplant earlier versions but also are incompatible with related technologies. For example, some printers from the

mid-1990s, and perhaps later models as well, are incompatible with new computers, which leads users to purchase new printers and dispose of old but working printers when they upgrade computers, contributing to the unconscionable level of toxic electronic waste (e-waste) containing substances hazardous to human health and the environment. According to the U.S. Environmental Protection Agency (EPA), millions of tons of e-waste are improperly disposed of in landfills in the United States every year. Because of the built-in obsolescence of many technologies, it can be challenging for individuals, organizations, and businesses to wholeheartedly adopt environmentally responsible practices relating to the manufacturing, usage, and disposal of information and communication technologies (ICT) and other electronics. See also retronym

**Busker** A musical or theatrical performer who plays on the street, in subway stations, or other public places, collecting donations from the audience of spectators and people walking by.

**Buzz** Enthusiastic and growing awareness of something, such as a person, event, or product, resembling bees humming excitedly around an area of interest. Advertising, marketing, and public relations (PR) campaigns often aim to generate this awareness. Buzz typically describes positive attention to something or someone, as opposed to the phrase negative publicity. To give someone a buzz is slang for calling the person on the telephone. Buzz is also slang for an intoxicated high. See also publicity

**Byline** The name of the author, authors, or organization that created a piece of journalistic writing. The byline is typically placed after the title or at the end of the work.

**Byte** Eight bits of computer data joined together, each of which is either 0 or 1. A bit is the smallest possible unit of computer data. Computer files and drives are measured in bytes. The units include kilobyte (KB), megabyte (MB), and gigabyte (GB).

**c.** Abbreviation for circa, which means approximately. It is also abbreviated as ca. This abbreviation is commonly used within parentheses when someone's exact year of birth or death is unknown. For example, Johann Gutenberg (c. 1400–1468) means that the German inventor was born sometime around the year 1400.

**Cable News Network** (CNN) Pioneer 24-hour-news network launched by Turner Broadcasting System (TBS) in 1980 and now a Time Warner company that primarily broadcasts live programs internationally. See also news

**Cable Television** Television show transmission using cable networks that were implemented initially to improve television set signal reception. Cable systems enable the transmission of many more television channels than broadcasting, which uses radio waves. Cable also supports Internet access and telephone service to subscribers. Cable companies typically offer bundled telecommunications services for a monthly subscription fee based on the services selected. See also subscription

**Cablecasting** Transmitting signals over cables as opposed to broadcasting or satellite transmission.

**Call Letters** A television or radio station name. For example, WBOS, a Boston metro-area radio station. Tune in at 92.9 FM or listen online

or on-the-go on a mobile device at your convenience. There's an app for that, as Apple's commercial would say. See also placeshifting, podcast, timeshifting

**Camcorder** A blend of "camera" and "recorder," it is a handheld video and audio recording device. The earliest camcorders recorded video on tape in analog form. Newer devices record in digital form at higher resolution and with other benefits. Digital copies can be made without generational loss of data; analog copies of copies become less and less clear as more copies of copies are made. Hybrid camcorders can record onto more than one type of digital memory component. Some camcorders have built-in editing features.

**Cameo** Also called a cameo appearance or cameo role, the brief appearance of a celebrity in a media production. See also celebrity, extra

**Campaign** See advertising campaign, public relations campaign

**CAN SPAM Act of 2003** See Controlling the Assault of Non-Solicited Pornography and Marketing Act of 2003

**Caption** Brief description that is typically one-sentence long that explains or identifies a photograph, graphic, or person appearing on the screen. Closed captioning is the inclusion of captions at the bottom of a television screen. In loud environments such as bars and gyms, the closed captioning feature of a television set is often enabled so that viewers can follow the dialogue. People who are hearing impaired also use the closed captioning feature on television. In dual language productions, captions, also called subtitles, provide translations for the audience from one language into another. The process of adding captions to a program is called captioning. See also subtitles

**Carbon Copy** In email, a copy of a message that is sent to one or more people in addition to the main recipient or recipients listed on the "To:" address line of the message. A carbon copy is also known as a "Cc" or courtesy copy. Courtesy copy is a backronym, which means that the words that the initials stand for were chosen after the acronym already existed. Before the widespread use of computers, people made carbon copies on typewriters by inserting inked paper called carbon paper behind the sheet being typed on and an additional sheet of paper behind the carbon paper, for a total of three sheets in the typewriter at once. When a typewriter key struck the top sheet, the inked sheet below it would transfer an imprint to the sheet behind

it to make a copy. Carbon paper was also sometimes used on documents written in longhand that the writer wanted to copy. Using carbon paper was messy, and errors on carbon copies were difficult to indiscernibly correct, according to the author's Mom, who learned to type on a pre-World War II manual typewriter. But sending carbon copies of email messages is easy and a whole different story. The email addresses of the carbon copy (or courtesy copy) recipients are typed on the "Cc:" address line, which is below the "To:" address line. The "Cc" recipients are informed via the email message but are not expected to take action, as opposed to the "To" recipients. Email also enables senders to mail blind carbon copies of their messages in which the "Bcc" recipients' email addresses are invisible to recipients of the message. To send blind carbon copies, the email address or addresses of recipients that are to remain invisible are typed on the "Bcc:" address line. Carbon copies and blind carbon copies are typically sent when people want to keep others informed about something. However, overuse of carbon copies or blind carbon copies in email can be poor netiquette. Sometimes recipients feel that they are being bombarded with too many extraneous messages that take time to read, and they wonder why they are receiving them. The reason often boils down to the popular business acronym CYA, also known as CYOA, which is the organizational practice of being careful about "covering your own ass." If an email sender wants to know if a recipient or recipients opened and therefore presumably read or at least browsed through an email message, a read receipt can be attached to the message. See also delivery receipt, netiquette, read receipt, typewriter

**Cartoon** Graphic caricature that can be entertaining, educational, and/or satirical. Beck, the mischievous cartoon dog that appears in the photo on the back cover of this dictionary as well as on the cover of two other books edited by the author of this dictionary and published by Peter Lang Publishing, was drawn by artist and graphic designer Jean Bronson Galli (1953–) based on Galli's own frenetic Border Terrier, Beck (2000–). Beck is a brand image used by the author of this dictionary as a distinctive representation of her work so that people can identify her books. Collections of cartoon drawings in a sequential row are called comic strips or funnies. Many newspapers obtain their comics from feature syndicates, which supply different categories of

content to media outlets for a subscription fee. Animated movies and television shows are called cartoons or animations. Although at the core cartoons are typically illustrated humor, they are sometimes politically and socially contentious. An example is a group of eleven controversial animated cartoons created in the 1930s and 1940s known as the Censored Eleven. These animations include stereotypical and racist depictions of characters that are offensive to most contemporary audiences. In 1968, the then-copyright owner United Artists removed these Warner Brother cartoons from syndication on television because of their controversial racial humor. However, they are available on bootleg videotapes, on the Web, on video hosting websites such as YouTube, and in some DVD animation collections in their uncensored format. See also animation, anime, censorship, claymation, comic strip, syndication

**Case Study** A research method used in communication and media research that involves detailed description and in-depth analysis of a social phenomenon involving one or more people, contexts, or events—that is, cases. The case study is also intrinsic to education in the fields of law and business. And, in the fields of medicine and psychology, professionals record and analyze detailed descriptions of their patients' lives and symptoms in order to diagnose illnesses, and trainees (professionals in training) prepare and present case studies as part of their training. A case study takes a holistic view of a context that is unashamedly particularistic and descriptive. Unlike an experiment, which is deductive, this method is inductive, which means that a hypothesis (educated guess) and concepts emerge from the study. Case studies are typically used for exploratory analysis, rather than for hypothesis-based, confirmatory analysis. An advantage of this method is that a rich portrait can be presented, including multiple points of view and interpretations. This exploration can lead to theory development. One disadvantage of this method is that it is challenging for the researcher to identify the most important findings to focus on from a potentially abundant and detailed body of collected data. Another disadvantage is that the findings from a case study of one context cannot necessarily be generalized to other contexts.

**Casting Director** Person in charge of hiring the actors for a media production.

**CD** See compact disc

**CD-ROM** See compact disc-read only memory

**Celebrity** A person who becomes widely renowned and recognizable due to one or more of the following factors: personal accomplishments that are covered in the media; talent; expertise; contributions to society in the domain of business, philanthropy, entertainment, sports, art, or science; interpersonal connections; social status; or media exposure and appearances, such as participation in a reality television show. See also icon

**Cell Phone** See mobile phone

**Celluloid** First synthetic thermoplastic material. It was developed in the mid 1800s and used in movie and x-ray film. Celluloid is a genericized trademark that is sometimes used to refer to movies or the movie industry as a whole, as it is in the title of the pioneering book *The Celluloid Closet: Homosexuality in the Movies* (1981) by American writer, movie scholar, and social activist Vito Russo (1946–1990), which was later adapted into a documentary of the same name released in 1995. See also genericized trademark, movie

**Censored Eleven** See censorship

**Censorship** Confiscating, deleting, banning, or blocking accessibility to a text in any possible physical or digital format so that it is not readily available to interested audiences. Certain websites, books, and other media and cultural productions that discuss content deemed to be politically sensitive, socially controversial, morally corruptive, heretical (contrary to faith or moral beliefs), or potential economic or security threats have been or currently are censored by government authorities in particular countries. One example of censorship involves a group of eleven controversial animated cartoons created in the 1930s and 1940s known as the Censored Eleven. These animations include stereotypical and racist depictions of some of the characters that are offensive to most contemporary audiences. In 1968, the then-copyright owner United Artists removed these Warner Brother cartoons from syndication on television because of their controversial racial humor. However, they are available on bootleg videotapes, on the Web on video hosting sites such as YouTube, and in some DVD animation collections in their uncensored format. Proponents of

showing these cartoons and others like them that were not part of this group with the racist depictions uncensored have argued that editing out the racist depictions would render invisible the racism of the era in which the cartoons were made, effectively denying the racism as well as the cartoon creators' part in propagating it. Some DVD collections that include the Censored Eleven have warning labels and/or introductions that inform viewers about the content and provide an explanation of the cultural context in which they were made. Three of the cartoons in the Censored Eleven are no longer copyright protected and are available in the public domain. Over the centuries, books have been subject to censorship, bans, and challenges in school libraries, public libraries, academic libraries, classrooms, and bookstores for a variety of social, religious, and political reasons. According to the American Library Association, in recent years nearly half of the formal complaints (known as book challenges) lodged about particular books in the United States have been initiated by parents concerned about material their children might be exposed to, 10% by administrators, and 10% were initiated by library patrons. In their complaints, people challenging a book cite reasons ranging from its inclusion of sexual content, violence, religious viewpoints, and political themes. The list of the 10 most challenged books in the United States in 2009 included *To Kill A Mockingbird* (1960) by American author Harper Lee (1926–), which became an immediate bestseller and whose author was awarded the Pulitzer Prize for Fiction in 1961 and the Presidential Medal of Freedom in 2007 for this work. Also on this list is the *Twilight* series, American author Stephenie Meyer's (1973–) bestseller series that began with the publication of *Twilight* in 2005. Aimed initially at young adults, these books have since attracted interest from people of a wider age range, and they have received American Library Association accolades. They have spurred vampire-themed high school proms and midnight fan parties. Another book on the 2009 list is *The Color Purple* (1982) by American author Alice Walker (1944–), who was awarded the Pulitzer Prize for Fiction as well as The National Book Award in 1983 for this book. The list of the most challenged classic books in the United States includes:

- *The Great Gatsby* (1925) by F. Scott Fitzgerald (1896–1940)
- *The Catcher in the Rye* (1951) by J.D. Salinger (1919–2010)

- *The Grapes of Wrath* (1939) by John Steinbeck (1902–1968)

- *Ulysses* (1922) by James Joyce (1882–1941)

- *Beloved* (1987) by Toni Morrison (1931–)

- *The Lord of the Flies* (1954) by William Golding (1911–1993)

- *1984* (1949) by George Orwell (1903–1950)

See also book challenge, First Amendment, Hays code, rating system

**Census** In research, taking a complete measurement that includes or at least tries to include all members of a population as opposed to measuring a sample, which is a subset of a population.

**Channel** Specific radio or television broadcast frequency. Television viewers often channel surf with the remote control. Channel is also used as a general term for any means of signal transmission from source to receiver.

**Chat Room** Online environment where people interact in real time one-on-one or with many others via text-based messages, typically anonymously or using pseudonyms. Chat rooms usually have themes that people with common interests gather to discuss online. See also instant messaging, persona, pseudonym

**Checker** Also called a fact checker, a person who verifies information before it is published or presented.

**Chronemics** The study of how time is used in and affects communication. People in different cultures as well as people in various social classes within a culture have different perceptions of time and are subject to different norms regarding the use of time and the strictness of adhering to set schedules. Typically, in workplaces as well as in other contexts, the more powerful that a person is, the more that others will have to adapt to her or his norms and expectations regarding time, schedules, deadlines, and even the pace of interpersonal interactions. See also haptics, kinesics, nonverbal communication, proxemics, vocalics

**Cinematographer** The person on a movie project who is responsible for photography. This position is also called the director of photography.

**Cinematography** The art and science of making movies.

**Circular** Also called a flyer, an advertising piece that is circulated by mail or by hand.

**Circular File** Funny euphemism for a wastebasket. It can be a physical object or an online deleted file folder. People hope that their work does not end up here. See also euphemism

**Citizen Journalism** Reporting by non-professional journalists who provide eyewitness accounts and interpretations of newsworthy events such as the emergency landing of a commercial airline in the Hudson River in New York on January 15, 2009, and the earthquake in Haiti in January 2010. Citizen journalists leverage the capabilities of mobile technologies such as smartphones for transmitting text, photographs, video, and audio. News organizations such as CNN and Fox News actively solicit citizen journalists' participation in newsgathering, welcoming user generated content (UGC) and increased viewer/user engagement. Citizen journalism is an important element in a larger socio-technical trend involving participatory, DIY (do-it-yourself) citizen engagement using digital tools. See also blog, hacktivist, prosumer, Twitter, user generated content

**Claymation** Animation technique that uses shapeable clay figurines and stop motion photography. *The Gumby Show*, an American television show created by Arthur Clokey (1921–2010), is an example of claymation. This popular show, which aired for 35 years from 1960 to 1995, starred the green Gumby character, Pokey the red horse, and other lovable, colorful handmade pals (see Figure 2 on page 42). See also animation.

**Client** In business, a synonym for customer with the distinction that client usually refers to a service user and customer usually refers to a product user. In computing, a computer that requests data or programs from another networked computer that is called a server. The term also applies to software versions of programs; there is server software and client software. See also server

**Cliffhanger** A story that stops abruptly at a thrilling or dramatic point, for instance, when a character is in grave danger, such as literally clinging to a mountain cliff for dear life. The intent is for the suspense to draw the audience back to learn the story's ending, which, in the case of a television series, could be revealed in the next episode a week

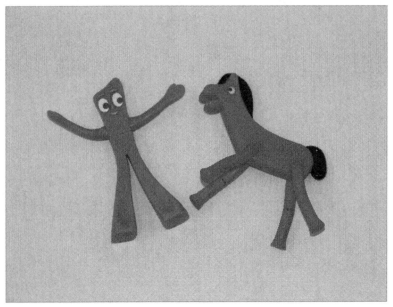

FIGURE 2. Best friends Gumby (left) and Pokey (right). Bendable toy action figures of the stars of *The Gumby Show.*

later or in the next season many months later, as was the situation in the 1980 season-ending cliffhanger of the American television show *Dallas*, which left everyone, including former actor and at the time U.S. presidential candidate Ronald Reagan (1911–2004), wondering, "Who shot J.R.?" In the case of a movie, the ending could be revealed in a sequel, a continuation of the story scheduled to be released a year or more after the movie. If no sequel is released or if the ending is ambiguous, fans sometimes speculate and concoct their own endings. This is what happened after the popular 1970s British science fiction television series *Blake's 7* ended ambiguously after four seasons. Cliffhangers have a long history. Early silent movie serials frequently used these plot techniques. Among the most memorable was *The Perils of Pauline* (1914) series, starring American actor Pearl White (1889–1938), an athletic person who performed her own stunts and was the queen of serial silent movies.

**Clip**  Section of a recording played on television, radio, the Web, or in another context, such as in a classroom. See also teaser, trailer, YouTube

**Closed Ended Question**  Also called a forced choice question or a multiple choice question, a question on a survey that has a selection of predetermined answers from which the respondent must choose. In contrast, an open ended question does not provide any predetermined answers to the respondent. See also interview, interview schedule, respondent

**Cloud Computing**  Shared, virtualized information technology (IT) infrastructure, including hardware and software resources, administered by third party providers. The word cloud is used in this term to emphasize that the IT resources are not "here" but rather are "out there," at some amorphous place like up in the clouds. Users from different locations access IT resources on the cloud through the Internet via computers or mobile communication devices. Many individuals, organizations, and private enterprises are migrating and/or outsourcing some or all of their IT functions to the cloud because cloud computing can be more cost effective, efficient, and innovative than on-site IT administration within private enterprise environments. Currently, companies are still in a transition period in terms of the growth and development of the cloud. Many IT assets are still operating within private enterprise environments as privacy, security, and interoperability challenges are being addressed by providers and users. The continued expansion of cloud computing is the trend for the IT industry. Rather than outsourcing to a third party, some entities develop a private cloud, also known as an internal or corporate cloud, to provide firewall-protected virtualized computing services to their employees. See also firewall, Internet

**CNN**  See Cable News Network

**Code**  Communication system used in contexts in which language cannot be used for a variety of reasons. Examples include: Morse code for use in contexts in which there is no auditory or visual contact; Braille for people who are sight impaired; American Sign Language (ASL) for people who are hearing impaired; and semaphore for contexts in which there is only visual contact. In semaphore, two flags are used to communicate at a distance. Different configurations of the flags represent the letters of the alphabet. In computing, code

is the mathematical language used to direct actions to be taken by a computer. See also American Sign Language, Braille, Morse code

**Codec** The acronym for "compression/decompression" that describes the software, hardware, or a combination of both that efficiently compresses and decompresses video images so that video clips can be transmitted over networks more fluidly, with fewer system delays due to bandwidth constraints. See also bandwidth, streaming media

**Coding** In media research, assigning numerical codes to raw data so that the data can be processed and analyzed by a computer.

**Cohort** A group of people who have something in common. An example is the graduating class of 2014 at a particular college.

**Comic Book** A book of cartoons or comic strips that tell an extended story or stories. The subject matter and plot can be humorous, satirical, political, or otherwise serious. See also cartoon, comic strip

**Comic Relief** A funny piece of a serious media production. Hopefully parts of this book provide comic relief. Laughter is good medicine.

**Comic Strip** Panels of cartoons. The genre dates back to the late 19th century. *Peanuts* by American cartoonist George M. Shultz (1922–2000) is one of the most famous and enduring. Shultz drew the comic strip for five decades, until 1999, and reruns of it continue to be published in syndication. See also cartoon, syndication

**Communication** Communication refers to both the act and process of transmitting and sometimes exchanging information, messages, or ideas using a system that others can, and hopefully will, understand. It also refers to the messages themselves, sometimes called communiqués or communications. The wide-ranging academic field of communication, variously labeled mass communication, communication studies, communication science, communicology, media ecology, communications, and media studies, among other names for specialty areas, explores the cornucopia of processes and techniques for transmitting and exchanging information and ideas—from pencil to smartphone—using a toolbox of quantitative and qualitative research methods. As an academic field, communication has rich roots in rhetoric as well as in sociology and related social sciences. Communication researchers take as their areas of study communication in the broadest sense possible.

The study of contemporary communication practices interests investigators from a variety of fields (e.g., psychology, anthropology, sociology, social psychology, linguistics, sociolinguistics, political science, science and technology studies), in addition to those formally located in the field of communication. See also Association for Education in Journalism and Mass Communication, International Communication Association, National Communication Association

**Communications Satellite** See satellite

**Compact Disc** (CD) Optical storage device developed in the late 1970s that is capable of storing approximately 700 MB of data. CD players and a limited number of albums on CD were available by the early 1980s. See also compact disc-read only memory, DVD, optical media

**Compact Disc-Read Only Memory** (CD-ROM) Optical storage medium developed in the 1980s that holds approximately 700 MB of data. A CD-ROM drive became a standard component of many personal computers (PC), replacing floppy disc drives. CD-ROM drives can typically play audio compact discs (CD), but audio CD players typically cannot read a CD-ROM. The CD-ROM is becoming obsolete as a back-up medium because of its relatively limited storage capacity as compared to that of hard drives and cloud computing technologies. However, CD-ROMs are still used for sharing files that are too big to be emailed or that contain data that people want to keep secure. See also DVD, optical media

**Compositor** In publishing, a synonym for typesetter.

**Computer** Electronic machine that processes and stores data and runs programs written in code. The computers of the 1950s used vacuum tubes and punch cards and were massive machines that took up the space of large rooms. Since the 1980s, technological advances in computer hardware and software have made it practical, affordable, and desirable for individuals to own their own computers. That was the beginning of personal computers, known by the acronym PC. In the 21st century, computers are integral parts of everyday life for millions of people around the world. Today's desktop, notebook (also called laptop), netbook, and handheld tablet computers have myriad features and capabilities for communication, entertainment, and information seeking. Tablet computers, like Apple's iPad, have

touchscreen user interfaces and are larger than a smartphone but more compact than a laptop. See also diffusion of innovations, hardware, Internet, personal computer, software

**Computer Virus** Malicious and potentially damaging computer program designed to be subversive that is spread via email or network or by attaching itself to an application or other computer software. Viruses can erase critical information on a computer or send the computer into an endless loop that prevents it from operating normally. Antivirus software is specifically designed to protect computers from viruses. It identifies, quarantines, and deletes viruses, but it has to be kept updated to effectively protect a computer system. Virus hoaxes are false alarms about viruses spread by well-meaning friends, family, and associates that can have the effect of saturating mailboxes because of the proliferation of these messages. See also adware, cracker, cybercrime, scareware, social engineering, spyware

**Computer-Mediated Communication** (CMC) Transmission via computer of interpersonal or task-related messages or information. Electronically mediated communication is a broader and often more apropos term for the 21st century because so much communication is now facilitated by portable electronic devices such as smartphones rather than computers.

**Concentration of Media Ownership** In the 21st century, a few media conglomerates dominate the media landscape, controlling cultural production in the news and entertainment industries and wielding tremendous social and economic power. Each of the six largest media conglomerates in the United States have diverse holdings in a range of media (i.e., television, radio, online ventures, movies, publishing, video games), a global reach to audiences and consumers, and widespread influence. These are the big six, listed in descending order based on their 2009 revenue: General Electric, which had 2009 revenue of $157 billion; Walt Disney, which had 2009 revenue of $36.1 billion; News Corporation, which had 2009 revenue of $30.4 billion; Time Warner, which had 2009 revenue of $25.8 billion; Viacom, which had 2009 revenue of $13.6 billion; and CBS, which had 2009 revenue of $13 billion. See also horizontal integration, oligopoly, political economy studies, vertical integration

**Connotation** The ideas, nuances, feelings, and subjective associations connected with something, as opposed to denotation, which is its literal, face-value meaning. See also cultural symbol, symbol

**Content Analysis** Media research method in which media content is systematically collected, coded, and analyzed. This approach does not aim to explain how audiences interpret the content or to measure the effects of the content. It is an unobtrusive method in the sense that it does not involve asking research participants questions about their media usage or their interpretations of media content. A wide range of types of content can be analyzed with this method: advertisements, movies, television shows, paintings, billboards, cartoons, websites, books, and so forth. See also latent meaning, manifest meaning

**Control Group** In an experiment in the social sciences or sciences, the group that does not receive any experimental manipulation or intervention, which is also called the treatment. The results from the control group are compared to those from the treatment group, also called the experimental group, at the end of an experiment to determine the effect, if any, of the experimental treatment. In a double-blind experiment, neither the investigator(s) nor the participants know which group is the treatment group and which is the control group.

**Controlling the Assault of Non-Solicited Pornography and Marketing Act of 2003** (CAN SPAM Act of 2003) U.S. Federal Law S. 877 that went into effect on January 1, 2004. This Act aims to reduce spam, unwanted and annoying junk email that clogs email inboxes and is time consuming for recipients to review and delete. The Act requires that businesses follow certain guidelines regarding how they label email advertisements and how they enable people to opt-out of receiving them. The Act allows federal courts to set damages of up to $2 million and to send spammers to jail and/or triple the damages if a violation of the Act is found to be willful. The high potential cost of damages and possibility of jail sentences are intended to dissuade people from sending spam. See also advertisement, blacklist, junk mail folder

**Convenience Sample** Sampling approach that draws on the most readily available research participants, such as college students in a class or shoppers in a mall. It is the least desirable sampling technique because although it is expedient it does not always yield as rich a

pool of information that a truly random sample would yield. For this reason taking a convenience sample is typically viewed as the least credible sampling approach. See also probability sampling, snowball technique

**Convergence** The merging of distinct technologies, media industries, or devices into a unified whole. An example of technological convergence is a smartphone that can be used not only for telephone calls, but also for taking digital photographs, shooting digital movies, playing video games, and as a pedometer, alarm clock, calendar, global positioning system (GPS), audio recorder, and digital wallet. See also KISS, new media

**Conversion Rate** See e-commerce

**Cookies** Data automatically stored on a computer hard drive by Web browsers that detail the uniform resource locator (URL) addresses that the computer's users have visited. Cookies are issued by the visited website and contain information about the user. A computer will be unable to access some websites if it is set to disable cookies. Cookies can be deleted from a computer. See also Web browser

**Copy** The text of any written work, such as an article or advertisement. In journalism, copy editors proofread writing for accuracy and stylistic consistency. Copy also refers to the duplication of any media product. In this case, a synonym for copy is dupe, short for duplicate. See also dubbing, Xerox

**Copyleft** In the software development realm, a social movement in which software and its source code are made available so that others can use, study, duplicate, and collaboratively modify them free of usage restrictions, though not necessarily free of charge, even for commercial purposes and for-profit, as long as the copyleft stipulation is retained. The copyleft movement was spearheaded by American computer programmer Richard Stallman (1953–), who founded the Free Software Foundation in 1985. See also copyright, Creative Commons, intellectual property, open source software, software, source code

**Copyright** Intellectual property ownership rights for the creators of works as defined by the laws of a country and/or international laws and treaties. In the 21st century, with the widespread usage of Web 2.0

and social media, it is becoming increasingly difficult for copyright holders to protect their works from infringement, that is, unauthorized usage or imitation, because it is easy to access, remix, and/or mashup digital content. In this environment, copyright enforcement is challenging. Some people are voluntarily making their creative works or information available legally for free for accessing, sharing, remixing, and reusing for noncommercial as well as commercial purposes via Creative Commons licenses as an alternative to copyright. See also bootleg, copyleft, Creative Commons, intellectual property, mashup, piracy, taper

**Corporate Art** Art collected by corporations for display in business settings. For insight into the realms of corporate art, gallery owners, art collectors, and avant-garde music, see the zany, satirical movie released in 2009 slyly titled *(Untitled)*.

**Corporate Blog** Social media marketing tool that companies use to publicize their products, services, goals, personnel, and initiatives. A corporate blog can enhance and augment a company's online presence and cultivate a group of opinion leaders who influence other people's perceptions of the company. Executives, public figures, celebrities, and blog ghostwriters contribute posts. Corporate bloggers can quickly and inexpensively disseminate information and analysis about a company's endeavors that might not be readily available from other sources. Corporate blogs can help make aspects of a company's operations more transparent to the public. Using the microblogging service Twitter, for example, consumer relations can be managed in the public's eye. See also blog, buzz, ghost, public relations, publicity, social media marketing, Twitter

**Cover Story** Article announced on the cover of a publication, such as a magazine, that is typically featured as the major piece within the issue. Also, a major story covered in a television show.

**Crackberry** Humorous slang for BlackBerry smartphone that refers to the fact that many BlackBerry "users" get somewhat, or a lot, addicted to their device. Crack is slang for crack cocaine, an addictive stimulant drug. Many users of other brands of smartphones habitually use electronically mediated communication, too. See also BlackBerry, information overload

**Cracker** A person whose expertise with computers enables him or her to illegally break into secured computer systems for malicious reasons such as to commit cybercrimes or financial fraud. The more well-known term hacker is sometimes misused as a pejorative word instead of the term cracker, particularly in journalistic accounts to describe people who maliciously break and enter into computer systems or attempt to do so. However, there is a subtle but important difference between hackers who enjoy tinkering with and understanding how things work and malevolent security crackers. A term related to cracker is phreak, someone who illegally breaks into and makes use of a telephone network for free. This practice is called phreaking. See also cybercrime, hacker

**Crawl** Also called crawl roll, scrolling captions on a television or movie screen, which flow either horizontally or vertically and provide the audience with information. A news crawl provides news updates and breaking news. The effect of scrolling words from the bottom to the top of a screen is called a creeping title. See also breaking news

**Creative Commons** Non-profit organization founded in 2001 and head-quartered in San Francisco, California, that offers a variety of licensing mechanisms for intellectual property (creative works) as alternatives to copyright. The aim of Creative Commons is to increase the number of creative works legally available for accessing, sharing, remixing, and reusing for noncommercial as well as commercial purposes. See also copyright, intellectual property

**Credits** Also called end credits, in movies and television shows the scrolling list of names and titles of the people who participated in the production. Actors are typically listed beginning with the well-known stars first and then in order of appearance, along with the names of the characters portrayed or, if unnamed, the name of the part. See also extra, fan

**Crop** In photography, to strategically trim part of an image in order to transform its composition. This can be done to enhance a photo and/or change its intended meaning, for instance, by centering an element of the photo that had been on the periphery. Cropping can also be used to change the intended meaning by removing certain elements. Software makes it easy even for amateur photographers or computer novices to instantaneously edit and enhance digital

photographs in myriad ways, including cropping. In printing, crop marks are lines printed on a completed print job that show where the publication should be trimmed.

**Crowdsourcing** The practice of harvesting the wisdom of the crowd online, a vast, undefined network of users who participate in Web 2.0, in an open call for ideas and/or peer production, as opposed to designating one person or a team to tackle a project or solve a problem. Collectively written and iteratively updated Wikipedia is an example of crowdsourcing. Collaboratively developed open source software is another. In order to save time and money many companies are expeditiously outsourcing functions using crowdsourcing techniques. Furthermore, people are contributing resources and data for free to Web 2.0 that are valuable to businesses. Individuals as well are drawing on and benefiting from the expertise and resources of the crowd online. See also open source software, Web 2.0

**Cultivation Theory** Media effects theory spearheaded by Hungarian-born American communication researcher George Gerbner (1919–2005) in the 1960s that asserts that television viewing profoundly shapes people's attitudes and opinions over time, leading individuals to view the world in ways that do not necessarily align with reality. For example, the typical "If it bleeds, it leads" local news programming approach with its disproportionate focus on stories of crime, violence, and tragedy leads viewers to think that American cities are more dangerous and crime ridden than they really are. Cultivation research analyzes the content of television shows. See also mean world syndrome, theory

**Cultural Imperialism** Idea that there is an uneven flow of media products, cultural artifacts, and social values concerning fundamental issues such as gender equality and sexuality from Western countries to non-Western countries. According to this viewpoint, much of the world's population is enamored by Western culture and its products because the corporate conglomerates that control the majority of the media have cultivated a fascination with the West by the rest. This cultural domination, also called cultural hegemony and media imperialism, produces a homogenized transnational consumer culture out of disparate local audiences. Media theorists' conceptualizations of multinational corporate cultural imperialism are supplanting earlier

ideas about American (only) cultural or media imperialism. Counter-arguments to cultural imperialism say that audience members are active interpreters of media products (the active audience thesis). Both views are accurate, according to some researchers. This third perspective suggests that there is a synergy between transnational corporate machinations and audience members' active agency in using consumer products of all kinds, especially media. See also globalization, polysemic

**Cultural Indicators Project** Hungarian-born American communication researcher George Gerbner (1919–2005) launched this longitudinal study in 1967 to examine the long-term and cumulative psychological and social effects of television on audiences. He and his co-researchers were concerned that media corporations were exporting television shows that contained homogenized common denominators of sex and violence that made them widely appealing to worldwide audiences, rather than pluralistic images and messages: consider the worldwide commercial successes of American television series such as *Baywatch* and *Sex and the City*. According to some critics, the television industry has, for the most part, squandered its potential power for having positive social impacts. As evidence, they point to the lack of diverse representation of viewpoints in television shows, the relative rarity of prosocial messages, and the promotion of sexual activity without showing reality-based consequences. Typically, television shows are designed to generate high Nielsen ratings and sell advertisements. See also Nielsen ratings

**Cultural Studies** Multidisciplinary approach to the study of media and popular culture that focuses on topics such as how people interpret media and use cultural symbols and artifacts of popular culture and on how the media express and reinforce social hierarchies and power relationships. This approach uses literary and cultural criticism qualitative methods such as textual analysis, audience studies, and political economy studies rather than quantitative social science methods such as surveys and experiments.

**Cultural Symbol** An artifact or image that is so widely understood within a culture or subculture that the creator of a non-fiction or fictional text can use it to convey a complex idea or sentiment economically, knowing that the audience will understand the intended meaning.

Examples include the cross as a symbol of Christianity, the rainbow flag as a symbol of gay, lesbian, bisexual, and transgendered people, and green—the color as well as the word—as a symbol of environmental sustainability. See also subculture

**Culture Jamming** Also called subvertising, a blend of "subvert" and "advertising," a form of media activism in which people creatively appropriate, reconfigure, and spoof advertisements, corporate logos, and other cultural symbols such as the U.S. flag in order to convey social and political messages that are different from those that their designers intended. Culture jammers aim to raise people's awareness about global environmental issues and, in particular, about the pervasiveness and power of advertising in the consumer cultures of developed countries. "Buy Nothing Day," which is held in many countries around the world, is one culture jammer activity that publicizes this environmentalist ideology. In the United States, Buy Nothing Day is held the day after Thanksgiving—traditionally called Black Friday—because it marks the beginning of the holiday shopping season and many stores offer big discounts and promotions to attract customers. On Black Friday, many retail stores typically earn a profit and are "in the black" rather than "in the red" in accounting terms. In accounting software, a loss or negative profit is often shown in red, whereas a profit is displayed in black. Other culture jammer activities include public performances of non-consuming at shopping malls, where activists wheel around a caravan of empty shopping carts. Critics of anti-consumerism protests like these point out that millions of poor people worldwide cannot afford the luxury of choosing whether to be a consumer or not. See also cultural symbol, jamming

**Curriculum Vitae** (CV) The Latin expression for "course of life." A type of resume used by people who are applying for positions in academia or for research grants that provides a comprehensive summary of a person's professional achievements and contributions. A CV usually includes details about the person's educational background, work history, publications, creative works, presentations, research funding, awards, and honors.

**Cut** See final cut, short list

**Cybercrime** Illegal activities committed online using information and communication technologies (ICT). See also Facebook stalker, phishing, smishing, social engineering, vishing

**Cyberspace** The totality of online environments. See also Internet, World Wide Web

**Cybersquatting** Also called domain squatting, according to U.S. federal law, the criminal practice that can entail registering, trafficking in, or using a domain name in bad faith in order to exploit someone's or an entity's trademark without their permission. Cybersquatters sometimes register misspellings of others' domain names as well as recently expired domain names with the hope that the rightful owners will buy the domain name registrations from them for exorbitant prices. Because the wheels of justice turn slowly, it is often more expedient for the rightful owners to pay cybersquatters for the domain name rather than sue them. See also domain name, trademark

**Dailies** In the film industry, dailies are the unedited footage shot during the making of a movie. They are also called rushes. In the newspaper industry, dailies are papers published every day of the week or at least several times a week. In the 21st century, some newspapers that had been published every day have reduced publication to five or six days a week as a cost-cutting measure in response to declining subscriptions and shrinking income from the sale of advertisements. See also subscription, weekly

**Data** Information in any format. Data is plural; a single piece of information is a datum.

**Database** A collection of information that can be organized, accessed, analyzed, and updated.

**Dead Air** In radio or television broadcasting, when there is unintended silence on-air, typically due to a technical problem or human error.

**Debriefing** In media research, discussing the purpose of a study with research participants after their participation is completed. See also informed consent

**Decibel** (dB) Measurement of sound that indicates the sound power per unit area on a scale of zero to 140. A decibel is one-tenth of a bel

(B), a unit named for Scottish-born American inventor, scientist, and teacher of the deaf Alexander Graham Bell (1847–1922). Repeated or prolonged exposure to sounds at 70 dB or higher can cause hearing loss. In the United States, hearing loss is the third most common health problem, affecting more than 36 million Americans. Personal audio electronics, such as iPods, can produce sound at 115 dB or higher. Aircraft take-offs produce 180 dB. Amplified rock music produces 120 dB. Chainsaws produce 110 dB. Lawnmowers and subways produce 90 dB. Listeners beware! See also music, noise

**Defamation**  A false statement about someone that damages his or her reputation and also in some places and under certain conditions a true statement about someone that is made with malevolent intent or ill will, such as in an attempt to inflict emotional distress. When spoken, the defamation is known as slander, when the defamation is written or in pictures, it is libel.

**Delivery Receipt**  An automated alert message activated by the sender so that the sender is notified when a particular message is delivered to the recipient mailbox. This is a useful tool for insuring that an email address is valid. An email delivery receipt works in a similar manner as a delivery confirmation from the postal service. If the email could not be delivered, the sender will receive a non-delivery report (NDR) that will state the reason for not delivering the email. The most common reasons are: the email address is erroneous or does not exist, the mailbox is full, or the email server is inaccessible. In case of an error, an NDR will be sent to the sender even if the sender did not request a delivery receipt. See also read receipt

**Demo**  Short for demonstration, an example of someone's work, such as a recording of a musician, actor, or broadcaster that is produced for auditions.

**Demographics**  Features of a human population that are commonly measured and described in government, marketing, and public opinion research. Some commonly measured elements include: sex, religion, race, ethnicity, age, income, highest education level attained, employment status, marital status, and home ownership status. Checking the demographics of a sample is a way to determine if it is a representative sample, which means that it is a good representation of

the population from which it was drawn or to which a particular study could apply.

**Denotation**  The literal, face-value meaning of something, as opposed to connotation, which refers to the ideas associated with something. See also cultural symbol, symbol

**Descriptive Statistics**  Statistics calculation such as the mean, which is the arithmetic average calculated by adding the values of several items and dividing by the number of items, that summarize the characteristics of a sample but do not make inferences about the population from which the sample was drawn. See also inferential statistics

**Desk Copy**  Complimentary copy of a book provided by a publisher to an educator who assigns the book as recommended or required reading in a class.

**Diagetic Space**  The imagined world of a narrative that audience members enter as they suspend their disbelief to experience and enjoy a movie, play, television show, novel, or video game. The world of a video game is particularly compelling because players interact in the game space. See also audience

**Dialogue**  The lines in a script for actors in a media production. Also, in interpersonal communication, a conversational exchange.

**Diary Method**  In media and marketing studies, having research participants keep a daily record of their actions or consumption behaviors.

**Diffusion of Innovations**  Theory by American communication scholar and sociologist Everett Rogers (1931–2004) first published in a book of the same name in 1962 that has become one of the most cited books in social science. According to this theory, an early adopter is part of the group of people who eagerly embrace and use a new idea, information, or technology before most of the rest of the population does, but after the small group of people known as innovators have adopted it. Following the early adopters are the early majority, then the late majority, and then the laggards. Today, people at the opposite end of the spectrum from early adopters who resist a new technology because they are not interested in it, cannot afford it, do not understand it, do not know about it, or believe that it threatens people's livelihoods because it replaces the human labor force with

technology, are sometimes labeled technophobes, someone who fears or dislikes technology, or neo-luddites. The latter term refers to the Luddites, a British protest movement of artisan textile workers who, in the early 1800s, were concerned about the implications of the Industrial Revolution. See also digital divide, theory

**Digital** A signal that consists of a series of discrete values, in contrast to an analog signal, which consists of a continuous stream of data. Digital technologies are electronic technologies that generate, store, process, and transmit data in one of two states: positive, represented by the numeral 1, and non-positive, represented by the numeral 0. Each of these pieces, either a 0 or a 1, is called a bit, which is a blend of "binary" and "digit." A bit is the smallest possible unit of computer data. A string of 8 bits joined together is called a byte. Digital data is always a string of 0s and 1s. It is measured in multiples of bytes. Prior to the invention of digital technologies, analog signals were used. Both analog and digital technologies are used for some tele-communications. Conventional television uses analog signals while digital television uses digital signals, which allow for interactivity as well as superior video and audio resolution regardless of varying reception distances. See also analog, gigabyte, Internet traffic

**Digital Divide** The concept that describes the quality-of-life inequality between technology-haves and technology-have-nots. It is also the disparity between the information-rich and the information-poor, since technology supports access to information. Because access to digital technologies, especially telephones and computers, is uneven across the world, people who have access to these technologies are able to benefit from them in ways that other people without similar resources cannot. The digital divide describes the disadvantages that accrue because of this disparity, especially in terms of educational, social, and economic opportunities. It makes sense to conceptual-ize the digital divide as a continuum (think of a line with multiple points on it) rather than as a dichotomy (something that has two sides with a chasm, metaphorically speaking, that separates the sides), because people have varying degrees of access to digital technologies. People also have varying degrees of facility with these technologies and, even more basically, varying levels of literacy. The populations of the poorest countries in the world have the lowest literacy levels.

But a person in a developing country who is highly literate might have slow and unreliable access to the Internet using a relatively old computer with outdated software. This person would not be able to leverage the potential of the computer and Internet for educational, business, social, or entertainment purposes to the same degree that someone with the latest computer technology and a reliable broadband Internet connection would. Telephone penetration, that is, how many people have telephones in a geographic region, is highest in developed countries. For many poor people in developing and underdeveloped countries, owning a telephone is completely out of reach. In contrast, in developed countries, a phone is considered a basic necessity. The concept of the digital divide highlights the complicated relationship between access to technology and access to social, educational, economic, and political power. See also media literacy

**Digital Immigrant** See net generation

**Digital Millennium Copyright Act** (DMCA) **Safe Harbor** The DMCA was signed into law by U.S. President William Jefferson Clinton (1946–) on October 28, 1998. It is Section 512 of Title 17 of the U.S. Code. The Act protects online service providers such as search engines, online directories, blogs, auction websites, and Internet service providers (ISP) from liability for copyrighted material that is illegally posted or transmitted by users of their services (their customers), if the service providers adhere to the provisions outlined in the Act. Service providers must respond expeditiously to a complaint from a copyright holder of alleged infringement and prevent further access to specifically identified material so that infringement cannot continue. DMCA Safe Harbor provisions immunize video file hosting websites like YouTube from copyright infringement liability. The DMCA Safe Harbor provisions do not apply to trademark infringement, just copyright infringement. See also copyright

**Digital Native** See net generation

**Digitization** The process of converting data from any format, text, audio, video, and so forth, into a digital format, which is a series of 0s and 1s.

**Dingbat** In typography, an ornamental or fun non-alphabetic symbol such as ♥ and ☼. The dingbats included in Microsoft Windows are called wingdings. In the U.S. television hit situation comedy *All in*

*the Family*, which aired on CBS from 1971 to 1979, Archie Bunker, played by American actor Carroll O'Connor (1924–2001), repeatedly calls his sweet and naïve wife Edith, played by American actor Jean Stapleton (1923–2010), a dingbat and tells her to "stifle yourself." See also typography

**Direct Mail** Promotional material delivered to people's mailboxes, including political pamphlets, fundraising materials, and shopping catalogs. Usually recipients have been identified by a direct mail company as being the target audience for the mailed material. See also advertisement, noise, pamphlet, spam

**Director** Person in authority position who coordinates a media production or aspects of it.

**Director of Photography** Also called cinematographer, the person working on a movie project responsible for the aesthetic and technical aspects of the movie photography.

**Disc Jockey** (DJ) In the radio industry, an on-air radio show host who introduces songs and talks with members of the listening audience who call. DJ is also the title for people who play records at parties, weddings, dances, clubs, and raves.

**Discography** The list of a musical performer's recordings. In the film industry, an analogous list of the movies of an actor, writer, or director is called a filmography.

**Discussion Board** Online forum where people post and respond to one another's messages asynchronously. A string of related messages is called a thread. The posted messages are archived. Discussion boards are often used in college-level online education courses as well as in traditional face-to-face (F2F) courses that have online components that are accessed via a course management system such as Blackboard or WebCT. On the Internet, there are an enormous number of discussion boards on practically every topic, hobby, and special interest imaginable. These are called newsgroups and are accessible through Usenet as well as through Web browsers. Many websites include discussion board features for visitors' participation. Some news websites have mini discussion boards at the end of each news article where readers can post comments related to the article. People who read but do not contribute to discussion boards are called lurkers. See also wiki

**Disinformation** See culture jamming, jamming, optics, propaganda, spin

**Disney** Short for the Walt Disney Company, a global media conglomerate headquartered in Burbank, California. It was founded in 1923 as Disney Studios by two brothers, American entrepreneurs Walt (1901–1966) and Roy Oliver Disney (1893–1971). Disney is the world's largest media company. It has operations in five business sectors: media networks, parks and resorts, studio entertainment, consumer products, and interactive media. The company's diverse holdings include: Walt Disney Pictures, Disney Theatrical Productions, Touchstone Pictures, Pixar Animation Studies, ABC-owned Television Stations Group, ESPN, Disney Music Group, Hyperion Books, Disney Cruise Line, Baby Einstein Company, and Muppets Holding Company. Disney subsidiaries provide the company with tremendous customer reach, worldwide audiences, and the advantages of synergy and cross-promotion. There are over 350 Disney Stores in the world. In terms of sales, Disney Consumer Products is the largest licensor in the world. Disney Online had more traffic than any other child- and parent-oriented website in 2009. Club Penguin is the most popular virtual world for children on the Internet. Annually, more people now visit Disneyland Paris than the Eiffel Tower and Louvre combined. The Disney brand and its characters are adored worldwide. In 2009, Disney's revenue was $36 billion, with net income of $3.3 billion. See also concentration of media ownership

**Distance Learning** See online education

**DIY** Acronym for "do-it-yourself." See also prosumer, user generated content, Web 2.0

**DJ** See disc jockey

**DMCA Safe Harbor** See Digital Millennium Copyright Act Safe Harbor

**Documentary** A non-fiction movie genre. Documentaries focus on a theme, person, or issue. They are typically filmed at real locations using non-actors. Examples include the French documentary *March of the Penguins* (2005), a commercially successful nature movie about the amazing life cycle of the emperor penguins in Antarctica, which features real penguins, and *Food, Inc.* (2008), an eye-opening and

stomach-turning exposé of American food industry practices. See also exposé, genre

**Dog's Cock** Slang for an explanation point!

**Domain Name** The location of a person, organization, or other entity on the Internet. For example, peterlang.com is the domain name for the publisher of this dictionary, and quinnipiac.edu is the domain name for the university where the author of this dictionary is employed as a professor of communications. The top-level domain (TLD) of a domain name is the part that comes after the period. In Peter Lang Publishing's domain name it is the "com," which stands for commercial. In Quinnipiac University's domain name it is the "edu," which stands for educational institution. A TLD can indicate something about the purpose of the entity with which the domain name is associated, it can be generic, or it can indicate the entity's location. Each country has a two letter TLD code. The code for the United States is "us," for France it is "fr," for the U.K. it is "uk," and so on. Some codes are reserved for specific usages. For instance "gov" can only be used by U.S. government agencies. Domain names are mapped to Internet Protocol (IP) addresses through domain name system servers (DNS servers), which replicate to one another all over the Internet so that domain names always reach the right website or IP address. When a user enters a domain name into the address line of a Web browser, the browser goes to the identified location on the Internet and opens a Web page for the user to view. The Internet Corporation for Assigned Names and Numbers (ICANN), a private, non-governmental non-profit entity formed in 1998 and based in California, licenses domain name registry companies and manages other technical protocol aspects of the Internet that keep it functioning. It is sometimes said wryly that the name ICANN refers to "*I can* at least try to manage the Internet." There are always people inventing ways to profit from technologies, including in the realm of Internet domain name registration. Cybersquatting is the term used in U.S. federal law to describe the criminal practice of registering, trafficking in, or using a domain name in bad faith in order to exploit someone's or an entity's trademark without their permission. This is also called domain squatting. The U.S. Internal Revenue Service (IRS) website is called irs.gov. Someone created a website called irs.com, which gets a lot of

visitors who typed hastily when searching for the official IRS website. Cybersquatters sometimes register misspellings of others' domain names as well as recently expired domain names with the hope that the rightful owners will buy the domain name registrations from them for exorbitant prices. See also uniform resource locator, Web browser

**Dot-Com** Slang for Internet related business. The term is based on the domain name format of many businesses in the United States that have ".com"—an abbreviation for commercial—as the top-level domain.

**Double Entendre** A provocative convention used by the creator of a text to imply two possible meanings, typically to be funny or sexy. British writer William Shakespeare (c. 1564–1616) was a master of cleverly titillating double entendre. See also bowdlerize

**Downloading** The process of obtaining any form of data, such as text files, MP3 audio files, video clips, movies, or computer software, from one device or system, typically a server, and putting it onto another device or system, typically a personal computer (PC) or smartphone, for "disconnected" usage. For example, people download songs from the iTunes website onto their iPods for their personal listening. Uploading is the reverse process: transferring data from a personal computer, smartphone, or other device onto another device or system, typically a server, for other people to use. For instance, people upload videos onto the YouTube website for any Internet user to view, and individuals upload vacation pictures onto their Facebook page to share with their family and friends.

**Drive Time** The times of day when many people commute to work and are likely to listen to the radio, typically 6 to 10 a.m. and 4 to 7 p.m.

**Driving While Intexticated** See short message service

**DSL** See broadband Internet

**Dubbing** In media productions of all kinds, the process of doubling or making a copy of a production. In movie and television production, also called post-synchronized sound, the post-production synchronization of a soundtrack of all types of sounds to the footage, including matching dialogue to the speakers' lip movements. Sometimes the soundtrack that is synchronized to the footage includes dialogue or singing performed by different people than those who appear

on-screen. Sometimes the soundtrack is in a different language than that spoken by the on-screen people in order to cater to an audience from a foreign country or speaking a foreign language. See also lip sync, soundtrack

**DVD** Optical disc technology developed in the mid-1990s that can store video, audio, video games, and computer data. The acronym DVD has been translated as "digital video disc," "digital versatile disc," as well as many other humorously derogatory terms, such as "digital venereal disease," because of the ease of making unauthorized (pirated or counterfeit) duplicates of copyrighted materials. DVD has also been translated as "delayed, very delayed," because of the postponed release of many of the DVD formats. Today there is widespread agreement to call the technology just by its acronym, DVD. The DVD exemplifies a highly successful consumer product. It was widely and quickly adopted for many uses. Because of its greater storage capacity and versatility, the DVD supplanted many of the data storage technologies that preceded it, including laserdisc, videotape, and compact disc-read only memory (CD-ROM). DVD players for home use were first available on the market in 1997 for about $1,000. As is the case with many digital technologies, such as personal computers (PC) and mobile phones, as more and more people purchased DVD players, the prices plummeted. By 2000, a DVD player cost less than $100, and by 2010, they were available for less than $50. See also compact disc-read only memory, diffusion of innovations

**Dystopia** A fictional place that is dreadful and repressive, in contrast to a utopia, where life is ideal. Examples of dystopias are the societies depicted in Indian-born British writer George Orwell's (1903–1950) book *1984,* which was published in 1949, Canadian writer Margaret Atwood's (1939–) novel *The Handmaid's Tale,* published in 1985, and the movie *V for Vendetta,* which was adapted from a graphic novel (comic book) by British cartoonist and writer Alan Moore (1953–) published between 1982 and 1985.

**e.g.** Abbreviation for the Latin expression *exempli gratia,* which means "for example." For clarity, use English words rather than Latin abbreviations *ad nauseam!* See also *ad nauseam,* et al., etc., i.e.

**Earbud** Headphones or headset loudspeakers that fit into human ears for personal audio listening. They can be plugged into devices such as computers, smartphones, and digital media players like the iPod. See also decibel, noise

**Early Adopter** According to American communication scholar and sociologist Everett Rogers's (1931–2004) diffusion of innovations theory, which was first published in a book of the same name in 1962 that has become one of the most cited books in social science, an early adopter is part of the group of people who eagerly embrace and use a new technology or idea before most of the rest of the population does, but after the small group of people known as innovators have adopted it. Following the early adopters are the early majority, then the late majority, and then the laggards. The group of people who resist a new technology because they are not interested in it, cannot afford it, do not understand it, do not know about it, or believe that it threatens people's livelihoods because it replaces the human labor force with technology are sometimes called neo-luddites or technophobes. See also digital divide, theory

**eBay** American Internet company that was launched in 1995, headquartered in San Jose, California. eBay was founded by French-born Iranian-American computer programmer and philanthropist Pierre Morad Omidyar (1967–), who serves as Chairman of the Board. eBay owns the well-known ebay.com auction website, the online money transfer company PayPal, which it acquired in 2002 for $1.5 billion, as well as many auction websites, online advertising, and e-commerce sites worldwide. Its 2009 revenue was $8.7 billion, with net income of $2.4 billion. The company employs 16,400 people, 9,700 in the United States and 6,700 in other countries. See also e-commerce

**E-Book** Short for electronic book. A book in digital format. More and more book publishers are taking steps to produce e-books when they acquire books and/or audio books. This practice is revolutionizing the book economy. See also amazon.com, e-reader

**E-Commerce** Short for electronic commerce. Any type of business transaction conducted online, such as purchasing an e-book or DVD from amazon.com. People appreciate the convenience, efficiency, and privacy of e-commerce. Shopping online can be fun and fast, without any transportation efforts for the consumer during in the shopping process. Indeed, online retailers (sometimes called e-tailers) work hard to ensure that customers enjoy visiting their websites. Purchases can be made easily and even impulsively with the click of a button. Most large companies have had a Web presence since 2000. In the last decade, conducting business of all sorts online has become business as usual for many people, from buying groceries to selling cars to trading stocks. Companies of all sizes and types have developed multiple types of online presence, including corporate websites, corporate blogs, Facebook pages, and Twitter accounts. It has become a necessity to develop an e-commerce business to maintain a competitive advantage. The largest U.S. online retailer is amazon.com. Founded by American Internet entrepreneur Jeffrey Bezos (1964–) in 1995, amazon.com first earned a profit in 2001. Internet related businesses like amazon.com are sometimes called dot-coms, referencing the last piece of their domain names—".com"—with com being an abbreviation for commercial. Businesses that sell products and/ or services in physical locations (stores) are sometimes called bricks and mortar companies. Companies that operate both online and in

physical locations are sometimes called clicks and mortar. The most challenging aspects of e-commerce are providing secure payments for the purchasers and marketing online. With respect to the issue of secure payments, the banking and credit card industries have developed protocols and rules to provide solutions for companies. With respect to marketing, new techniques are constantly being developed to bring potential customers to e-commerce websites (e.g., pay-per-click marketing) and entice potential customers to make a purchase. The measure of how many visits end in a purchase is called the conversion rate. This is something that companies are constantly trying to improve. The proliferation of mobile devices, especially smartphones, continues to support the e-commerce explosion. It is predicted that smartphones will become the next generation of payment method, replacing credit cards in the future. See also amazon.com

**Economies of Scale** Business concept that explains the variety of reasons that savings tend to accrue for a company as sales volume is increased. A company can negotiate lower prices from its vendors when it purchases more of the parts, services, real estate, and so forth it needs to operate. Fixed costs are spread over a wider base. In addition, companies or subsidiaries of companies can benefit from increased purchasing power and reduced costs when they collaboratively negotiate with vendors.

**Editor** A person who is responsible for gatekeeping and organizing media content. In the movie and television industries, the editor constructs and sequences the production after the footage has been filmed. In movies, the end result is called the final cut or fine cut. In the magazine, newspaper, and book industries, professionals in various editorial positions participate in the processes of selecting and preparing material for publication and ensuring that it meets the standards of the organization that is releasing it. See also gatekeeping

**Editorial** Opinion piece broadcast on television or radio or published in a newspaper or magazine, sometimes without a byline. See also opinion piece

**Edutainment** A blend of "education" and "entertainment," this term encompasses all television programming designed to teach something to viewers. Examples of edutainment in the United States range from documentaries to reality television shows like *The Biggest Loser*

and *What Not to Wear* to children's programs such as *Sesame Street.* Since the 1970s, organizations based in developed countries have used edutainment as part of public health campaigns for audiences located in developing countries. In the 21st century, there are television networks that focus exclusively on edutainment programming, such as The Food Network. Some websites can also be classified as edutainment, such as howstuffworks.com.

**Electronic Frontier Foundation** (EFF)  Nonprofit watchdog and lobbying group that works in the public interest to preserve civil liberties on the Internet and to promote the responsible use of new media. The EFF was founded in1990 by American software entrepreneur and co-founder of Lotus Development Corporation Mitch Kapor (1950–); American writer, political activist, and former Grateful Dead lyricist John Perry Barlow (1947–); and American computer entrepreneur and digital rights activist John Gilmore (1957–). Membership is open to the public. See also new media

**Electronic Media**  Media category that includes radio, television, computers, video games, and the Internet.  Other media categories are print media, which includes newspapers, magazines, and books, and photographic media, which includes movies and photographs.

**Electronic Waste** (E-Waste)  Obsolete electronic equipment and components such as computers, digital media players, mobile phones, video games, and related peripherals, which contain materials that are hazardous to human health and the environment when disposed of improperly. The e-waste stream includes valuable non-renewable resources. Many components of obsolete electronics can be refurbished and reused. Yet too many people inexplicably stow and stockpile obsolete gear or improperly discard it, perhaps because it is not always obvious how or where e-waste can be recycled. The U.S. Environmental Protection Agency (EPA) estimates that, appallingly, only one out of ten obsolete computers are properly disposed of and recycled. See also built-in obsolescence

**Electronically Mediated Communication** (EMC)  Transmission via electronic devices of interpersonal or task-related messages or information. EMC includes: email, short message service (SMS) texting, blogging, instant messaging (IM), and social networking via websites such as Facebook. These practices are all affecting how people use language

and, at the core, manage relationships. Electronically mediated communication is a broader and often more apropos term for the 21st century than computer-mediated communication (CMC) because so much communication is now facilitated by portable electronic devices such as smartphones rather than computers.

**Email** Short for electronic mail, a communication application developed in 1971 by American computer programmer Ray Tomlinson (1941–) so that text messages could be exchanged between geographically dispersed computer users connected via the Advanced Research Projects Agency Network (ARPANET), a precursor to the Internet. Each user is identified by an email address, which uses a specific syntax to ensure that an email message is delivered to the right mailbox. Each user has one or more mailboxes. Each mailbox has a unique email address. A mailbox is located on a server that a user accesses with a secured user identification (ID) and password for confidentiality reasons. Tomlinson has said that he invented email as a way to reach colleagues who did not answer their telephones. Over the next 25 years, email became a killer application for the Internet, one that motivated people who did not previously use computers to learn to use them so that they could send and receive email. Email is an asynchronous form of communication. Sent messages are stored on a server until they are retrieved by recipients. The predecessor to email, handwritten or typed documents delivered by the postal service, is now sometimes called snail mail as a humorous reference to its relatively slow delivery pace as compared to that of email. But sending a personal letter or postcard by snail mail can have a tremendous psychological impact in the digital age. See also Internet

**Embedded Journalist** Also called an embedded reporter, a journalist and/or photographer who travels with military troops on missions as a war correspondent. The journalist has first-hand access to what the troops are experiencing, which can be conveyed in reports for the broadcast or print media. This arrangement also gives the military control of where the journalist goes and what the journalist experiences, which will ultimately influence the content of the reports. Critics of embedded journalism argue that the journalists can become too sympathetic to their own country's point of view while travelling with the troops, losing their journalistic objectivity.

**Emoticon** A blend of "emotional" and "icon." Also called a smiley or smiley face, an arrangement of typed characters used inventively in email or short message service (SMS) texting to express emotions that might not be obvious to the reader based on the text only. Emoticons are useful because text-only messages have reduced social cues as compared to face-to-face (F2F) communication or voice telephone calls. Examples include:

:-) a sideways smiley face to indicate happiness

:-( a sideways frowning face to indicate sadness

;-) a sideways smiley face winking

**Emotional Contagion** The transfer of emotions between individuals in a workplace, crowd, lynch mob, witch hunt, or any other context. The innate human phenomenon of being influenced by another's mood. For instance, when a person smiles at another person, the other individual typically smiles back, mirroring the positive emotion. According to neuroscience research, people are able to understand and empathically experience or resonate with another's emotions through a simulated shared body state facilitated by mirror neurons. See also moral panic

**Empirical** Based on direct observation, real life experience, experimentation, or data that was systematically collected as opposed to based on logic, speculation, or theory. See also data, theory

**Encryption** To prevent data leaks, security breaches, and fraud, software can be used to convert sensitive and private digital data into an unintelligible coded format so that unauthorized people cannot easily access it. Encryption algorithms are used to encrypt the data, and they are becoming more and more complex. Decryption keys then convert the data back into an understandable form. See also crackers, cybercrime, hackers

**End User License Agreement** (EULA) See software license

**Entertainment Software Rating Board** (ESRB) See rating system

**Eponym** Something such as a place or invention that is named after the person who originated it. Morse code is named eponymously after its inventor Samuel Morse (1791–1872), and Braille is named after

its creator Louis Braille (1809–1852). See also acronym, neologism, pseudonym, retronym, synonym

**E-Reader** Portable, handheld, battery-operated device that can be used to wirelessly download, store, and access digital copies of books (e-books), newspapers, magazines, and games such as Sudoku and chess. Examples include the Barnes and Noble Nook, amazon.com Kindle, and Apple iPad tablet computer. The market for physical books has been shrinking while e-books, digital media players, and e-reading applications for mobile devices such as smartphones are proliferating. See also e-book

**Erotica** Media products such as books, magazine stories, and movies that are meant to sexually arouse readers or viewers. See also censorship, First Amendment, obscenity

**ESRB** See rating system

**et al.** Abbreviation for the Latin expression *et alii,* which means "and others." This abbreviation is commonly used in bibliographic citations when the publications referenced have multiple authors. Here is an example in the American Psychological Association (APA) style of an in-text citation for a publication with multiple authors: (Kleinman et al., 2011). See also e.g., etc., i.e.

**etc.** Abbreviation for the Latin expression *et cetera,* which means "and other unspecified things." For clarity, use English words rather than Latin abbreviations *ad nauseam!* "And so forth" is a good synonym for etc. See also *ad nauseam,* e.g., et al., i.e.

**Ethnography** Research approach that involves observation and detailed description of events and social interactions that occur in a real-life setting as opposed to in an experimental context. See also participant observation

**Euphemism** A word or phrase used metaphorically to soften the impact of something that could be uncomfortable for a speaker or writer to communicate and/or for audience members to hear or read. Examples include: "adult entertainment" for pornography, *"au naturel"* for naked, "lady of the night" for prostitute, "negative patient care outcome" for the death of a patient, "pre-owned" for secondhand (as in a pre-owned car), "erectile dysfunction" for impotence, and "with

child" for pregnant. The opposite of a euphemism is a dysphemism, which is a word or phrase that is meant to be shocking, offensive, or funny. Examples include: "boneyard" for cemetery, "bitch" and "snake" for a person, and "idiot box" and "electronic babysitter" for television set. See also censorship, seven dirty words, wardrobe malfunction

**Evergreen** Television show that is aired as reruns in syndication for many years. Also, a newspaper or magazine feature article that would be interesting and appropriate to publish at any time. See also syndication

**Experimental Group** See control group, treatment group

**Experimenter Effect** Error in a research study caused by the researcher's behavior and/or characteristics. Experimenter expectancy is one type. This is when a researcher encourages a research participant's behavior or choices that support the hypothesis. See also hypothesis, observer effect, response bias

**Exploratory** In media research, inductive study designed to enhance understanding of a phenomenon rather than to test a hypothesis. See also pilot study

**Exposé** Work of investigative journalism presented in an article, book, or documentary that reveals scandalous information not widely known about an event, situation, or person. See also freedom of information, WikiLeaks

**Extemporaneous** In public speaking, a talk delivered on-the-fly, improvised without a prepared script.

**Extra** In the movie and television industries, an actor employed for a minor, non-speaking role. A bit player, in contrast, is an actor employed for a small role with some dialogue called a bit part. See also cameo

**Eye Candy** In computing and design, visual elements that are decorative, compelling, and fun to look at.

**Facebook** Extremely popular social networking website launched in 2004 by American Internet entrepreneur Mark Zuckerberg (1984–) when he was an undergraduate at Harvard University. Facebook is now available in over three dozen languages. As of 2011, more than 500 million people worldwide had become registered users, which means that approximately 1 out of every 14 people on Earth has a Facebook account. It is also one of the top websites in the world in terms of the number of visitors per month. See also Facebook stalker, social networking website

**Facebook Stalker** A person who tracks another's life via the targeted person's page on the Facebook social networking website. Many people reveal an astonishing amount of detailed, private information about their activities and whereabouts on Facebook as well as in other online contexts. Facebook self-disclosures are often accompanied by photographs uploaded to the website. College students sometimes unabashedly describe themselves as Facebook stalkers, acknowledging that this is a common practice among people in this age group. Facebook stalking is often motivated by benign curiosity about the life of someone who is a friend, family member, potential friend, or love interest. But the motivation and consequences of Facebook stalking can also be malevolent, and the behavior can become obsessive.

Facebook stalking motivated by anger at an ex-lover has led to violent encounters in real life. See also cybercrime, social networking website

**Face-To-Face** (F2F) In-person communication that is not facilitated by a technology such as a telephone or computer. See also computer-mediated communication, electronically mediated communication, nonverbal communication

**Fair Use Doctrine** Title 17, Section 107 of the U.S. Code, which stipulates the conditions and contexts in which using a copyrighted work or a portion of it falls under the guidelines for fair use, that is, when it is legally okay to use the work without the copyright holder's permission and that it would not be an infringement of the rights of the copyright holder. See also copyright

**False Claim** In advertising, an inaccurate statement about a product or service that is being pitched. Comparative advertising sometimes makes false claims about the competitive product to which another product is being compared.

**Fan** An enthusiastic follower and/or promoter of something, such as a movie, television show, or book; or of someone, such as a musician, writer, politician, or athlete; or of a hobby or pastime, such as photography, reading, or yoga. Fan is short for fanatic, which is sometimes used as a subtly pejorative term connoting (suggesting) an uncritical obsession with something. Fans of creative works of all sorts such as soap operas, romance novels, and movies sometimes create fan subcultures, including online communities where members discuss the works, share alternative readings (interpretations), and even remix, transform, or rewrite the storylines. Fans sometimes participate in festivals and conventions dedicated to the object of their fandom. For instance, in 2008, fans of the horror movie genre held a convention in the town where *Night of the Living Dead* (1968) was filmed to celebrate the 40th anniversary of this black and white horror classic. One fan traveled from France to the United States for the event. Several of the amateur actors who played the ghouls in this movie and were paid $25 for their on-screen appearances back in 1968 attended the 2008 convention (by then they were in their 70s and 80s) to sign autographs at $20 each for the fans. Remarkably, this cult thriller was produced for about $6,000 and has grossed tens of millions of dollars. Fans worldwide of the American television show *Star Trek*

participate in Trekkie (also called Trekker) fan club chapters, meeting in online forums as well as face-to-face (F2F) at regional and international conventions. The Trekkie fan phenomenon is so robust and noteworthy that it is the subject of a 1997 documentary that features interviews with *Star Trek* actors and producers as well as with fans such as a Florida dentist whose office is decorated in *Star Trek* style and who, along with his staff, wears a *Star Trek* uniform while treating patients. Fans of musicians and bands sometimes follow them on tour, travelling from city to city to attend concerts. The legendary American jam band *Grateful Dead,* which toured from 1965 to 1995, had intensely loyal fans called Deadheads who toured with the band, some of them for years at a time. See also taper

**FAQ** See frequently asked questions

**FCC** See Federal Communications Commission

**Feature Creep** The practice of adding more capabilities to a technological device that are unlikely to be used by most people. See also convergence, KISS

**Feature Film** A full-length movie, usually 60 minutes or longer, from any genre, intended for release to theaters. See also documentary, short

**Federal Communications Commission** (FCC) Agency created in the Communications Act of 1934 at the request of U.S. President Franklin Delano Roosevelt (1882–1945) to regulate the U.S. telegraph, broadcast, radio, and telephone industries and protect the public interest. The FCC now regulates the radio, television, wire, satellite, and cable industries. It has five commissioners appointed by the U.S. President and confirmed by the Senate who supervise the endeavors of the agency's staff. Commissioners serve for five-year terms. At the international level, the International Telecommunication Union (ITU), an agency of the United Nations (UN) that is headquartered in Geneva, Switzerland, oversees the telecommunications and broadcasting industries. In addition, in most countries there is a government agency that regulates telecommunications and broadcasting in that country.

**Feedback** Response to any type of message. In the case of a face-to-face (F2F) conversation, when one person says something, that is, sends a message, the other person receives and decodes it and then responds

with feedback that can be verbal (words), nonverbal (gestures, facial expressions), or a combination. Feedback can be positive or negative constructive criticism given to a message originator. It helps communicators to tweak—adjust and fine tune—their messages in order to optimize understanding and impact. In acoustics, feedback is a disturbing squealing noise from a microphone or speaker that is typically accidental but sometimes an intentional effect that musicians use for artistic impact. Known as the Larsen effect, acoustic feedback occurs when a sound loop exists between an audio input such as a microphone and an audio output such as a loudspeaker. The Larsen effect is an eponym. Danish scientist Søren Larsen (1871–1957) first discovered its principles.

**Fiction** A media product such as a movie or book that has an invented (i.e., not real) plot, as opposed to non-fiction, which tells a real story. Historical fiction is based on actual people or events but also has an invented plot and some invented characters. An example is American writer Edgar Lawrence (E.L.) Doctorow's (1931–) novel *Ragtime* (1975), which features characters from real life such as J.P. Morgan, Emma Goldman, Harry Houdini, and Henry Ford.

**Field Notes** In research of all types, the investigators' documentation of observations and data collection. See also participant observation

**Fifth Estate** Media watchdogs in the United States who critique the press, which is also known as the Fourth Estate, holding corporate media accountable for what they print and publish. The Fifth Estate includes private citizens as well as members of partisan groups. See also Fourth Estate

**Film** A synonym for movie that also refers to the flexible, transparent photographic material on which movies are recorded. Exposed (i.e., used) film stock is called footage. See also celluloid

**Filthy Words** See censorship, obscenity, seven dirty words

**Final Cut** Also called the fine cut, in filmmaking, the version of a movie released to the public. It might differ from the director's cut, also called the director's fine cut, which is a version that the director has final say on and which is sometimes released in a special collector's edition of the production or not released at all. In contrast, an early edited version of a movie is called a rough cut.

**Firewall** In computing, a security technology that can be hardware and/or software that prevents certain data from being transmitted from one computer network to another. The main purposes for using a firewall are to protect a network from intrusion and crackers, maintain the confidentiality and integrity of data, and authorize only authenticated users to access a system. Also, a firewall prevents computer users from pulling certain content from the Internet, such as violent or pornographic content. This can be enabled by network administrators through the use of filters. See also cracker, cybercrime

**First Amendment** Amendment 1 in the Bill of Rights of the U.S. Constitution. It is a 45-word passage that guarantees certain freedoms regarding religion, speech, press, assembly, and petition: "Congress shall make no law respecting an establishment of religion, or prohibiting the free exercise thereof; or abridging the freedom of speech, or of the press; or the right of the people peaceably to assemble, and to petition the government for a redress of grievances."

**Five W's and One H** The journalistic questions who, what, when, where, why, and how.

**Flack** A pejorative term for public relations (PR) professional. Also, a term for negative publicity.

**Flame** A mean-spirited and aggressive email message or posting to a blog or other online forum. People who flame are provocateurs.

**Flash Drive** Plug-and-play portable digital data storage device that uses flash memory and does not require any power to maintain the data on it. It is also called a universal serial bus (USB) drive; keychain drive, because it typically has a little ring on it for easy attachment to a keychain; and thumb drive, because it is usually the size and shape of a thumb. A flash drive can be used for quick and convenient computer file backups and to easily transfer files from one computer to another. See also archive

**Flashback** Stories in movies, books, and plays are not always told chronologically. A flashback is a plot technique that writers use to show the audience events that took place prior to the current time in the story and/or to present information or explain motivation. Flashbacks are often presented as characters' memories or dreams. A related term is a less common plot technique called flash-forward. In this case,

shots from future scenes in the story are shown, sometimes in a brief, ambiguous, or hazy way so that later in the plot when the significance of the flash-forward is revealed it is emotionally impactful to the audience.

**Flick** A synonym for movie that references the early motion picture era when filming and projection technologies often unintentionally yielded movie images that flickered on the screen. In that era, movies were sometimes called flickers.

**Focus Group** A group discussion organized and led by a facilitator that is documented and/or recorded for later analysis. The benefit of having a group discussion as compared to an individual interview is that the participants play off of one another's comments in a synergistic manner, thereby providing enriched responses to the facilitator's questions. Focus groups are often used in research studies to test a product, idea, or service.

**Font** In typography, the complete set of characters, including letters, numbers, and punctuation marks, of a particular style of type. Fonts are distinctive and recognizable. Some are ornate and others are simple. Graphic designers, typesetters, art directors, artists, and writers use particular fonts in deliberate ways to enhance the messages being communicated, whether the message is a slogan on a billboard or a chapter in a book. Examples of fonts include Times New Roman, which has decorative lines at the ends of the characters that are called serifs, and Arial, which is a sans serif font, meaning it does not have decorative lines at the ends of the characters. **Bolding** or *italicizing* fonts like this are two techniques used for emphasis in writing. See also typography

**Forced Choice Question** See closed ended question

**Four P's** In marketing, four key elements traditionally considered in the promotion of products and services: product, price, promotion, and place. In some businesses and trades, additional p's are also important. For instance, in retailing other factors include: people, position, presentation, and purchasing.

**Fourth Estate** A synonym for the press, whose role includes informing the public about issues and events of public interest, promoting and providing a forum for public debate, and critiquing and questioning

government policies and actions. The origin of the term can be traced back to the French Revolution when estates (*états* in French) referred to different categories of people. See also Fifth Estate

**Framing** In journalism, the practice of selecting which stories, especially news stories, are depicted in the media and how the depictions are organized and conveyed with language and visuals. The way that stories are framed by media gatekeepers influences how audience members experience and interpret the stories, and it shapes public opinion and attitudes. In filmmaking, framing refers to the composition of the images that are filmed. Under the direction of the cinematographer, also called the director of photography, a cameraperson literally looks through the camera's viewfinder to frame the shots, adjusting camera angles, filming distances, and so forth to help convey the story. See also agenda setting, polysemic

**Freedom of Information** The idea that convenient access to government information is a basic human right and a necessity for informed citizen engagement in a democracy. Although many countries have freedom of information laws, access to government information remains uneven worldwide. In the United States, the Freedom of Information Act (FOIA), U.S. Code § 552 (2006), amended by the Openness Promotes Effectiveness in our National (OPEN) Government Act of 2007, Pub. L. No. 110-175, 121 Stat. 2524, applies only to federal agencies; each state has its own public access laws. See also censorship, First Amendment, gatekeeping, WikiLeaks

**Freedom of Speech** See book challenge, censorship, First Amendment, gag order

**Freelancer** Self-employed person such as a journalist, photographer, writer, musician, artist, actor, or graphic designer. Freelancers sometimes use agents or belong to organizations that promote them or contract with them for projects. See also crowdsourcing, paparazzi

**Freeware** Computer software that is available without cost to users for an unlimited amount of time that does not provide any financial benefits to the creator. Sometimes freeware has a restricted use license, such as for personal, non-commercial uses only. Sometimes this is called shareware, but these terms are not interchangeable. Shareware is copyright-protected proprietary software available for trial use without

a charge for a limited time, typically ten days to two months. Not all of the features are included in the trial version. Mechanisms in shareware make it inoperable after a certain time period. If users like the software and want to keep using it, they have to buy the software license. See also open source software, software license

**Frequency** Measurement of sound in hertz (Hz). People can typically hear sounds that are in the frequencies ranging from 30 to 20,000 Hz. The upper range that an individual can hear generally decreases with age. Many animals, including dogs, can hear sound frequencies that humans cannot. See also noise, pitch

**Frequently Asked Questions** (FAQ)  A list of typical questions on a particular subject with the answers. Directing users of software, technology, or websites of all sorts to an FAQ often enables them to solve their own problems or answer common questions without the assistance of technical support staff.

**F2F**  See face-to-face

**Gag Order** A restriction on access to or the communication of information on a certain topic. Gag orders are issued for different purposes and can be made by courts, governments, employers, or organizations. In the United States, a gag order is a court order issued typically in high-notoriety cases that restricts what trial participants can communicate about a case to the press during the trial. Gag orders are issued to reduce the chance that publicity about a case could prejudice members of the jury, thereby denying an accused person the right to a speedy and fair trial by an impartial jury. See also censorship, First Amendment, journalist shield laws

**Galley Proof** Also called a galley, in printing, a test copy of the set type that is proofread and corrected by publishing professionals and the author. Proofreaders correct typographical errors (typos) such as spelling mistakes and grammatical errors. An author's significant changes to a galley that are not typographical error corrections are called author's alterations (AA). Publishers sometimes charge authors for each alteration.

**Game Show** Also called quiz show, a television program genre typically featuring celebrity hosts in which contestants compete for prizes.

**Gamer** Video game devotee or fan.

**Gatekeeping** The process of determining what matters, who has access to it, and in what form. According to German-born American psychologist Kurt Lewin's (1890–1947) conceptualization of how information flows, there are gates, metaphorically speaking, through which information must pass, and one or more gatekeepers select the information that will pass through the gates. There are many authority figures in media industries that influence which information and media products such as news stories, songs, or movies are made available to the public as well as how products are conveyed and packaged. While members of the public can choose which media products they consume, the choices are limited by what has been pre-selected by the gatekeepers. In the print and broadcast news media, editors and producers determine what is newsworthy, that is, relevant to or of interest to their audience. In addition, these gatekeepers are responsible for ensuring that the information is fact checked, so that what is published or broadcast adheres to their organization's news values and criteria. It is interesting to see the differences in how the same story is covered, hardly covered, or not covered at all by news media operating in different parts of the world. See also checker, polysemic

**Gaze** See male gaze

**Genericized Trademark** Also called generic trademark, a trademark that has been used generically or colloquially to refer to a process or category of products. A valid trademark that is protected by law can become generic and not subject to legal protection if people use it so much that it becomes associated as the mainstream, generic name for the product. "Heroin," "yo-yo," "escalator," "laundromat," and "cellophane" are all trademarks that became the common term for a type of product. These trademarks experienced what is called genericide. Trademark protection is territorial in nature. A trademark can become genericized in one country while still being a valid trademark in other countries. According to the U.S. Code, Title 15, Chapter 22, Subchapter III, § 1127, a trademark "includes any word, name, symbol, or device, or any combination thereof—(1) used by a person, or (2) which a person has a bona fide intention to use in commerce and applies to register on the principal register established by this chapter, to identify and distinguish his or her goods, including

a unique product, from those manufactured or sold by others and to indicate the source of the goods, even if that source is unknown."

**Genre** Category of a communication medium in which the members of the category have certain defining and recognizable characteristics in common. Examples of film genres are horror movies, westerns, and romantic comedies. Examples of musical genres are jazz and country. Examples of literary genres are fiction and poetry, and examples of television genres are reality television, game shows, crime shows, and soap operas.

**Geotag** Geographic coordinates (longitude and latitude) embedded in the metadata of a digital photo or other digital media, similarly to the archival information that is automatically embedded in a digital photo detailing the date and time the photo was taken and the photographic settings used. Geotagged digital media can be sorted and searched by location. Maps and travelogues can be created using geotagged digital photos. Software and hardware are available for geotagging in real time as the photo is being taken or after the fact. Some digital cameras and smartphones can be configured to automatically geotag photos using software applications that interface with Internet services such as Google Earth to embed location information in the metadata of digital photos. There are also hardware devices for automating the geotagging process. Locative computing technologies that can track where people are anytime, anyplace are being leveraged in innovative ways by amateur and professional photographers to geotag photos that are uploaded to photo sharing websites like Flickr. Geotagging is also used in augmented reality (AR) technology, which enables people to access collectively contributed (crowdsourced) online information about specific geographic locations. For instance, users of GPS-enabled smartphones can access restaurant reviews from the user review website Yelp and other online sources such as the microblog Twitter and social networking website Facebook while standing at the front door of a restaurant they are considering patronizing for a meal. The increasingly pervasive practice of geotagging has led to creative marketing strategies in which location specific advertising is sent to people's mobile devices. See also location-based applications

**Ghost** Also called ghostwriter, a professional who creates something for a client or who creates most of the work, such as a memoir, novel, scientific paper, painting, musical composition, speech, or even college entrance essay, using the other person's style, voice, and perspective in the work. In order to ensure a certain quality of writing and to meet publication deadlines, entertainment celebrities, politicians, musicians, and business professionals often collaborate with ghostwriters in the creative process or outsource all of a project to a ghost. Celebrities are often paid large advances for their memoirs by publishers who anticipate that the books will be hits. Similarly, successful musicians are often paid large advances for their albums by record companies. Ghostwriters typically have to sign confidentiality agreements certifying that they will not reveal information about works they are paid to produce, especially information about their participation in the creation of the works. The client typically takes credit as the sole creator. In the case of a musical composition, the ghost might be acknowledged cryptically in the liner notes, also called sleeve notes or album notes, which are part of the packaging of albums and compact discs (CD). In the case of a celebrity memoir, the client might acknowledge the ghost's assistance on the acknowledgment page of the book in somewhat vague terms.

**Gigabyte** (GB)  A measure of data storage capacity for computer hard drives and other digital storage technologies. For instance, a DVD-R can hold 4.7 GB and a dual-layered Blu-ray disc can hold 50 GB.

**Global Positioning System** (GPS)  Also known as locative computing, technology that pinpoints the place of things in terms of latitude and longitude using data from satellites orbiting the Earth. There are GPS systems in many automobiles, mobile phones, and stand-alone, portable GPS devices. Location-based services are becoming increasingly popular; more and more people rely on their mobile phones to direct them to the nearest gas station and automatic teller machine (ATM). A dynamic positioning system (DPS) is a related technology. It is a computer-operated system used in unanchored and unmoored vessels in water that integrates data from many types of sensors to control the vessel's propellers and thrusters in order to maintain a certain fixed geographic position or a position relative

to another object in the water that might be moving. See also augmented reality technology

**Global Village** Concept suggesting that communication technology shrinks the world into a village, metaphorically speaking, because electronic communication enables people to instantaneously transcend spatial constraints and also fosters interdependence. The term was coined by Canadian literary and media scholar Marshall McLuhan (1911–1980). His thinking about the macro level effects of different types of communication technologies on civilizations throughout history was influenced by his political economist colleague at University of Toronto, Canadian Harold Adams Innis (1894–1952). McLuhan's other well-known saying is, the medium is the message. The telegraph, developed in the 19th century, was the first communication technology that enabled information to be communicated quickly across great distances. With the diffusion of the telegraph, news became decontextualized for the first time because telegraph messages were relatively brief, communicating basic information without providing background information and context. For the first time people could know what was going on far away from them, but what they were able to know about the goings-on elsewhere was superficial. The telegraph facilitated business transactions of all sorts faster than ever before too. About a century later, the Internet turbocharged the speed at which business could be conducted in the late 20th and early 21st centuries. In the digital era, our global village is a global marketplace of information, news, ideas, media, entertainment, and business. The Internet allows people to experience in a mediated way what others are experiencing worldwide, including immense and serious events, such as natural disasters and wars, in video, audio, photographs, and first-person accounts. The Internet also allows people to enjoy light-hearted amusements, such as personal video blogs made for fun and uploaded to websites like YouTube, and conversations with geographically dispersed loved ones held using voice over Internet protocol (VoIP) services such as Skype. With Web 2.0, people are not only consuming content online, they are producing it, individually and collaboratively, and sharing it globally. Widespread prosumption (a blend of "production" and "consumption") on the Web in the form of video blogs, wikis, video and photography file sharing, social networking websites, and so forth, is altering the social order

in developed countries in ways that continue to unfold. As of 2011, more than 500 million people worldwide had registered themselves on the social networking website Facebook. On YouTube, the world's largest video file sharing website, people watch more than 2 billion videos a day and upload hundreds of thousands of videos to the site daily. It is important to note that people in some countries are unable to be part of the global village for political and cultural reasons. See also cultural imperialism, digital divide, e-commerce, globalization, medium is the message, piracy, prosumer

**Globalization** The process of extending and integrating something to a worldwide level. International exchanges of knowledge, ideas, creative productions, goods, and services are not new occurrences confined to the information age. However, in the 20th and 21st centuries, domestic and international economic policies coupled with technological advancements, particularly in transportation and communication, made the process of scaling something up to a worldwide level more efficient, practical, and advantageous in many sectors. In his pivotal book *The Rise of the Network Society* (1996), Spanish-born American communication scholar and sociologist Manuel Castells (1942–) explains how the progression and diffusion of information and communication technologies (ICT) since the 1970s have been central to the process of globalization and the development of a globally interdependent economy that functions in real time. See also concentration of media ownership, cultural imperialism, global village, political economy studies, syndication

**Gmail** Google's free application for email available to individuals and businesses. Among Gmail's attributes are aggressive spam filters and a large storage capacity. Gmail is accessible via mobile devices as well as computers. See also Google

**Gold Record** See Recording Industry Association of America

**Google** A global information technology company headquartered in Mountain View, California, which was co-founded in Menlo Park, California, in 1998 by American computer scientist and Internet entrepreneur Lawrence Page (1973–) and Russian-born American computer scientist and Internet entrepreneur Sergey Mikhailovich Brin (1973–). Google released a powerful search engine in 1998 that continually searches and indexes the contents of the Web, using a

sophisticated information-retrieval algorithm (mathematical procedure) to categorize and rank websites based on keywords and hyperlinks to and from the sites. More than three-quarters of the Web searches conducted in the United States in 2009 used Google, while competitor Yahoo!, which was founded a few years earlier in 1994, was used for about 11% of the searches. Google has become such a popular search engine on the Web that the term "to Google" something or someone has become associated with the activity of keyword searching for information about something or someone online, even when not using the Google search engine. This is reminiscent of the way that "to Xerox" something is commonly used to refer to the process of making a photocopy, even when a machine manufactured by a company other than Xerox is used! To quash this usage of the Xerox brand name and protect their trademark, Xerox Corporation spent a lot of time and money on advertising campaigns and outreach initiatives to educate people about trademarks so that theirs would not become genericized, that is, used so often in a generic or colloquial manner that it no longer would have legal protections against infringement. Interestingly, some dictionaries suggest writing google with a lowercase "g" when referring to the process of searching the Web and writing it with an uppercase "G" when referring to the company's proprietary search engine. It is possible that Google could become a genericized trademark as the public continues to use this immensely popular word in creative ways without acknowledging that Google is the registered trademark of a company. Google offers other free services in addition to keyword searches in order to encourage people to use its website, including email accounts with large storage capacities for individuals and businesses, which they call Gmail, as well as other Web-based applications, such as calendars, blogs, and Google Docs, which is word processing software that facilitates collaborative authoring and sharing of documents. Like other media companies, Google earns revenue by selling advertisements. It uses an innovative business model to sell ads. Interested parties bid in an open and competitive auction to have their advertisements appear next to the search results for specific keywords. Ads do not appear within search results but instead they appear next to them, identified either as "sponsored links" or "Ads by Google." Google's applications, services, and subsidiaries, including the tremendously popular video

hosting website YouTube that Google bought in 2006 for $1.65 billion, are all accessible on mobile platforms, such as smartphones. Google's 2009 revenue was $8.3 billion dollars, with net income of $6.5 billion. It employs approximately 23,300 people worldwide. See also genericized trademark, network neutrality, search engine, Yahoo!

**Graphic Novel** A book that conveys a fiction or non-fiction story primarily through drawings. Comic books, a related medium, also tell stories mostly through drawings, but they are published in magazine format.

**Graphical User Interface** (GUI)  See user interface

**Gutenberg Bible** The first substantial book printed on a printing press with movable type in the Western world. It was printed by German inventor Johann Gutenberg (c. 1400–1468) in Mainz, Germany, around 1455. It is 1,286 pages long and bound into two volumes. It includes ornate initial letters and decoration that were added by hand after the book was printed. Of the approximately 200 copies printed, only 22 complete copies are known to exist today. Only five complete copies exist in the United States. See also book, printing press

**Gutter** In book, magazine, and document printing, the margin of blank space on the bound side of a page, also called the inside margin.

**Hacker** Expert computer programmer or engineer who passionately believes that free access to information is a basic human right. The early hackers in the United States in the 1970s were primarily young adults with counter-culture ideologies who enjoyed tinkering with computer technology. Hackers are sometimes called white hats, drawing on the symbolism of the American western movie genre in which the quintessential good guy wears a white hat and the bad guy wears a black one. Hackers are sometimes employed by government agencies and corporations to break into their systems in order to point out security flaws. This practice is called ethical hacking, penetration testing, intrusion testing, and red teaming. Swedish author and journalist Stieg Larsson's (1954–2004) best-selling mystery thriller Millennium-series trilogy of novels, *The Girl With The Dragon Tattoo* (2005), *The Girl Who Played With Fire* (2006), and *The Girl Who Kicked the Hornet's Nest* (2007), which were published posthumously and later adapted for film, feature a hacker protagonist, Lisbeth Salander. A term related to hacker is cracker, someone who breaks into or tries to break into secure computer systems without authorization for malicious purposes or for financial gains. See also hacktivist, jailbreak

**Hacktivist** A blend of "hacker" and "activist." An expert computer user who develops creative ways to leverage the power of computers and the Internet to advance social causes. Hacktivists have designed software that maps crises by integrating information from many sources. This software has been used to aid humanitarian rescue missions during natural disasters and to expose acts of voter intimidation and election tampering. They have also designed programs that enable political dissidents in totalitarian regimes to anonymously share news and information with the rest of the world that would otherwise be suppressed by government authorities. See also cracker, exposé

**Handheld** Pocket size, portable device such as a smartphone or global positioning system (GPS) that handily fits in a person's hand.

**Haptics** Computer applications and user interfaces for electronic devices that employ natural feeling and intuitive tactile (touch) sensations as user feedback. Also called full-force feedback, rumble feedback, tactile feedback, touch-enabled, vibration, and vibrotactile, haptics technology is used on touchscreens for computers and electronic devices, in video games, and in surgical training simulators. Components of haptics technology include: sensors, motor control circuitry, actuators that vibrate or exert force that the user can feel, and software that controls the effects in a library of haptics effects. See also proxemics, user interface, virtual reality

**Hard Copy** Also called a printout, a printed copy of a digital document.

**Hard Drive** Digital storage technology that allows a user to save, store, and delete data files on hard disks. A hard drive can be built into a computer, known as an internal hard drive, or it can be a separate device typically used for file back-ups (archives) called an external hard drive.

**Hard News** See news

**Hardware** Computer components, machinery, and peripherals, as contrasted with software, which are programs that control how computers operate.

**Hays Code** Production guidelines that were voluntarily followed by the U.S. movie industry from 1934–1968. The code was abandoned when the Motion Picture Association of America (MPAA), composed of

representatives from the world's largest media corporations such as Sony and Disney, developed a new rating system. American lawyer William H. Hays (1879–1954) developed the code to obviate the need for government censorship of the movies. See also censorship, rating system

**Hertz** (Hz)  Measurement system for sound frequencies. The word is an eponym. German physicist Heinrich Rudolph Hertz (1857–1894) was the first to demonstrate that radio waves could be varied and projected. People can typically hear sounds that are in the frequencies ranging from 30 to 20,000 Hz. The upper range that an individual can hear generally decreases as the person grows older. Many animals, including dogs, can hear sound frequencies that humans cannot. See also broadcasting, noise, radio

**Hidden Agenda**  A synonym for the ulterior motive for doing something. See also optics, propaganda, spin

**High-Definition Television** (HDTV)  Television with better resolution and a different aspect ratio (16x9, also known as 1.78:1 and wide screen) than the standard definition that preceded it (4x3, also known as 1.33:1 and standard). HDTV provides clearer and more vibrant images than standard definition. It is digital and has become the new worldwide standard for broadcasting. HD cameras are required for HD broadcasts. See also television

**Hit**  In computing, requesting any file on a website. Website traffic can be tracked in terms of number of hits. In the entertainment industries, a media product such as a song, record, movie, play, video game, or television show that is a commercial success, also called a smash or smash hit.

**Hoax**  Internet pranks include duckrolling and rickrolling. Duckrolling is when an Internet user types in a keyword or clicks a link, expecting to be taken to a certain image or discussion thread and instead gets redirected to an image of a duck on wheels with the word "duckroll" written on it. This spurred some people who had been duckrolled to duckroll others. The duckrolling practical joke morphed into rickrolling, which became a viral Internet meme. Rickrolling is when a user searches for something else and is mischievously redirected to a video clip on YouTube or another website that shows, in one version of the prank, an image of British rocker Richard Paul "Rick" Astley's

(1966–) head photoshopped onto a duck while playing Astley's 1987 hit song, *Never Gonna Give You Up*. Other rickrolls link to videos of people lip syncing to *Never Gonna Give You Up,* or link to Astley's actual music video of that song or another song. See also lip sync, pseudo-event, spoof website

**Hollywood** Slang for the U.S. movie industry. Hollywood, California, became the hub of the American movie industry in the early 20th century. Hollywood's Golden Age began around 1915. Its studio system, narrative style, and star-studded casts dominated the movie industry from the 1930s to 1950s. Then audiences in the United States turned their attention to the newer medium of television. Hollywood continually evolved, however, creating movies with more and more astounding special effects, such as 3-D (three-dimensional), for instance, beginning in the 1950s, to woo and wow audiences. Hollywood studios also diversified their ventures. They became key players in television show production. They also leveraged new sales and delivery methods for their movies: the videocassette in the late 1970s, followed by the DVD in the 1990s, and digital distribution in the 2000s. In addition, movie studios increasingly capitalized on innovative sources of revenue, such as product placement and merchandise tie-ins, a trend that continues today. See also Bollywood, Disney, movie, product placement, tinseltown

**Home Page** Page of a website that is a visitor's typical landing spot or first page reached when typing the uniform resource locator (URL) in the Web browser address bar. Home pages welcome users and direct them to other pages of the website through hyperlinks.

**Hook** In music, a catchy and memorable melody or refrain that often stays in a listener's mind. In writing of all types, including journalism and fiction, an opening that grabs readers' attention and makes them want to read more. British writer Charles Dickens's (1812–1870) novel *A Tale of Two Cities* (1859) hooks readers with the first line, which is 60 words long!

> It was the best of times, it was the worst of times, it was the age of wisdom, it was the age of foolishness, it was the epoch of belief, it was the epoch of incredulity, it was the season of Light, it was the season of Darkness, it was the spring of hope, it was the winter of despair.

American writer Herman Melville (1819–1891) hooks readers of his novel *Moby-Dick* (1851) with a first line that has just three words: "Call me Ishmael." American writer Allen Ginsberg (1926–1997) begins "Howl" (1956), his sexually explicit social commentary tour-de-force lengthy and long-lined iconic poem of the 20th-century Beat Generation of artists and writers: "I saw the best minds of my generation destroyed by madness, starving, hysterical naked..."

**Horizontal Integration** When a company expands its market by buying other companies in the same field in order to benefit from the efficiencies and cost benefits of economies of scale. For instance, a newspaper company that owns many newspapers can share resources and eliminate positions in order to streamline operations and reduce costs. A larger market presence comes with concentration of ownership. See also concentration of media ownership, economy of scale, vertical integration

**HTML** See Hypertext Markup Language

**Human Interest Story** See news

**Hyperlink** Also called an embedded link or, in the case of a word or group of words, embedded text, a hyperlink is an image, word, or group of words in a Web document that connects the user to another place in the document or to another Web page. Embedded text hyperlinks typically stand out with a blue font and underlining.

**Hyperlocal** News coverage that focuses on a small, targeted geographic area.

**Hypertext Document** A document with embedded links called hyperlinks on images and/or highlighted words or phrases that when clicked on take the reader to other parts of the document. Hypertext allows information to be retrieved in a flexible, non-linear way.

**Hypertext Markup Language** (HTML) Computer language developed in 1990 by British engineer and computer scientist Sir Timothy John Berners-Lee (1955–) and his colleagues at CERN (*Organisation Européenne pour la Recherche Nucléaire,* which is French for European Organization for Nuclear Research) in Geneva, Switzerland, to link hypertext documents on the Internet. HTML defines the layout of individual Web pages and the functions embedded within them. It made the World Wide Web (WWW) possible and remains the basic

language of the Web, though many websites today use several other languages as well, such as CSS, JavaScript, and Flash. Berners-Lee built the first website at CERN. It was put online in August 1991. As founder of the World Wide Web, Berners-Lee is an influential proponent of network neutrality and open and free online access to as much information as possible. See also Web 1.0, Web 2.0, World Wide Web

**Hypothesis** An educated guess that tentatively explains something that is assumed to be true for the purpose of discussion or research. In the scientific method, a hypothesis is formed logically or deduced from a theory and then tested in an empirical way. See also theory

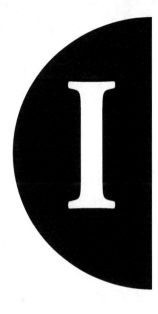

**i.e.** Abbreviation for the Latin expression *id est,* which means "that is." For clarity, use English words rather than Latin abbreviations *ad nauseam!* See also *ad nauseam,* e.g., et al., etc.

**ICA** See International Communication Association

**Icon** A person whose extraordinary accomplishments elevate her or him into a symbol of excellence in a field. Examples include Michael Jackson (1958–2009) in the music industry, Mohammed Ali (1942–) in boxing, and Mother Theresa (1910–1997) in religious charity work. Icon also refers to a graphic symbol used in computer software, such as the trashcan used to identify a virtual recycle bin where computer files can be moved and then discarded when the can is emptied, and the shopping cart on websites that sell goods and services. Clicking on the shopping cart takes the user to the list of items selected from the online catalog in order to place and confirm the order. Icons are used in signage of all sorts. Man and woman signs label men's and women's public restroom doors. Suitcase signs direct people to baggage claim areas in airports. Religious icons are painted or carved art objects representing religious figures. See also cultural symbol, symbol

**Ideographic Language** In ideographic languages, such as those of some Native American tribes, Mandarin Chinese, and Japanese, written

symbols represent words or ideas, not just single sounds as they do in phonetic languages, like English and French. The written marks in ideographic languages are called ideographs, logographs, or ideograms. See also symbol

**Idiom**  Also called an idiomatic expression, a phrase in one language that does not make sense when it is translated literally into another language. For instance, the expression "It's Grand Central Station here," meaning there are lots of people in this bustling place, would not convey the same meaning if it were translated word-for-word from English into another language. See also acronym, jargon, vernacular

**Idiot Box**  A dysphemism (the opposite of euphemism, a word or phrase meant to be shocking, offensive, or funny) for television set. Electronic babysitter is another dysphemism for television. See also euphemism

**IMAX**  A blend of "image" and "maximum," a movie format developed in Toronto, Canada, in the 1970s that enables very wide-screen projection of movies in IMAX theaters where, in some cases, panoramic screens literally wrap 360 degrees around the audience. Coupled with 360-degree surround sound technology, IMAX movies can be highly visceral, immersive experiences. See also surround sound

**Impression**  Also known as an ad view or view, in Web advertising each time the image of an ad is requested from a Web page is counted as one impression. See also hit, website traffic

**Independent Media**  Also known as indie or alternative media, those that are not sponsored or supported by major media organizations. An independent film is produced autonomously from a major Hollywood movie studio. An independent record label is not associated with a major record label. In contrast to mainstream media (MSM), indie media products are sometimes produced with less focus on or concern about maximizing public appeal and achieving mainstream commercial and financial success. They are often produced and distributed with fewer resources than mainstream media products. American director Daniel Myrick (1962–) and Cuban-born American director Eduardo Miguel Sánchez-Quiros's (1968–) low-budget and highly popular horror mockumentary (pseudo documentary) film, *Blair Witch Project* (1999), is an example. It was reportedly shot for approximately $25,000. A new sound mix and reshoots

for various scenes cost an additional half a million dollars. Artisan Entertainment bought the film for $1.1 million and spent about $25 million to market it. With this film, they were among the first to leverage Internet marketing. *Blair Witch Project* grossed over $248 million worldwide, making it one of the most lucrative independent films ever produced. Working outside of established media outlets gives the producers of independent media increased latitude to create cutting-edge, experimental, or controversial works. Consider, for example, independent documentaries such as American writer Eric Schlosser (1959–) and American director, producer, and writer Robert Kenner's (1952–) *Food, Inc.* (2009), American filmmaker, author, and political activist Michael Moore's (1954–) *Sicko* (2007) and *Roger and Me* (1989), and American filmmaker Morgan Spurlock's (1970–) *Supersize Me* (2004). Achieving fame, notoriety, accolades, and/or financial success via an indie media production can be a critical step toward commercial success in the mainstream market. There is a synergistic relationship between mainstream and indie media. For example, indie record labels are sometimes bought by major record labels, while indie films are sometimes distributed by major movie companies. See also mainstream media

**Indie** See independent media

**Inferential Statistics** Statistical techniques that researchers use to test a hypothesis or draw conclusions based on computations made on data collected from a sample of a population. See also data, descriptive statistics, hypothesis, margin of error, population, sample

**Infomercials** A blend of "information" and "commercial," infomercials on television are extended commercials, usually about 30 minutes long, that raise awareness about and sell particular products, such as exercise equipment or cooking gadgets. They are often presented in a talk show format with exuberant celebrity hosts demonstrating the features of the products. In print media, infomercials are multiple-page-long special advertising supplements that contain informative content about specific products and services. These supplements are intentionally formatted with the look and feel of the regular news sections of the publication, and it can be hard to distinguish them from the non-advertising content. Interactive banner advertisements

on websites that sometimes include Flash animations are another form of infomercial.

**Informant** In journalism, communication, and social science research, the person who provides information and insider explanations to an interviewer. In journalism, this person is also known as a source. See also respondent

**Information Age** Today's era characterized by the ubiquitous, routine, and intensive usage of and dependence on computer and telecommunications technologies for practically all aspects of life. Prior to the information age, societies were predominantly industrial (relating to manufacturing, especially in urban areas) or agrarian (relating to rural land ownership and farming). See also digital divide, Net generation

**Information and Communication Technology** (ICT) A broad category of equipment ranging from computers to global positioning systems (GPS) to smartphones that enables people to accomplish a wide range of functions, including communication, information seeking and sharing, and entertainment. See also computer, personal computer

**Information Overload** Excessive accumulated data that is beyond the amount that a person can absorb, comprehend, and productively use. Information overload is not a new phenomenon. Concerns about it were voiced in the 15th century as the printing press with movable type diffused throughout Europe and mass-produced books, pamphlets, and other documents proliferated. See also media multitasking, noise

**Informed Consent** The practice of giving a prospective research participant enough information about a study, including information about its purpose, duration, procedures, and risks as well as contact information for key researchers, so that he or she can make an educated decision about whether to participate. Participants in social scientific experiments as well as other types of research are typically asked to sign an informed consent form on which they agree to participate and acknowledge that they understand any risks involved and that they can withdraw from the study at any time. See also debriefing

**Infotainment** A blend of "information" and "entertainment." Shows on television or in other media that present information and/or news stories in an amusing format.

**Instant Messaging** (IM) Engaging in a rapid tête-à-tête online. People IM via smartphones and computers to efficiently connect synchronously (in real time) with their friends and acquaintances. IM is used to build, strengthen, and sustain relationships with others who might be known from face-to-face (F2F) contexts. A recent trend is for businesses to integrate IM features into their corporate websites in order to provide real-time one-on-one customer service and technical support. In addition to text-based exchanges, some IM systems allow for file sharing and the saving of IM exchanges in files. See also electronically mediated communication, real time

**Instrument** In research, a synonym for measure. In music, an object that makes sounds. See also survey research

**Intellectual Property** Original creative work or information that has commercial value. Based on laws and international treaties, intellectual property (IP) can be protected from infringement by trademarks, patents, and copyright. However, in the 21st century, with the widespread usage of Web 2.0 and social media it is easy to access, remix, and/or mashup digital content. In this environment, enforcement of intellectual property rights is challenging. In an alternative to copyright, some people are voluntarily making their creative works or information available legally for free for accessing, sharing, remixing, and reusing for noncommercial as well as commercial purposes via Creative Commons licenses. See also copyright, Creative Commons, globalization, mashup, trademark

**Interactive** A synonym for two-way communication that is also used to describe a system that allows receivers to provide feedback to message senders or sources.

**Intercoder Reliability** In media research, when two or more researchers independently classify (code) data from a study such as a content analysis, focus group, or interview and then examine where their classifications are identical and where they differ. Intercoder reliability is the measure of the extent to which multiple coders agree on the classifications, so the higher the intercoder reliability, the more confidence someone reading the findings should have in the study. See also content analysis, focus group, interview

**Interface** See user interface

**Interlibrary Loan** (ILL)  When a library lends a book or other material to another library that does not have the item in its collection for the use of one of its patrons. There is typically no charge to the patron for making use of interlibrary loan services. A librarian locates the requested material through online searches of the aggregated holdings of numerous libraries that share information about their collections.

**International Communication Association** (ICA)  Founded in 1950, this academic organization for people who study, teach, or work in the communication field has more than 4,200 members in 80 countries. ICA hosts conferences where scholars, educators, and practitioners meet to discuss research in their fields, and it sponsors academic journals where scholarship is published. See also Association for Education in Journalism and Mass Communication, National Communication Association

**Internet**  Global system of networked (linked) computers designed in the 1970s that is not owned by anyone. As the Internet has grown, it has shrunk the world into a global village, metaphorically speaking, because users are able to freely communicate with people, access information, and conduct business virtually anytime and anywhere, even on-the-go, using wireless mobile communication devices. Theoretically, all of the resources on the Internet are available equally to the billions of people worldwide who have Internet access, but in practice this is not the case for a variety of political, economic, and technological reasons. See also censorship, digital divide, global village, Internet service provider, network neutrality

**Internet Addiction Disorder** (IAD)  Also called pathological computer use, problem Internet use, pathological Internet use, and heavy Internet use, this disorder is characterized by excessive, non-essential Internet usage that leads to negative repercussions in domains such as an individual's job, health, and relationships. IAD is proposed for inclusion in the 2013 edition of the *American Psychiatric Association's Diagnostic and Statistical Manual of Mental Disorders* (DSM-V). According to research conducted at the Stanford University School of Medicine in 2006, one in eight people in the United States is addicted to the Internet. See also crackberry, screensucking

**Internet Dropouts** People who adopted Internet technology, invested time to learn to use it, and then decided to discontinue using it for reasons that can be financial, technological, or social.

**Internet Hoax** See hoax, spoof website

**Internet Service Provider** (ISP) National or local cable, telephone, or satellite companies that provide connections to the Internet to customers that pay a monthly subscription fee.

**Internet Traffic** Data transmitted over the Internet in the form of words, graphics, audio, or video. It is measured in megabytes (MB), each of which is equal to one million bytes of data. Since the Internet's inception in the 1970s, the amount of traffic on it has increased because people have devised more and more uses for it beyond just exchanging a few lines of text via email, like pioneering American computer engineer Ray Tomlinson (1941–) did in the late 1960s when he first invented the protocol for email for the Advanced Research Projects Agency Network (ARPANET). Internet innovations have included: sharing information in newsgroups, building communities on listservs, communicating with customers and stakeholders via corporate websites, sharing music via peer-to-peer applications, sharing photographs and videos on websites, Web data mining for marketing research, advertising, e-commerce, and teaching and learning in online education environments. Many of the newer applications use rich media, including music and video, and they require wider bandwidth than text-only email messages. Video data especially uses a lot of bandwidth as compared with text-only data. See also Advanced Research Projects Agency Network, bandwidth, Internet, website traffic

**Interview** An interactive data collection method used by journalists and social researchers to obtain personal accounts, perceptions, information, and perspectives. Interviews can be structured, semi-structured, or unstructured. Notes are taken and/or recordings are made and sometimes transcribed for later analysis. The person who conducts an interview is the interviewer. The person interviewed is the interviewee. Interviews may be conducted by telephone or in person. A benefit of face-to-face (F2F) interviewing is that the interviewer can attend to the interviewee's nonverbal communication in addition to what is said. See also interview schedule

**Interview Schedule** Also called an interview guide, the list of questions that an interviewer intends to ask an interviewee. Unlike in survey research, the questions in an interview can be asked in any order and are usually open ended questions. See also survey research

**Intexticated** See short message service

**iPad** Apple tablet computer released in April 2010. More than four million iPads were sold within the first six months. Its intuitive user interface is a finger-sensitive touchscreen similar to that of the iPhone and iPod Touch. The iPad is smaller than a notebook computer but larger than the iPhone smartphone, weighing about 1½ pounds. It is battery powered and has wireless fidelity (Wi-Fi) capabilities, and, on some models, 3G cellular network capabilities for use with almost any GSM carrier, making the sleek device handy for users who frequently work, learn, communicate, read, and/or play multimedia on-the-go. The iPad is configured to run applications available from iTunes only, which have been vetted by Apple, but some owners jailbreak their iPads in order to run non-Apple approved applications. See also Apple, application, book, e-book, iTunes, jailbreak, touchscreen

**iPhone** Apple smartphone released in June 2007 (see Figure 3 on page 103). By 2010, over 73 million iPhones had been sold. The device's intuitive user interface is a touchscreen with a virtual keyboard. It weighs approximately 4.8 ounces. Like the iPad and iPod Touch, the iPhone is configured to run applications available from iTunes only, which have been vetted by Apple, but some owners jailbreak their iPhones in order to run non-Apple approved applications. See also Apple, application, iTunes, jailbreak, mobile phone, telephone, touchscreen

**iPod** Apple portable digital media player and hard drive released in 2001 that interfaces with Apple's iTunes software for digital content downloading. As of January 2010, over 240 million iPods of several generations and models with varying features and storage capacities had been sold worldwide, including the nano, shuffle, classic, and touch. An iPod can be synchronized with a computer via a universal serial bus (USB) connection. It can store many gigabytes of digital content, including thousands of tracks of music. See also Apple, application, iTunes, jailbreak, MP3, touchscreen

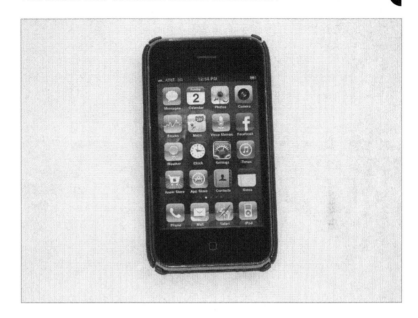

FIGURE 3. An Apple iPhone.

**iTunes** Apple's highly successful online store, founded in 2003, where consumers can browse, listen to, rent, or purchase a wide range of media, including movies, music, television shows, video games, video and audio podcasts, college lectures, and applications. iTunes has been the world's largest music retailer since 2008. Digital files can be downloaded quickly and easily from the iTunes store to computers or other digital devices. The iTunes player is a computer program that organizes and stores digital media files on a computer or another device. Downloading music from websites like iTunes is a growing trend, and retail purchases of compact discs (CD) are declining. Other major online media sellers include amazon.com and barnesandnoble.com. See also Apple, application, bootleg, iPod, jailbreak, MP3, piracy, podcast, there's an app for that

**Jailbreak** The practice of bypassing or removing manufacturer-installed technical limitations on a mobile device that are meant to prevent the modification of the device and the usage of applications other than those that have been vetted and authorized by the manufacturer. Jailbreaking a mobile device such as an iPhone gives users more consumer choices but at some expense. It breaches the software license agreement but, significantly, it no longer violates the Digital Millennium Copyright Act (DMCA). Jailbreaking increases the risk of damaging the device through the use of jailbreaking software and non-manufacturer approved applications, which could lead to a bricked device, that is, one that has become as useless as a brick, albeit an expensive one that contains electronic waste (e-waste) components. Jailbreaking can also void the product warranty. A practice related to jailbreaking is unlocking a mobile device. Some mobile phones are technologically married to a specific network service provider. A user might choose to unlock a mobile phone when the provider contract expires in order to use the phone with a different provider rather than buying a new phone. Unlocking a phone also allows the user to move the subscriber identity module (SIM) card that stores the user's phone data, including phone number, preferences, contacts, text messages, and so forth, to another phone, especially for use during international travel. In some cases, a SIM card can be swapped

between mobile devices without unlocking the devices. In reaction to the U.S. Copyright Office's decision to legalize mobile phone unlocking (technically, it is an exemption to the pertinent copyright law), some manufacturers are making it extremely difficult to unlock their products. As a result, businesses that offer unlocking services have sprouted up. See also application, cracker, hacker, phreak

**Jamming** Interfering intentionally with a signal such as a radio or television transmission or morphing a message to achieve a different goal than the original sender intended. Jamming is also a synonym for improvising, especially in a creative endeavor like music. Some genres of music are particularly improvisational, such as blues and jazz. See also culture jamming

**Jargon** Specialized words, phrases, abbreviations, and acronyms used in a field or occupation that are not necessarily familiar to others outside of the field. Examples are killer app (application), ICT (information and communication technology), VNR (video news release), and PSA (public service announcement). Demystifying jargon is a goal of this dictionary! See also acronym, idiom, vernacular

**Journalism** Spread of news, information, and interpretations of these things to the public through media such as newspapers, magazines, radio, and the Internet. Sometimes called a "watchdog of democracy," journalism also entails analysis and critique of power structures within societies. See also broadcasting, citizen journalism, gatekeeping, independent media, mainstream media, mass media, news

**Journalist Shield Laws** In the United States, statutes in most states (36 states plus the District of Columbia) that ensure that journalists do not have to reveal their sources of information gathered in the course of carrying out their professional duties. These laws are intended to protect the confidentiality of informants and the First Amendment rights of journalists. Because there are no federal shield laws in the United States, journalists can be subpoenaed by prosecutors for federal cases. See also First Amendment, gag order, informant, source

**Jukebox** Machines invented in the late 1800s that play music from records stored within the device. They are typically located in public places like bars and restaurants. The earliest versions were called automatic coin-operated phonographs, automatic phonographs, or

coin-operated phonographs, and they played a song for five cents. See also phonograph

**Jump the Shark** An idiom used in the American television and movie industries and by media enthusiasts to refer retrospectively to the point in which the quality of a television or movie series changed for the worse, and it began to become almost a parody of itself, and/or its popularity began to decline. The term refers to a 1977 episode of the American sitcom *Happy Days,* which ran from 1974 to 1984, in which Arthur Fonzerelli, a.k.a. The Fonz, played by American actor Henry Winkler (1945–), literally jumps a shark on water skis in a daredevil stunt. A similar term is "nuking the fridge," which refers to a scene in *Indiana Jones and the Kingdom of the Crystal Skull* (2008), the fourth movie in the Indiana Jones series by American screenwriter and producer George Lucas (1944–) and American screenwriter, director, and producer Steven Spielberg (1946–), in which the main character, Indiana Jones, played by American actor Harrison Ford (1942–), goes into a refrigerator for protection and survives a blast from a nuclear weapon as the kitchen appliance is hurled through the air. See also idiom, vernacular

**Junk Mail Folder** An email folder that stores email messages received from users on the blacklist and emails that have spam characteristics. These characteristics are set with filters to capture mass sale emails, sexually explicit emails, and solicitations. See also blacklist, spam, whitelist

**Justification** See alignment

**Karaoke** A blend of the Japanese words *kara,* which means "empty" and *oke,* an abbreviation of *ōkesutora* that means "orchestra." A form of musical entertainment that originated in Japan in the late 1970s in which a person sings into a microphone along with an instrumental recording of a well-known song. Karaoke nights are popular at bars and restaurants where people under the influence of alcohol are sometimes uninhibited on stage even if they are musically challenged. The lyrics to the song are typically projected onto a screen so that the singer and audience can follow along. Karaoke applications are available for downloading to computers and mobile devices. Some video on-demand (VOD) television services offer karaoke. There are karaoke online communities where people upload, share, and comment on karaoke performances. Paradoxically, sometimes the worse the Karaoke singer is, the more the audience enjoys the performance.

**Keyword** A word related to a particular topic that can be used as a search term in a dictionary, encyclopedia, library database, or search engine to locate more information about the topic. See also Google, search engine, Yahoo!

**Kill Fee** Amount paid to a freelance writer or other artist according to a contractual agreement with a publisher or other entity when commissioned work ends up not being published or used. See also advance, freelancer

**Killer App** See application

**Kindle** Amazon.com's handheld e-reader device that allows for two-way electronic communication between the Kindle user and the online bookseller via mobile phone technology. See also amazon.com, book, e-book, e-reader

**Kinesics** The study of nonverbal communication also known as body language, which includes unconscious and conscious facial expressions, eye movements, gestures, body stance, and proxemics, which refers to how personal space is occupied, shared, or invaded during interactions. See also chronemics, haptics, nonverbal communication, vocalics

**KISS** Acronym for "keep it simple, stupid" and "keep it short and simple," extolling the benefits of not complicating a technology or anything else for that matter by piling on more capabilities, a phenomenon known in technical circles as feature creep. See also convergence

**Laggard** In the diffusion of innovations theory, a person who is a late adopter of a technology. See also diffusion of innovations

**Landline** Telephone connected via a wire to a telephone company that provides service, in contrast to a mobile phone. A cordless phone has a base unit that is connected to the telephone wires in a building, but the handset does not have a cord connecting it to the base unit. Users are able to roam within a certain radius of the base unit while making or receiving calls. See also mobile phone, telephone

**Language** System of verbal, written, or visual signs for communication. In computing, a set of instructions and parameters that form a computer programming language. See also American Sign Language, Braille, code, communication, ideographic language

**Larsen Effect** See feedback

**Latent Meaning** Subtextual meaning (underlying message) of a text or something in a text as opposed to the face value or manifest meaning.

**Leading Question** An interview or survey question that is phrased in a manner that elicits a certain answer from the respondent that might not be the person's most honest response.

**Leaflet** See pamphlet

**Leap-Frog Strategy** Adopting a newer version of a technology and in doing so skipping one step in the development of that technology. For instance, people in developing countries who do not have land-line telephones because their neighborhoods do not have the infrastructure to support landlines may adopt mobile phones. See also diffusion of innovations

**Legacy Media** Pre-Internet media such as newspapers, television, movies, and radio. See also new media

**Libel** Writing or pictures, but not spoken words or gestures, that defame or maliciously harm someone's reputation. When journalists knowingly print or broadcast false statements it is called actual malice. It is slander when the defaming words are spoken rather than written. See also defamation

**Likert Scale** A multiple point scale for answering questions on a survey. There are usually an uneven number of possible answers to a question that uses a Likert scale for possible answers so that a neutral, mid-point answer is an option for the respondent. The answers to Likert scale questions are typically on a continuum of intensity ranging from *strongly agree* to *strongly disagree.* The name of this technique for measuring attitudes is an eponym. The Likert scale was developed by American social scientist and management consultant Rensis Likert (1903–1981) as part of his doctoral dissertation work in psychology at Columbia University in the early 1930s.

**LinkedIn** See social networking website

**Lip Sync** Also spelled lip synch, short for lip synchronization. The matching of mouth movements to a prerecorded speech or musical track as part of a performance. In live concerts, some singers resort to lip syncing so that they are able to perform strenuous dance routines that would compromise the quality of their singing. In some high pressure situations, a singer's vocals are prerecorded for later playback while the singer lip syncs so that she or he does not flub (mess up) the words to songs such as *The Star Spangled Banner* at major sports events like the Super Bowl football game. One of the most infamous cases of lip syncing involved German pop/dance music group Milli Vanilli (1988–1998), fronted by French Fabrice Morvan (1966–) and German-American Robert Pilatus (1965–1998). Their meteoric career

ascent into international superstardom began to down spiral in 1989 when they lip synced at a live performance for U.S. cable television network MTV and the record skipped, repeating a line over and over again. The singers ran off the stage, mortified, but the concert went on. Morvan and Pilatus were awarded a Grammy as Best New Artists in 1990 that was later revoked when it was revealed that the vocals on their hit albums were not their own. In movie production, sound-film editors are responsible for ensuring that actors' lip movements on the screen appropriately match dialogue on the soundtrack. It is an awkward experience to watch a movie in which these elements are out of sync! A related term is dubbing, which refers to the post-production synchronization of a movie or television soundtrack of sounds of all types, including matching dialogue to the speakers' lip movements. Sometimes the soundtrack that is synchronized to the footage includes dialogue or singing performed by different people than those who appear on-screen. Sometimes the soundtrack is in a different language than that spoken by the on-screen people in order to cater to a different audience. See also caption, dubbing, soundtrack

**Literature Review**  In scholarly research, the process of identifying and examining previous published scholarship on the topic of interest. In academic papers, the literature review section typically follows the introduction or is incorporated as part of the introduction. A literature review provides readers with a condensed summary and interpretation of prior work on the topic.

**Location-Based Applications**  Also called location-based services, location-aware mobile technologies, and locative computing technologies, these applications track where users of global positioning system (GPS)-enabled devices are and allow them to connect to information about their physical surroundings as well as to connect with nearby people. These technologies are being leveraged innovatively for information seeking, rendezvousing with friends and acquaintances, dating, entertainment, marketing, and, by some parents, for keeping track of their kids' whereabouts. Some location-based applications deliver to users' mobile devices advertising content that is relevant to their physical location. A related term is geotagging, the process of annotating geographic location data (longitude and latitude) into the metadata of digital photographs and other digital

media. Social media such as the microblogging service Twitter and social networking website Facebook have features that enable users to geotag their updates. Geotagging is used in augmented reality (AR) technology that enables people to access crowdsourced (collectively contributed) information online about specific geographic locations. For instance, users of GPS-enabled smartphones can access restaurant reviews from the user review website Yelp as well as from other online sources while standing at the front door of a restaurant they are considering patronizing for a meal. Amateur and professional photographers geotag the digital photos that they upload to photo sharing sites like Flickr so that others can access the photos by searching by location. See also application, augmented reality technology, geotag, global positioning system

**Logo** Short for logotype, a memorable and distinctly recognizable picture or design that represents a brand, such as Nike's "swish" and McDonald's golden arches. The area around a printed logo where no other graphic or words can appear, according to the brand guidelines, is called the exclusion zone. See also brand, genericized trademark, trademark

**Logon** In computing, the protocol that must be followed to gain access to a system or application as an authorized user. To log on to a system, a user typically needs to use a registered user identification (ID) and password. Computer security experts recommend the use of strong passwords. These are passwords that a computer or human cannot easily guess or decipher. They typically include a combination of uppercase and lowercase letters, numbers, and symbols and are changed periodically for enhanced security. Weak passwords lack these characteristics and can be deciphered quickly with a password cracker program. Enforcing the use of strong passwords is a form of password hardening. Other strategies for password hardening include using biopasswords and biometric verification. See also biometric verification

**Luddite** See neo-luddite

**Lumen** Unit of measurement of the intensity of light. A lux (lx) is equal to one lumen per square meter. See also projector

**Lurker** Someone who posts no public messages to an online forum such as a chat room or discussion board, as contrasted with an occasional contributor who sometimes posts messages, and a frequent contributor who posts often. Intriguingly, people can be lurkers and still feel intensely connected to an online group. Someone who reads a blog but does not contribute to it is called a blurker, a blend of "blog" and "lurker." See also blog, chat room, discussion board

**Lyrics** The words to a song.

**Magazine** A publication produced on a periodic basis, such as weekly, monthly, or quarterly, that may include articles, graphics, and photographs. It may be aimed at a general, mainstream audience or a special interest group. Magazines earn revenue through the sale of individual issues from a newsstand or bookstore, subscriptions to individuals, libraries, and businesses, and through the sale of advertisements. Depending on the size and type of the magazine, the staff might be comprised of people serving in some or all of the following positions: editor, writer, fact checker, publisher, contributor, copy editor, advertising director, circulation director, and marketing director. See also pamphlet, peer reviewed journal, subscription, trade publication

**Mainstream Media** (MSM) Conventional and dominant mass media typically supported by large corporate entities. Mainstream media are readily available for public consumption and have wide intended audiences and commercial viability, as opposed to being unproven and/or experimental like alternative or independent media often are. There is a synergistic relationship between mainstream and independent media. For example, independent record labels are sometimes acquired by major record labels, while independent movies are sometimes distributed by major movie companies. What is considered in the mainstream and conventional and what is considered unconventional

and out of the mainstream are shifting categories, reflecting the fact that cultural values, customs, and social attitudes evolve and change over time. See also independent media, mass media, popular culture

**Malapropism** A misused word that is typically an unintentional slip but sometimes the result of the speaker or writer not knowing the appropriate word for a context. For example, using the word antidote, which is a poison remedy, rather than anecdote, which is a story. See also blooper, outtake, political tracker

**Male Gaze** The concept in feminist theory that many media products are constructed from the perspective of men. According to this concept, women are too often portrayed as objects that are meant to be looked at as opposed to being portrayed realistically as active participants in life. See also perspective

**Malware** Malicious and potentially damaging computer software. See also adware, cybercrime, scareware, spyware

**Manifest Meaning** In any text, the meaning at face value as opposed to the subtext (underlying message) or latent meaning.

**Manuscript** A hand-copied text, as compared to a book, which is printed with a printing press. Also, a manuscript is the unpublished and sometimes rough version of a publication such as an article or book. See also book, printing press

**Margin of Error** Statistical technique that indicates the level of accuracy of a research finding. A margin of error is expressed as plus or minus a percent, for example, +/- 3%. See also inferential statistics, sample

**Marginalia** Reader's notes written in the margins of a book, magazine article, or other type of text that typically comment on the content of the page on which they are written. Marginalia can provide insight into a reader's interpretation of the text. Also, in situations in which paper is scarce or unavailable, writers have drafted letters and essays in the margins of books.

**Mashup** A website, Web application, song, or television show segment that aggregates, blends, and presents content from other sources. In the computing field, the term describes the combination of routines and scripts from two or more sources into a new program. Mashup contests sponsored by computer industry companies have been held

to encourage people to create innovative applications by combining and leveraging extant (existing) applications in new ways. In the American television show *Glee*, mashup is used to describe the new musical composition created when two songs are blended and performed seamlessly together. *Glee* mashup renditions are even available for purchase on iTunes. With 21st-century media technologies, much of the bricolage of life is mashable, except perhaps raw produce, as American communication scholar Brenda Berkelaar has smartly noted. See also prosumer, remix, Web 2.0

**Mass Media** Media that aims its messages at large, mainstream audiences, the masses. Popular mass media of the 21st century include magazines, books, newspapers, radio, television, the Internet, and even smartphones, such as the iPhone and BlackBerry, which can be used as one-to-many (mass) communication devices. The once apparent and mostly rigid boundaries between media content creators and media audiences, and between interpersonal communication and mass media, have blurred tremendously in the last few decades such that the term mass media has lost its precision in the digital age. Media is a more appropriate term now, because it is comprehensive and therefore better reflects the reality of today's highly technologically convergent communication landscape. See also convergence, legacy media, new media

**Massively Multiplayer Online** (MMO) **Game** Video games such as *Quake* and *World of Warcraft* (WOW) that are played collaboratively in real time through a network or over the Internet. See also video game

**Masthead** In magazines and newspapers, the printed list of owners, publishers, editors, designers, contributors, and business and production staff. On the Web, the top of a Web page with the identifying title and sometimes also an image or images and website navigation hyperlinks.

**Mean World Syndrome** Theory that people who watch a lot of television spuriously (incorrectly) believe that the world is more dangerous than it is in reality because what they see depicted in television shows and reported on the news disproportionately focuses on negative events. See also theory

**Mechanical Royalties** Also called mechanicals, the fee paid by a record company to the publisher or writer of a song for the right to record the song. The name refers to the fact that because copyright law mandates the payment of these fees, they are paid automatically, in other words, mechanically. See also American Society of Composers, Authors and Publishers; Broadcast Music, Incorporated; copyright; piracy; royalties; SESAC; taper

**Media** Media, not mediums, is the plural of medium. This broad term encompasses the myriad technologies and means for communicating with, informing, and entertaining individuals and the masses. Examples include: print and digital versions of texts such as books, magazines, and newspapers; radio; television; the Internet; video games; and relatively new innovations and applications that leverage and converge the features, capabilities, and capacities of information and communication technologies (ICT), such as blogs, the micro-blogging service Twitter, portable digital media players like the iconic iPod, e-reading devices like the amazon.com Kindle, the Apple iPad tablet computer, and social networking technologies and tools. In the 24/7/365 digital age, media are virtually everywhere, and practically everything is mediated—conversations, dating, commerce, political campaigns, music, sex, news, art, and even people. In this environment, developing media literacy is crucial. See also audience, avatar, convergence, media literacy, mediatization, new media, video games

**Media Convergence** See convergence

**Media Ecology** An interdisciplinary approach to the study of media and communication environments. Media ecologists examine how people create and modify media and communication technologies, which then, in turn, influence and transform the social and symbolic environment and people's experiences, behaviors, and interpretations of it. Canadian literature professor and media scholar Marshall McLuhan (1911–1980) and American media theorist and cultural critic Neil Postman (1931–2003) were two seminal writers in this area.

**Media Literacy** A significant level of understanding that can be developed through education that enables people to distinguish credible sources from those that are less reliable, to critically think about and judge the value and veracity of information transmitted in the wide spectrum of media available in the 21st century, and to competently use

different media and communication technologies. We live in a media saturated world in which all media products and productions—video games, talk radio shows, comic books, reality television shows, soap operas, billboards, blogs, and newspapers—implicitly convey values and perspectives about the world through their form and content. The media tell stories about all aspects of life that typically reinforce the status quo, but sometimes question it. Being media literate means having the capability to step back enough from the mediated world in which we are constantly engaged in order to recognize and analyze the powerful and wide-ranging psychological, social, economic, and political effects that the broad array of media have. See also perspective, source

**Media Multitasking** Using two or more media at the same time. Multitasking with media and in digital environments has become routine for many people today, especially using computers and mobile devices. Work on a spreadsheet one minute, attach it to an email message and "mail" it across the world at the click of a button the next minute, while listening to a radio show in real time or a podcast of a previously broadcast radio show. Of course, people multitasked before the digital age; over the centuries, mothers comforted and cared for their children while cooking, cleaning, sewing, farming, or doing other work in the household or on the homestead. They multitasked among cognitive, physical, and emotional activities. Parents today routinely comfort their children over mobile phones while the parents are flying in airplanes, driving cars, and working on computers. People adapt to situations and adopt technologies to help them get things done. Media multitasking highlights that people are creative and technologies are adaptable. Mobile phones, like their predecessors, landline telephones, were developed for business uses, not social uses. People modified the phone's intended applications, using it for social and psychological reasons. Today, people are developing and adopting social applications for media and communication technologies at a breakneck pace. Consider all of the social networking applications available for mobile devices such as the iPhone and BlackBerry. See also augmented reality technology, information overload

**Media Studies** The academic field that focuses on the content, effects, and history of various media. It draws on the techniques and theories

of a wide variety of other academic fields. Media studies researchers analyze the different facets of media effects and influence on individuals and audiences. Areas of interest within the media studies field include: psychological and sociological effects of media and communication technologies, propaganda, public opinion, media economics, concentration of media ownership, political communication, latent and manifest meanings of media messages, media audiences and fandom, media content production, consumer culture, and youth culture. See also audience, media

**Mediatization** The concept that in modern life media are pervasive and have become essential to the functioning of social institutions such as work, family, religion, politics, and education while, at the same time, media institutions wield tremendous power extrinsically, influencing individuals and social institutions from the outside. One conspicuous outcome of the process of mediatization is that politicians now strategically frame and adjust their rhetoric to ensure media coverage. As Swedish media researcher Kent Asp noted in his scholarship in the late 1980s, individuals and institutions adapt to the logic of the media out of necessity. See also media

**Medium** See media

**Medium is the Message** Saying coined by Canadian literature professor and media scholar Marshall McLuhan (1911–1980), whose thinking about the effects of different types of communication technologies on cultures was influenced by his political economist colleague at University of Toronto, Canadian Harold Innis (1894–1952). This phrase emphasizes that the channel used to transmit a message is extremely important. The medium affects how the receiver will interpret and understand the message. Global village is another well-known phrase from McLuhan. See also communication, global village

**Megapixel** In digital photography, one million pixels. A pixel is the smallest color unit that an image can be divided into. Pixel is a blend of the words "picture" and "element." See also pixel, resolution

**Melodrama** A story characterized by hyperbolic emotions and thrilling action that typically resolves with a happy ending. Television crime shows are one example of this genre.

**Memoir** An autobiographical story written about an aspect of a person's life with the intention of getting it published, unlike a diary, which is not written with the intention of publication. Examples include U.S. veteran broadcaster Barbara Walters's (1929–) *Audition: A Memoir* (2008), in which she discusses her 50+ year career in the television news industry, and U.S. President Barack Obama's (1961–) *The Audacity of Hope: Thoughts on Reclaiming the American Dream* (2006), published while he was serving in the U.S. Senate. See also autobiography, biography, biopic

**Meta-Analysis** A systematic interpretation of a collection of research findings on a topic. A meta-analysis is done to uncover if apparently systematic variations are more than just chance events. Because a meta-analysis is an analysis of the findings of multiple previous analyses, it draws on a larger pool of data than the data used in these individual previous studies, and so the meta-analysis results may be statistically significant even if the results of the original studies were not. See also inferential statistics

**Metaphor** An expression that implies a comparison in a figurative or symbolic rather than literal way. For example, "standing on the shoulders of giants" is a vivid, and indeed old, metaphor that illustrates how knowledge grows when one person builds on the previous work of others. Sir Isaac Newton (1642–1727), a British philosopher, theologian, mathematician, and scientist, used this metaphor, but variations of it were used by others centuries before Newton was born. A mixed metaphor, also known by the blend word mixaphor, combines two metaphors that clash awkwardly because they do not work logically together.

**Method** Also called methodology, an approach to collecting and analyzing empirical data used in research. See also data, empirical, hypothesis, theory

**Microblog** See Twitter

**Microcoordination** The process of organizing meetings, events, and other types of social interactions, like locating friends in a large concert venue, on-the-fly, using mobile communication technologies such as smartphones. See also mobile communication

**Microsoft** American computing technology company headquartered in Redmond, Washington, which was founded in 1975 by American entrepreneur, software designer, and philanthropist Bill Gates (1955–) and American entrepreneur, software designer, and philanthropist Paul Gardner Allen (1953–). Microsoft was incorporated in 1981 and had its initial public offering (IPO) in 1986. The company develops, sells, and licenses software as well as hardware and related services. Its early software helped launch the personal computing revolution in the 1980s. In 2010, Microsoft's revenue was $62.5 billion, with net income of $18.8 billion. Microsoft has offices in over 100 countries. It employs 89,000 people, 54,000 in the United States and 35,000 in other countries. See also computer, hardware, personal computer, software

**Mix** In media productions of all types, to blend audio and video elements to produce a master. In music recording, to blend separate tracks into a single track. The resulting track is called a mix or mixdown. In typography, the use of two or more typefaces or point sizes within a word or line, typically for emphasis or special effect. See also font, mashup, remix, typography

**MLA Style** See Modern Language Association

**Mnemonic** A system of cues used to aid in the memorization of something complicated. For instance, biology students sometimes memorize a sentence like this one, or a sexier version, in which the first letter of each word helps them to recall the name of each of the twelve cranial nerves in the human body: "On old Olympus' towering top a Finn and German viewed some hops." The cranial nerves in order are: olfactory, optic, oculomotor, trochlear, trigeminal, abducens, facial, acoustic/vestibulocochlear, glossopharyngeal, vagus, spinal accessory, and hypoglossal.

**Mobile Application** See application

**Mobile Browser** A Web browser designed for mobile devices such as smartphones that typically have small viewing screens and limited memory. Some mobile browsers can display regular HTML websites while others only work with websites developed specifically for viewing on mobile devices. The latter are predominantly text-based and/or low graphic websites. See also Web browser

**Mobile Communication** The process of sending and receiving messages from any place using portable devices with wireless capabilities. With mobile communication, the "here" and the "there" can be virtually anywhere and, moreover, both can be moving.

**Mobile Learning** See online education

**Mobile Phone** Throughout most of the world, this term is used for portable handheld wireless telephones. However, in the United States, they are typically called cellular phones or cell phones. The cell in the name refers to the fact that the phone communicates via a nearby cell transmitter (cell tower). As the phone and its user travel, the signal is picked up by another cell transmitter in a process called a handoff. The geographic area of coverage for each transmitter is called a cell. In 1983, the Federal Communications Commission (FCC) approved the world's first portable mobile phone for commercial use in the United States. It was called the Motorola DynaTAC 8000X. DynaTAC is an acronym for "dynamic adaptive total area coverage." The phone weighed two pounds, needed to be recharged after about 30 minutes of usage, and sold for $3,995. Motorola invested $100 million to develop the phone, and it took their engineers and designers more than ten years. They built a working prototype in 1973. Nokia released the first mobile phone with Internet access in 1996. Since then, developers have added more features to these devices called smartphones. A cordless telephone has an extremely short wireless connection to a base unit that is plugged into a hardwired phone outlet; it is not the same thing as a mobile phone. It is usually used only within a house because the signal is relatively short range. See also mobile communication, smartphone, telephone

**Modder** Slang for modifier, a person who inventively modifies a technological device, piece of software, video game, or anything else to suit her or his own needs and desires, often in ways that the original developer could never have anticipated. See also hacker, jailbreak, phreak

**Modem** Device that connects a computer to another computer or server and can provide an Internet connection using the wired telephone network. An air card performs the same function through the wireless phone network.

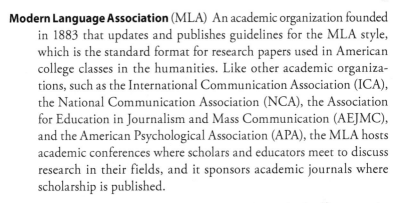

**Modern Language Association** (MLA) An academic organization founded in 1883 that updates and publishes guidelines for the MLA style, which is the standard format for research papers used in American college classes in the humanities. Like other academic organizations, such as the International Communication Association (ICA), the National Communication Association (NCA), the Association for Education in Journalism and Mass Communication (AEJMC), and the American Psychological Association (APA), the MLA hosts academic conferences where scholars and educators meet to discuss research in their fields, and it sponsors academic journals where scholarship is published.

**Mogul** Extremely powerful and influential industry leader, for example, Ted Turner (1938–), who founded Cable News Network (CNN).

**Monopoly** In business, when one company dominates an industry locally, nationally, or internationally. Also, the name of the world's most popular board game, which was developed in the early 20th century. See also oligopoly

**Montage** In filmmaking, the essential practice of editing a series of shots and scenes together to tell a story. Various montage techniques are used for different purposes in movies. For instance, sometimes images are edited together in a way that they represent a long time period using a brief amount of time. This is called accelerated montage. In creative productions of all types, art, photography, newspaper clippings, and/or everyday objects are imaginatively mixed and mashed to convey emotions and ideas. See also bricolage, culture jamming, mashup, remix

**Moral Panic** When many people in a population become concerned, upset, or outraged with a behavior or cultural phenomenon that they have been led to believe is detrimental, dangerous, or a threat to prevailing cultural values based on the amount and nature of media exposure given to the topic. Moral entrepreneurs are opinion leaders who attempt to focus the public's attention on a controversial topic or group of people. They often use the media to stir up an irrationally disproportionate frenzy and false sense of urgency about something that may not be as much of a treat as the coverage of it suggests. An example of something that could be amplified into a moral panic is

the idea that video games incite violence in users. See also emotional contagion, opinion leader

**Morse Code**  A system of communication developed in the mid-19th century by American artist and inventor Samuel Morse (1791–1872) that uses a series of short and long signals to represent the letters of the English alphabet. The code was modified and expanded by people in various countries and became integral to nautical, aviation, military, and commercial communication by the early 20th century. The U.S. military as well as amateur radio operators still use it at times. Until 2007, the U.S. Federal Communications Commission (FCC) required proficiency in Morse code to obtain an amateur radio license. Morse code can be used in situations where there is no visual or auditory contact. A famous acronym from Morse code is the international emergency distress call SOS, which is signaled ". . . ––– . . ." The letters SOS were chosen because of the ease of transmission, not because they stand for a particular phrase, but they are often translated as "save our ship" or "save our souls." See also telegraph, wireless communication

**Motion Picture**  See movie

**Motion Picture Association of America** (MPAA)  Movie industry trade and lobbying organization founded in 1922 that created the rating system for movies used in the United States. See also censorship, rating system

**Mouseover**  Also called a rollover, when a computer user rolls the cursor over a particular area of a screen and a pop-up window opens.

**Movie**  At the end of the 19th century and turn of the 20th century, a movie, also called a motion picture or film, was an astonishing novelty and technological achievement. A series of images projected sequentially gives the illusion of movement. The earliest movies were 30- to 90-second recordings of events called actualities. They depicted things like people dancing and horses galloping. French brothers Auguste (1862–1954) and Louis Lumière's (1864–1948) film, *Train Arriving at a Station* (1895), led audiences worldwide to scream and in some cases to run fearfully away, believing that a real train was actually headed toward them. Amusingly, *lumière* means "light" in French. American inventor Thomas Edison (1847–1931)

was one of the first to direct and produce dramatic films that told a story. His 30-second long film, *The Execution of Mary, Queen of Scots* (1895), shows Mary being led to the block, pushed down on it, and having her head chopped off. In *The Kiss* (1896), Canadian-born American actor May Irwin (1862–1938) and American actor John C. Rice (1858–1915) kiss in the movie, reenacting their kiss from *The Widow Jones,* a Broadway play in which they were then appearing. Print press coverage of the content of this hit film, including still photographs of the kiss, led to the first calls for the censorship of movies with content that some considered to be immoral. By 1900, actualities and other brief clips were replaced by longer narrative films that told more fleshed out stories. By 1905, movies were being shown from early in the morning to late at night in store-front venues that were called nickelodeons because it cost a nickel per person for admission and odeon is the ancient Greek word for small theater. During this era, motion picture producers often exhibited their own movies. By the 1920s, grandly ornate movie palaces attracted moviegoers from all social classes and audience sizes expanded. In the 1930s and 1940s, the Hollywood studio system, headed by powerful movie moguls and based in Hollywood, California, dominated the industry through a business practice called vertical integration, which in this case refers to the control of the production, distribution, and exhibition of commercial movies. By the 1950s, the commercial and creative dominance of the major Hollywood studios declined. Movies had to compete for audiences with television, a new medium that was another astounding technological achievement. In the 21st century, the movie industry has continued to find ways to attract and wow audiences in order to earn revenue. Enhanced special effects, such as those used in 3-D (three-dimensional) movies like *Avatar* (2009), continue to thrill moviegoers. Merchandise licensing agreements for toys and clothing related to the movies, product placement/integration in movies, DVD sales, digital downloads, video on-demand (VOD), and musical theater adaptations are additional ways that movies generate revenue for their producers. For instance, Disney's animated movies *The Lion King* (1994) and *Beauty and the Beast* (1991) were remade as theatrical productions. They became blockbusters on stage just as they were in the cinema. As of the beginning of 2010, more than 50

million people worldwide had seen *The Lion King* stage show. See also Hollywood, multiplex, nickelodeon, projector, silent film, talkie

**Movie Score** Background music composed or arranged for a movie. In contrast, a soundtrack is the totality of the dialogue, sounds, songs, and background music in a movie or other type of media production.

**MP3** Digital music file format that supports fast downloading from the Internet for later listening or real-time listening via streaming audio from the Internet. The acronym stands for the "Motion Picture Experts Group Audio Layer 3" compression algorithm used to compress sound into a small digital audio file that preserves the original sound quality. An MP3 can be played on a computer or a digital media player such as an iPod or Zune. MP3 files have names ending with the extension "mp3" and can be downloaded from a number of websites, most famously Apple's iTunes. See also iTunes, streaming media

**MPAA** See Motion Picture Association of America

**Multiplex** Large movie theater complex with many screening rooms.

**Music** A played composition of sounds created by voice, instruments, or a combination of both in order to create a certain effect. Musical tastes are subjective and idiosyncratic. What is music to one person's ears is noise to another's. In the United States, revenue from music sales and licensing was $6.3 billion dollars in 2009, less than half of what it was a decade earlier. Several factors have contributed to this decline: the ease and spread of unauthorized digital downloading of music; the enormous music repertoire available through peer-to-peer networks; the worldwide recession, which shrunk consumers' discretionary spending; and the fact that it took the music industry years to adapt its business practices to suit emerging technologies, particularly mobile technologies. See also acoustics, airplay, album, ambiance, genre, hit, hook, independent media, karaoke, lip sync, lyrics, mashup, mix, movie score, MP3, phonograph, piracy, popular music, record, recording

**Narrator** The voice that speaks directly to the audience to tell the story in a movie, book, or play. The narrator may appear as a character in the story. For example, in American director and actor Clint Eastwood's (1930–) movie *Million Dollar Baby* (2004), the character Eddie "Scrap-Iron" Dupris, played by American actor Morgan Freeman (1937–), narrates the story, offering verbal commentary on the events that unfold and psychological insights about the characters. Depending on the creator's intention for how to tell the story, the narrator can be omniscient (all knowing), partially knowing, or even unreliable. The narration in a documentary movie is typically done as a voiceover, and the narrator does not appear on screen. Morgan Freeman did the voiceover for the English version of the French documentary *March of the Penguins* (2005).

**National Communication Association** (NCA) A nonprofit academic and professional organization founded in 1914. NCA, with over 8,000 members, has grown into the largest U.S. organization promoting communication scholarship and education. It hosts conferences where scholars and educators meet to discuss research in their fields, and it sponsors academic journals where scholarship is published. See also Association for Education in Journalism and Mass Communication, International Communication Association

**National Public Radio** (NPR) Listener-supported, noncommercial public radio network formed in the United States in 1967. In 2010, NPR received approximately two percent of its operating budget from the U.S. Federal Government. See also network

**Native Language** The first language that a person learned to speak.

**NCA** See National Communication Association

**Neologism** A new term or phrase or a new meaning for an existing term. Languages are dynamic, and people devise neologisms all the time. In the domains of media and communication, coining new words and wordplay can be particularly fun. Twenty-first century neologisms range from tweaching, instructing using Twitter, to sexting, a blend of "sex" and "texting" that refers to the now commonplace practice of sending flirty or lewd messages and/or nude or partially nude photographs via communication devices such as mobile phones. A neologist is someone who invents new words. See also acronym, blend word, euphemism, idiom, jargon, retronym, synonym, vernacular

**Neo-Luddite** A person who opposes technical innovations and change. The term refers to the Luddites, a British protest movement of artisan textile workers who, in the early 1800s, were concerned about the implications of industrialization. They rioted and destroyed the then-new machinery that threatened their jobs. A related term is technophobe, someone who fears or dislikes technology. Neo-luddites who hang onto their older media and communication technologies rather than upgrading to the new next big thing are sometimes wryly labeled analog retentive.

**Net** Slang term for the Internet.

**Net Generation** Also called the millennial generation, the millennials, and generation Y, this generation is the last one of the 20th century, those who were born between 1980 and 2000. Many in this generation grew up using computers, mobile phones, and the Internet, are accustomed to electronically mediated communication, and take the anyplace, anytime connectivity that mobile technologies support as a given. Many are adept at media multitasking. They are said to be digital natives, born into digital culture, rather than digital immigrants, which refers to those in the generations preceding theirs. See also demographics, digital divide

**Netbook** Ultra-portable, lightweight, battery or AC-powered, small and slim type of laptop or notebook computer that typically has less processing power and fewer features than a regular size laptop but also typically costs less. Netbooks are especially convenient for commuters and travelers who want to use something larger than a smartphone for their computing and Internet connectivity needs. See also computer, iPad, personal computer

**Netiquette** A blend of "net" for Internet and "etiquette," which refers to good manners. Netiquette is a set of conventions for polite online behavior, such as not sending spam, which is unsolicited junk email, or flames, which are mean-spirited, aggressive email messages or posts to blogs or other online forums. See also Controlling the Assault of Non-Solicited Pornography and Marketing Act of 2003, defamation, flame, libel, spam

**Network** The first radio network was formed with 24 stations in 1926 by NBC, a subsidiary of the Radio Corporation of America (RCA). Other networks were formed soon after. Television broadcasting began in the 1940s. In computing, network refers to a system of linked computers. The Internet is a global network of interconnected computers. See also Internet

**Network Neutrality** Also called net neutrality, the concept that everyone is entitled to equal, non-discriminatory access to all of the lawful content and services available on the Internet, regardless of whether the individual or the content providers paid fees and how much was paid. The opposing view favors tiered access and a tiered pricing structure in which some users are prioritized over others in terms of access and some content is privileged over other content in terms of how readily it is available and how quickly it can be accessed. In August 2010, Internet company Google and telecommunications company Verizon reached a controversial agreement regarding the treatment of content delivered to mobile devices. Proponents of an open Internet and net neutrality argue that the pact threatens to destroy features of the Internet that allowed innovative companies like Google to flourish in the first place. Critics of net neutrality argue that prioritizing the flow of content on the Internet is common sense: emergency responder communication should take precedence over spam, to give an extreme example. See also digital divide

**New Media** What counts as a new medium depends on the historical context: mass produced books were new in the mid-15th century; the telegraph in the mid-19th century; and the phonograph, radio, and silent film were late 19th-century innovations that spread in the early 20th century, capturing people's attention and imagination. But in the 21st century, the term new media typically refers to digital media and their associated processes and systems whose development and diffusion have been facilitated by advances in computers, software, communication and networking technologies, and especially the Internet. New media are now pervasive. They supplement older media such as books, newspapers, radio, and television. But beyond that, they have become integral to the infrastructure and interactive functioning of older media, a convergence trend that began in the late 20th century and continues to intensify. Examples of new media include e-books, blogs, MP3 files, and social networking websites. See also legacy media, social media, user generated content, Web 2.0

**News** The media genre of reports of recent events. From the 1920s to the 1950s, movie audiences watched 15-minute documentary-style reports of national and international happenings on film called newsreels that were played in theaters before the feature film. Once television became ubiquitous in U.S. homes in the 1950s, newsreels were no longer necessary and newsreel production ceased. In the 21st century, people easily and instantaneously access worldwide news via radio, television, newspapers, magazines, and, increasingly, online from anyplace at anytime, using personal computers (PC) and mobile devices such as e-readers and smartphones. Matters concerning politics, crime, weather, and stories of an important and serious nature are called hard news. Human interest stories and reports of local activities and events are called soft news. Stories that provide historical contextualization and analysis to supplement current stories are called think pieces. Media professionals, such as journalists, editors, and producers, had been the traditional gatekeepers of the news until relatively recently. They determined what was newsworthy, that is, relevant or of interest to their audience. In addition, they fact checked the information so that what was published or broadcast took into account their organization's news values and criteria. The widespread adoption of information and communication technologies (ICT) such as camcorders in the late 20th century and, in the 21st century,

smartphones with powerful video and photographic features has led to an explosion of citizen journalism and do-it-yourself (DIY) media. Today, anyone from anyplace can report current events, relaying it in real time to traditional media outlets such as television and radio stations or publishing it online to websites, blogs, and other online venues. There is an abundance of news reports, firsthand accounts, and opinion pieces available 24/7 online. Much of it is of mediocre quality, gleaned or remixed from other sources, or filled with inaccuracies. Media literacy is extremely important for this reason. See also citizen journalism, journalism, media literacy, opinion leader, user generated content

**News Anchor**  Main newsreader and host of a television or radio news show. When two people share these responsibilities, they are called co-anchors.

**News Crawl**  See crawl

**News Framing**  See framing

**Newshole**  The newspaper layout term for the space left for news articles, illustrations, and other non-advertising pieces after the advertisements are laid out on the pages. Because advertising generates revenue for newspapers, advertisements take precedence over news articles in the layout of newspapers; articles are shortened or eliminated to accommodate ads. Online versions of newspapers have an infinite newshole, because space is not limited to the physical size of the page or a specific number of pages per issue.

**Newspaper**  A publication of general or special interest that is published daily, several times a week, or weekly that contains news, information, and advertisements (see Figure 4 on page 132). Revenue is generated for newspaper owners through sales at newsstands, subscriptions, and advertising, with the latter typically providing the most income. Many newspapers now supplement their printed versions with online versions, and some have moved entirely to online formats. In the United States, less than half of all adults read a daily newspaper, a decline from over three-quarters of all adults in the mid-1970s. People over 55 years old are more likely to read a daily printed paper than younger people, who tend to get their news from

other sources, such as the Internet or television. See also gatekeeping, mass media, news, opinion leader, subscription

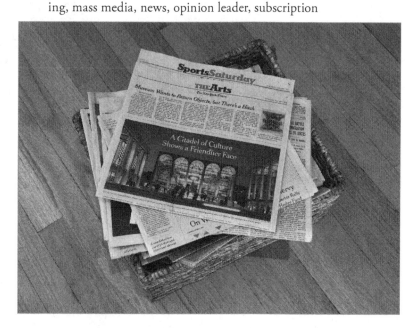

FIGURE 4. Sections of the *New York Times*.

**Newsreel** A 15-minute documentary style report of national and international happenings captured on film. Newsreels were played in movie theaters from the 1920s to the 1950s before the feature film. Once television became ubiquitous in U.S. homes in the 1950s, newsreels were no longer necessary and newsreel production ceased. See also news

**Nickelodeon** Early 20th-century motion picture theater. Movie exhibitors opened them virtually anyplace that they could set up chairs and project movies onto a screen or wall. Nickelodeon is a blend of "nickel" and "odeon." In ancient Greece, a small roofed theater was called an odeon. The name nickelodeon refers to the fact that admission to these movie theaters cost a nickel per person. Two entertainment entrepreneurs in Pittsburgh, Pennsylvania, Harry Davis (1861–1940) and John P. Harris (1872–1926), who were brothers-in-law, are credited with opening one of the first nickelodeons in June 1905. Their

idea to show movies continuously from early in the morning until late at night caught on rapidly as other entrepreneurs in Pittsburgh and elsewhere adopted this business model. The nickelodeon concept, known also as the "Pittsburgh idea," spread quickly to U.S. cities such as Philadelphia, Rochester, Toledo, Buffalo, and Cleveland. By April 1906, the phenomenon hit New York City, and six months later New York had more nickelodeons that any other city in the United States. The movie industry flourished in U.S. cities because working-class immigrants eagerly patronized nickelodeons, which provided affordable entertainment. Because movies were silent during this era—the technology for motion pictures with sound had not been invented yet—audiences made up of immigrants to the United States who might not be fluent in English could understand them. Eventually, people in the middle class took notice of the moviegoing phenomenon. Nickelodeons spread to more affluent areas and the popularity of moviegoing crossed class lines. By 1910, there were 20,000 nickelodeons in northern cities in the United States alone. During the next decade, nickelodeons were eclipsed by large, luxurious movie palaces built to lure and accommodate moviegoers from all socioeconomic classes. Nickelodeon is also the name of a popular U.S. cable television network that is typically abbreviated as Nick. See also American dream, movie, projector, silent film, talkie

**Nielsen Ratings** Results from the audience measurement systems developed by the Nielsen company, which track and analyze how many people access particular media content, such as a television sitcom (situation comedy) or radio talk show, and how and where they access it (homes, cars, offices, on-the-go). Nielsen rating data are used by radio and television networks to determine their programming schedules, by advertising agencies, and by corporations to inform their advertising and marketing strategies. Company founder, American marketing research pioneer Arthur Charles Nielsen, Sr. (1897–1980), developed his first television audience measurement method in 1936 when there were about 200 televisions worldwide. In 2009, Nielsen began to compete with another media research firm, Arbitron, which focuses on collecting data about radio audiences. Arbitron reports radio ratings estimates based on samples from the population in 302 metropolitan areas in the United States. Nielsen compiles radio listening estimates (their station ranking estimates) for radio markets

in the United States ranked 101st and smaller. Arbitron no longer provides television rating reports. Each company has a method for selecting a sample of media consumers and collecting and analyzing data about their media consumption in order to generalize about the market (the population of a specific region) based on the data. See also Arbitron ratings, audience, peoplemeter

**Noise** Unwanted, distracting message or information. The jack hammering of a concrete city sidewalk that drowns out a conversation with a friend and unintended crackles on an MP3 audio file are noise. So are pop-up advertisements on websites containing graphics and words. In digital photography, noise refers to random or superfluous pixels that detract from the quality of an image. In other words, noise is not necessarily something aural that is heard but rather anything that interferes with the clear communication (transmission and reception) of a signal. Further, what is noise to one person is music to another. People have varying abilities to consciously block out noise and focus on something else. Recent neuroscience research confirms that people can train their minds to focus better with repeated practice. Nevertheless, noise can be a powerful health hazard. The louder a noise is, the shorter the amount of time it is safe to be exposed to it before people's hearing will be damaged. Sound is measured in decibels (dB) that indicate the sound power per unit area on a scale of zero to 140. Repeated or prolonged exposure to sounds at 70 dB or higher can cause hearing loss. In the United States, hearing loss is the third most common health problem, affecting more than 36 million Americans. Personal audio electronics such as iPods can produce sound at 115 dB or higher. Aircraft take-offs produce 180 dB. Amplified rock music produces 120 dB. Chainsaws produce 110 dB. Lawnmowers and subways produce 90 dB. Listeners beware! See also feedback, information overload, music

**Non-Delivery Report** (NDR)  See delivery receipt

**Nonverbal Communication** Also called body language and paralanguage, all of the visual means of communicating emotions, beliefs, attitudes, and ideas without words, including conscious and unconscious facial expressions and gestures as well as body stance, dress, and other aspects of self presentation. Unintentional nonverbal communication is called

emotional leakage. See also American Sign Language, chronemics, haptics, kinesics, proxemics, vocalics

**Normal Distribution** Also called a bell curve, the distribution that many things in nature that have continuous variables follow, such as the heights and weights of people. Many statistical tests assume that the data are normally distributed.

**Nostalgia Technique** In advertising, using images that portray a bygone era in a positive light that might not be an entirely accurate representation in order to appeal to consumers' emotions.

**Novel** An extended story written in prose (as contrasted with poetry) that is fictional, which means that it is not real. In contrast, a graphic novel conveys a fictional or non-fictional story primarily through drawings. Graphic novels are published in book format, while comic books, which also tell stories mostly through drawings, are published in magazine format.

**NPR** See National Public Radio

**NTSC** Acronym for the National Television Standards Commission signal standard, which was the first analog video broadcast engineering standard for the generation, transmission, and reception of signals in the United States. It was adopted by the Federal Communications Commission (FCC) in 1941. NTSC has 525 lines of vertical resolution, 30 frames per second with interlaced scanning of the frames, 60 fields per second, and FM (frequency modulation) sound. This standard was adopted by Canada, Japan, South Korea, Mexico, and some other countries. Much of the rest of the world, including Europe, uses other standards, such as PAL (Phase Alternate Line), a 625-line, 50 Hz system, and SECAM (*Séquentiel Couleur à Mémoire,* French words that mean "Sequential Color with Memory"), a 625-line, 50 Hz system. Differences in the standards make it impossible to play a videotape or DVD made in Europe in PAL or SECAM on an American video or DVD player in NTSC and vice versa.

**Nuking the Fridge** See jump the shark

**Number Portability** See wireless number portability

**O & O** See owned and operated

**Obscenity** Something that is offensive or lewd that can be a word, action, or expression. It can be challenging to determine exactly what is and is not obscene in the digital era, just as it was in 1957, when one of the most famous obscenity trials in U.S. history was held in San Francisco, California. American publisher and poet Lawrence Ferlinghetti (1919–) was charged with violating obscenity laws because his City Lights publishing company had in 1956 published American writer Allen Ginsberg's (1926–1997) lengthy poem "Howl" in a book titled *Howl and Other Poems*. "Howl" contains sexually explicit words and references to illegal drug use. Reports about the trial, including articles in *Time* and *Life* magazines, propelled "Howl" and Allen Ginsberg into the public's eye. The judge ruled that the poem had serious literary value and was not obscene, that it used the vernacular of the time to convey its points. This decision was a landmark First Amendment victory. "Howl" became one of the most well-known poems of the 20th century, and Ginsberg became one of the most celebrated American poets. An icon of the Beat Generation's writers and artists, he provocatively archived 20th-century America in his work. "Howl" was pioneering because of its content, which included searing and rebellious social commentary along with graphic references to body parts

and heterosexual and homosexual sex. The poem resonates powerfully more than five decades after it was written. Remarkably, in 2007, the staff at WBAI, a New York community radio station that is part of Pacifica Radio, the oldest independent media network in the United States, decided not to air a reading of "Howl" on the 50th anniversary of its publication, fearing that the Federal Communications Commission (FCC) would slap the station with millions of dollars in fines for violating obscenity laws, which would financially cripple the station, even though a court had ruled in 1957 that "Howl" is not obscene. Rather than take the risk, the station staff prepared a special online show instead, because the FCC's power to regulate indecency extends to radio and television broadcasts, but not to the Internet, cable, satellite, or pay-per-view services. WBAI was not a newcomer to free speech controversies. In 1973, it aired American stand-up comic George Carlin's (1937–2008) "Filthy Words" comedy routine uncensored, which led to a public debate about censorship and was part of the landmark U.S. Supreme Court case in 1978 (FCC v. PACIFICA FOUNDATION, 438 U.S. 726) that established indecency regulation in U.S. television and radio broadcasting. The original seven dirty words in Carlin's comedy routine about what supposedly could never be said on television and radio were: shit, piss, fuck, cunt, cocksucker, motherfucker, and tits. As was the situation with publisher Ferlinghetti and poet Allen Ginsberg's "Howl" in the 1950s, people charged with violating obscenity laws today must prove that their creative work has serious artistic value and does not violate "community standards." Considering that the adult entertainment industry has estimated revenue of $10 billion a year, and more than half of all hotel patrons view adult entertainment in their hotel rooms, according to industry insiders, the community referenced in the term "community standards" must be gigantic and diverse. The line between what is and is not obscene remains blurry and contested today, and mainstream media (MSM) typically self-censor to avoid the risk of fines. The FCC fined CBS $550,000 for airing American pop singer Janet Jackson's (1966–) breast for 9/16th of a second during the half-time show of the 2004 Super Bowl football game in an incident that has become immortalized euphemistically as a "wardrobe malfunction." The fine on CBS was subsequently overturned by a federal appeals court in 2008 and then reviewed again in 2010

by an appeals court, which ruled in favor of CBS. See also bleep out, censorship, Federal Communications Commission, vernacular

**Observer Effect** In social science, the concept that what is being studied can be changed by the act of the investigator studying it. See also response bias

**Off the Record** In journalism, information or a comment an interviewee, informant, or source communicated to a journalist that, it is mutually agreed, will not be published or broadcast. In the case of a videotaped or audiotaped interview, the source might request that the recording equipment be turned off so that the off-the-record part of the conversation is literally off the record, that is, not recorded. Off-the-record information is useful for furthering journalists' research and for enhancing their understanding of the story that they are pursuing. In contrast, on-the-record comments and information are those for which there is the understanding between the source and the interviewer that the comments or information might be published or broadcast. In other conversational contexts, off the record means that a person is passing on information that she or he does not want to be quoted on or linked to.

**Oligopoly** In business, when a few companies or individuals control the majority of an industry. For instance, a few powerful multinational record labels control most of the worldwide music industry, influencing to a large degree the music that is heard on the airwaves and popularized. See also concentration of media ownership, horizontal integration, independent media, political economy studies, vertical integration

**On the Record** See off the record

**On-Demand** Service accessed anytime, such as movies downloaded over the Internet or through a satellite or cable television service. Movies are usually available for a defined time period, typically 24 or 48 hours, and users are charged for each download. See also placeshifting, timeshifting

**Online** Being logged onto the Internet or taking place over the Internet, such as online shopping, online banking, online dating, and online education.

**Online Education** Also called distance learning, learning through the use of synchronous and asynchronous software tools, typically via Web-based course management systems such as BlackBoard and WebCT. Asynchronous features allow the instructor and students to access course materials and class discussions anytime and from anyplace. The flexibility and accessibility of online education make it appealing to a variety of constituencies, including non-traditionally aged college students, working adults, and people with conditions that affect their hearing, speaking, or mobility. A related term is mobile learning or mLearning, which refers to learning remotely and sometimes on-the-go using a mobile device such as a laptop computer, netbook, or digital media player rather than a desktop computer. Tweaching is using the microblogging service Twitter for instruction. This term was coined by online education specialist and neologist Brian Salerno (1980–) in 2009, while he was an instructional designer at Quinnipiac University. See also discussion board, wiki

**Open Ended Question** In social science or marketing research, questions on a survey or in an interview that do not require the respondent to choose from a set of predetermined answers. In contrast, a closed ended question provides predetermined answers from which the respondent must choose. See also interview schedule

**Open Source Software** Computer software whose source code, the underlying programming instructions, has been made available by its developers so that people can use, modify, or extend the software. See also hacker, modder

**Operating System** See platform

**Opinion Leader** According to the two-step flow theory of communication, opinion leaders are people who have influence over others' opinions, values, and attitudes because of their knowledge, expertise, and/or social status. In some cases opinion leaders have influence over others regarding one topic and in other cases they hold authority on a range of topics. Opinion leaders serve as intermediaries who spread to others and interpret for them the meaning of mass mediated messages, such as the information contained in news stories. See also theory

**Opinion Piece** In journalism, an article or television or radio segment expressing personal opinions rather than just facts. An editorial is an

opinion piece by a staff member or members of a media organization that is broadcast on television or radio or published in a newspaper or magazine, sometimes without a byline.

**Opinion Poll** Survey that samples a population to find out information about their opinions, beliefs, or attitudes on a topic. When a true random sample is surveyed, that is, when the subset of the population is selected in a way that guarantees all members of the population have an equal chance of being selected, then the responses to the survey questions are considered to be representative of the opinions, beliefs, or attitudes of those in the population that the sample comes from, for instance, all registered voters in a state. See also public opinion

**Optical Media** Digital storage technologies such as the compact disc (CD), DVD, and Blu-ray disc that are written and read by a low-powered laser beam.

**Optics** A physics term relating to the properties of light. In media fields, optics refers to camera technologies that use light, such as lenses. More recently, this word has been used to describe how something will be perceived from a public relations (PR) standpoint. See also propaganda, spin

**Oral History** Interview with someone who answers questions and recounts his or her life story for historical purposes, typically while being recorded.

**Original Source** See source

**Oscar** See Academy Awards

**Outtake** Unused recording of a media production, such as a scene from a movie or television show or sound recording of a song. Outtakes sometimes contain bloopers or flubs, which are unintentional, sometimes embarrassing mistakes or slipups. See also bleep out

**Owned and Operated** (O & O) Television and radio stations that are owned and operated by television and radio networks.

**Pamphlet** Also called a booklet, brochure, or leaflet, a written piece that promotes a social cause or conveys information. Pamphlets originated in 16th-century England.

**Paparazzi** Photographers who intrusively stalk celebrities with the intent of taking photographs of them that are outrageous or shocking, and exclusive, and, therefore, will be highly sought after by the press, which will pay a lot for the photos. Paparazzi, plural of paparazzo, became an infamous word because of the circumstances surrounding the death of Diana Princess of Wales (1961–1997) and her companion Egyptian-born British film producer and businessman Dodi Al-Fayed (1955–1997) in a car crash in a tunnel in Paris on August 31, 1997. Within the context of Web 2.0, many people have become self-paparazzi, posting their own images online and disclosing things about themselves that are sometimes outrageous or shocking, using venues such as the video hosting website YouTube.

**Paralanguage** See nonverbal communication

**Paraphrasing** Restating in a different way or summarizing something that was said or written. See also quotation, retweet

**Parasocial Relationship** When members of a media audience feel that they have an intimate connection with an actual or fictional media

personality, such as a television news anchor, movie actor, or soap opera character. This illusory relationship is cultivated by the media to maintain audience members' attention. In some cases, people feel closer to on-screen characters with which they have parasocial relationships than with people they actually know face-to-face (F2F). This intimacy is created through prolonged and repeated viewing through which audience members paradoxically get to know people, or at least their on-screen personae, up-close while nevertheless at an electronically mediated distance. See also fan

**Parchment** Writing material made from treated animal skins. Parchment was used after papyrus, which is paper made from plant reeds, and before the widespread diffusion of paper made from wood pulp. See also book

**Parody** Related to satire, a parody is a mocking imitation of something, such as a television commercial, movie, musical composition, literary piece, or person. Parodies are also called spoofs or lampoons. See also satire

**Participant Observation** A qualitative research method associated with ethnography in which investigators conduct intensive fieldwork. They immerse themselves within the context they are studying and observe and also to some degree participate in and experience its dynamics, activities, and unfolding events along with the people who are natives (insiders) to the context. Researchers using this method try to be as unobtrusive as possible to avoid changing the nature of the context and events they research. This method allows for in-depth study of the worldview (frame of reference) of the context participants. A disadvantage of participant observation is that findings from one research context might not be generalizable to other contexts. See also ethnography, observer effect

**Participatory Media** Media content produced in open and collaborative environments by specialists as well as non-specialists. The collectively written and edited online encyclopedia Wikipedia is an example. Anyone with an Internet connection can edit or augment entries to it. See also network neutrality, social media, user generated content, Web 2.0, YouTube

**Passivity Theory** Media theory arguing that the audience typically does not actively interpret the meaning(s) of media productions. See also active audience, audience agency, theory

**Payne Fund Studies** Controversial media effects research published in the 1930s that suggested a correlation (relationship) between movie viewing and children's behavior.

**Payola** Also called plugola, referring to plugging (promoting) something, the illegal practice by record companies and music promoters of bribing radio disc jockeys (DJ) and program directors to play certain songs on the air to popularize the songs in order to sell compact discs (CD) or MP3 downloads.

**Pay-Per-View** Satellite and cable television services that allow audience members to purchase movies and other shows such as broadcasts of special events on-demand for viewing at their convenience. See also placeshifting, timeshifting

**Pecha-Kucha** A fast-paced, entertaining presentation format invented in Tokyo, Japan in 2003 by two Tokyo-based architects, Italian-born Astrid Klein (1962–) and British-born Mark Dytham (1964–). Pecha-kucha, which means "chit chat" in Japanese, is a way for designers, artists, academics, comedians, and others to share their work in a quick, concise format; reach and entertain audiences; and meet one another. The 20x20 format means that presenters can show 20 slides for 20 seconds each, which translates into 6 minutes 40 seconds per presentation. By 2011, pecha-kucha nights were being held in over 370 cities worldwide.

**Peer Review** See blind review, peer reviewed journal

**Peer Reviewed Journal** Also called refereed journal, academic journal, juried publication, or scholarly journal, a peer reviewed journal is a scholarly publication whose content is checked for accuracy and completeness by several experts in the field who serve as unpaid reviewers. In order to promote impartial evaluations, the reviews of articles are typically conducted as blind reviews. This means that neither the reviewers nor the author(s) are told one another's identities. The reviewers suggest ways to improve the articles, point out omissions or mistakes, and convey to the journal editor their expert opinions about whether an article should be accepted for publication

as is, revised based on certain criteria and resubmitted, or rejected. Peer reviewed journal articles typically have bibliographic references, which are indicated in the form of footnotes, endnotes, or parenthetical citations, depending on the style guide used by the journal (i.e., American Psychological Association [APA], Modern Language Association [MLA]). These references point readers to the sources that the author consulted for information and ideas. Libraries subscribe to print and online versions of peer reviewed journals. Articles submitted to popular press (non-scholarly) magazines and trade publications do not undergo the same rigorous peer review process although professional editors review articles before they are published. See also blind review

**Peer-To-Peer** (P2P) **File Sharing Website** Website that supports the uploading and downloading of files, ranging from photographs to music to short amateur videos to full-length feature films to pirated television show episodes. In contrast to a client/server model, a P2P system allows computer users to directly access files from one another's hard drives. See also bootleg, piracy, taper

**Pen Name** Also called *nom de plume,* a made-up name that hides a writer's real identity, typically to avoid negative repercussions. British novelist Mary Anne (also Marian) Evans (1819–1880) used the pen name George Eliot to conceal that she was a female writer. American science fiction writer Alice Bradley Sheldon (1915–1987) used the pen names James Tiptree, Jr. and, occasionally, Raccoona Sheldon. Both authors thought that their work would be more favorably received by reviewers and readers if people thought they were male. Indian-born British author, journalist, and poet Eric Arthur Blair (1903–1950) used the pen names John Freeman and, more famously, George Orwell. A related term is pseudonym, a fake name used to protect privacy and maintain anonymity often used in online contexts such as chat rooms. In research, investigators often assign pseudonyms to study participants even if they know the participants' real names in order to protect their privacy and maintain confidentiality. See also avatar, persona

**Peoplemeter** Electronic television audience measuring device connected to a television set that tracks household members' viewing behaviors. See also audience, Nielsen ratings

**Performance Royalties** Performing rights organizations such as the American Society of Composers, Authors and Publishers (ASCAP); Broadcast Music, Incorporated (BMI); and SESAC track when a musical composition is performed on radio, television, or in a concert venue. These organizations collect licensing fees on their artists' behalf and distribute royalties to them. See also bootleg, mechanical royalties, piracy, royalties, taper

**Performing Rights** The right to publicly play a copyrighted work, that is, a legally protected original piece, such as a song. Copyright law is based on the notions that intellectual property such as works of creative expression like plays, novels, musicals, and songs are equal to material property and that legal protections encourage the creators of intellectual property to keep doing what they do. An opposing viewpoint conceptualizes copyright as a philosophical construct that actually serves corporate interests more than artists' interests or the public interest. See also copyleft, copyright, Creative Commons, intellectual property

**Periodical** See magazine, peer reviewed journal, trade publication

**Peripherals** In computing, hardware such as printers, external hard drives, keyboards, mice, and monitors that are used with computers. See also software

**Persistence of Vision** Also known as the phi phenomenon, the theory explaining the visual phenomenon that creates the illusion of motion with still frames. See also movie

**Persona** A representation of the self, which might be inaccurate. The plural is personae. American psychologist Sherry Turkle (1948–) was among the earliest to study people's interactions with computers and their construction of personae, concepts she discussed in her books *The Second Self: Computers and the Human Spirit* (1984) and *Life on the Screen: Identity in the Age of the Internet* (1995). See also avatar, pen name, pseudonym

**Personal Computer** (PC) A computer designed to be used and owned by one person. Since the 1980s, technological advances in computer hardware and software have made it practical, affordable, and desirable for individuals to own their own computers. Prior to this time, computers were much larger machines than today's familiar array of

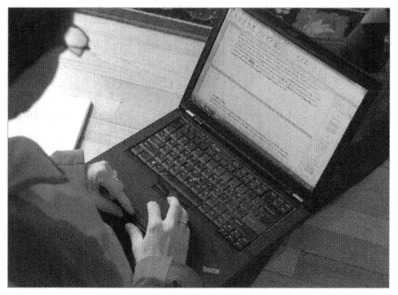

FIGURE 5. A personal computer user hard at work while the photographer shoulder surfs.

desktop and portable computers (see Figure 5), and multiple users connected to them at once via computer terminals. Early computers required users to have specialized knowledge to operate them and were expensive. All these factors made computers appealing, accessible, and useful to only a limited group of people. Today, PC is used typically to refer to IBM-compatible machines as opposed to Apple computers, which are called Macs, short for Macintosh. See also Apple, Microsoft, netbook

**Perspective** What people are able to perceive depends on where they are positioned and the lenses—both real and metaphorical—that they look through, and where they look. Everyone, including journalists, photographers, cinematographers, artists, and social researchers, has a perspective, or point of view, which necessarily foregrounds some things while others are placed in the background. In architecture, painting, and graphic arts, perspective concerns how three dimensions are represented on two-dimensional surfaces and how things look in terms of their size, shape, and viewing angle.

**Persuasion** The act of influencing someone to think or do something, such as to believe in equality, vote for a political candidate, or purchase a certain brand of car. See also advertisement, propaganda, public relations, social engineering

**Phatic Communication** Speech acts or exchanges that are intended to perform a social bonding function rather than to convey substantive information. For example, "Hi, how are you?" is a polite, small talk phrase uttered on-the-fly when passing an acquaintance on the street. It is almost always said without the expectation of a detailed or candid response. The usual rejoinder, "Fine, how are you?" typically ends the exchange but nevertheless serves the purpose of communicating recognition.

**Phishing** When cybercriminals send a deceptive email message that attempts to persuade individuals to reveal their private information such as usernames and passwords for an online banking system, date of birth, mother's maiden name, or social security number. A phishing email may contain text, logos, and/or color schemes that make it appear to be an official message from a legitimate organization, business, or government agency. Phishing emails often contain hyperlinks to spoof websites that deceptively mimic legitimate websites. Phishing is a playful homonym of fishing. That is, the word phishing is pronounced the same as fishing but spelled differently. The crucial thing phishing and fishing have in common is that they both use bait to catch something. Phishing emails can be highly targeted. They might be addressed personally to the recipient or phrased in a way that they seem to be. They might be addressed to employees of a specific company. This type of phishing is called spear phishing. When the phishing message is sent via short message service (SMS) text messages, it is called smishing, a blend of "SMS" and "phishing." When phishing is conducted over the telephone, it is called vishing, a blend of "voice" and "phishing." In this scam, people are instructed to dial a certain phone number that is purportedly their bank's number and to enter their passwords and personal identification numbers (PIN), which are then captured for the criminal's fraudulent use. Phishing, smishing, and vishing use social engineering strategies to trick people into doing certain things. See also cybercrime, social engineering, spoof website

**Phonograph** Synonym for record player or turntable. In 1877, American inventor and entrepreneur Thomas Edison (1847–1931) thought the phonograph he developed would be useful as a telephone answering machine. He did not anticipate that people would enjoy listening to pre-recorded music on mass-produced records. This illustrates that technology developers and proponents are often not the best predictors of how their technologies will be received, reshaped, and put to use by others. German-born American inventor Emile Berliner (1851–1929) made the first sound recordings on flat discs in 1887. His device for playing records was called a gramophone. After reviewing a draft of this dictionary, American psychiatrist and music enthusiast Ellis A. Perlswig, M.D. (1923–) commented that his family bought their first phonograph in 1929, and that it was a wind-up machine, not electric. See also jukebox

**Photomontage** See montage

**Phreak** Someone who illegally breaks into and makes use of a telephone network for free, a practice called phone phreaking or phreaking. See also cracker, hacker, jailbreak, modder

**Pilot Study** A preliminary research project that is typically a smaller scale version of a planned larger project. A pilot study is conducted in order to identify in advance any potential problems in the design or implementation of a larger proposed study, to generate new ideas, and/or to provide evidence that would justify a larger scale study. See also exploratory

**Pilot Television Show** An example episode of a television show produced in order to gauge people's interest in a potential new television series.

**Ping** Acronym for "packet Internet groper," a computer program used as a diagnostic tool to check if a particular Internet Protocol (IP) address exists and is operating, to troubleshoot equipment, and to measure response time. This computer term is borrowed from the vocabulary of sonar technology such as that used in submarines in which a sound pulse called a ping is sent and its echo response is then used for navigation purposes and to determine the location of other vessels. Sonar is also an acronym. It stands for "sound navigation and ranging."

**Piracy** Illegally sharing or selling copies of copyrighted works, such as movies, music, software, video games, or television shows. Digital piracy threatens copyright owners' right to profit from their works. There is resistance in some parts of the world to the U.S.-based global copyright industries for many reasons. There is also uneven enforcement of copyright laws throughout the world. People in different cultures have differing philosophical views about what can actually be owned individually, as opposed to what should be shared collectively for the common good (opposing values regarding individualism and collectivism), that has led to public demand for access to copyrighted materials. For instance, in China, many American television shows unavailable on Chinese television are coveted as pirated copies on DVD and on computer files accessed from peer-to-peer (P2P) file sharing websites that function in the manner of YouTube. Piracy ultimately benefits copyright holders in unintended ways, according to some researchers, because it publicizes the products of the copyright holders, which are typically global media conglomerates. This publicity ultimately cultivates an increased demand for the copyright holders' products and expands the market for them. In this sense, piracy is like almost-free advertising. Moreover, pirated copies of media products carry within them subliminal messages that stimulate consumption and embedded consumerist values that are conveyed somewhat explicitly through product placement and less obviously through seamless product integration. For example, television show storylines promote brand awareness. Consider the various models of Verizon phones that the characters use on the American television show *Gossip Girls*. According to a 2010 study of young adults in China, watching pirated American television shows such as *Gossip Girls* is part of being fashionable. Pirated media function as shopping catalogs, showcasing trendy products. Moreover, according to some people who access pirated copies of media for free that they could not afford to purchase, pirated copies help bridge the digital divide, the gap between the information-rich and information-poor. At the end of 2010, the movie *Avatar* (2009) had earned the most revenue worldwide, had the most viewings, and was also the most pirated. See also advertisement, bootleg, concentration of media ownership, copyright, freeware, intellectual property, modder, open source software, taper

**Pitch** Proposing an idea for a media product to someone or many people who are in the position to bring the idea to fruition. A pitch is also the proposal itself. Examples of media products that are pitched to executives such as producers, directors, and editors include television series, movies, and newspaper and magazine articles. In music, pitch refers to an attribute of musical tone that is perceived subjectively in the human auditory (hearing) system. Pitch and frequency do not mean the same thing in acoustics, but they are related. Frequency, unlike pitch, is an objectively measurable attribute of sound.

**Pixel** A blend of "picture" and "element." It is the smallest programmable color unit in an image or on a computer display.

**Pixelation** Process of converting a printed image into a digitized image file, for instance, to be used on a Web page. The term also refers to the effect that happens when a low-resolution digital image is blown up to such a degree that each pixel becomes viewable individually. This is sometimes done as an intentional special effect for artistic reasons. See also pixilation

**Pixilation** Animation technique for movies that uses stop-action (also called time-lapse) cinematography. In this special effect technique, objects or people, rather than drawings, are filmed frame-by-frame as the camera is stopped and started over and over again, as opposed to the conventional manner of filming action continuously. Pixilation was used to animate miniature dinosaur models in American director Steven Spielberg's (1946–) blockbuster science fiction movie *Jurassic Park* (1993), which was based on American author Michael Crichton's (1942–2008) novel *Jurassic Park* (1990). See also animation, pixelation

**Placeshifting** To view or listen to a video or audio show or other media production in a context that is different from where it might typically be experienced. For example, downloading and listening to a podcast of a radio show on an MP3 player rather than on a radio. See also timeshifting

**Planned Obsolescence** See built-in obsolescence, electronic waste

**Plasma Screen** Flat panel display screen technology used for computer monitors and television sets.

**Platform** The aims and principles of a political party, organization, or social movement. In computing, a platform is the operating system, such as Windows, that is needed as a basis for other programs to function on a computer.

**Play List** List of songs a radio station puts into rotation for airplay, which can be influenced by payola, the illegal practice of bribing radio disc jockeys (DJ) and program directors.

**Plug-And-Play** Also called plug-n-play, an attribute of electronic devices that require minimal or no set-up to make them work. For instance, a computer automatically recognizes when a plug-and-play thumb drive is inserted into one of its universal serial bus (USB) ports. A thumb drive is a portable flash storage device with no mechanical parts that is so small that it can be carried on a keychain and so robust that it can store gigabytes (GB) of data. A computer will automatically integrate a thumb drive into the system so that the user can access files on it or transfer files onto it. See also flash drive, universal serial bus

**Podcast** Digital audio, text, image, or video file that is accessible to people for downloading from the Web to a mobile device or computer for listening or viewing at the user's convenience. Podcast content ranges from radio shows to music to educational lectures and training sessions. See also placeshifting, timeshifting

**Poem** A literary composition written in a way that conveys ideas and emotions through the use of language in imaginative ways that sometimes include: metrical rhythm, rhymes, intense language, and metaphors as well as creative and non-standard punctuation, spelling, syntax, and arrangement of the words on the page.

> Do you know the poem "Howl"? Legendary Beat Generation poet Allen Ginsberg's (1926–1997) iconic poem written in 1955. It's over 5,000 words long; the first sentence has exactly 2,107 words in it. That's part I of the three-part poem. Ginsberg used a lot of clauses in that first sentence. I know it is 2,107 words long because I checked with the word count feature in Microsoft Word— something Ginsberg didn't have on his manual typewriter when he wrote that poem. Anyway, "Howl" begins…

"I saw the best minds of my generation destroyed by madness, starving hysterical naked…"

And it goes on…raw, searing social commentary, Ginsberg punctuating his points about alienation and sex and mental health and capitalism and illegal drug use in the vernacular of the time.

This is a kind of howl too, to get the attention of everyone who is so distracted, distracted, distracted by

virtual reality

augmented reality—do you know what that is?

pings and tweets and earbuds and loudspeakers and fast talkers and high-definition and simulators and wireless fidelity and mashups.

We are the masters of our technologies, developers, proponents, adopters, modifiers, remixers, transformers, translators, transcribers, and also the mistresses of our technologies.

We are the heroes and the victims of our own special effects.

We have always multitasked, or at least toggled our attention back and forth, which technically isn't multitasking but whatever, from the meat on the fire pit to the animal sounds in the forest back to the meat. We focus on one thing and then go off in another direction and then another. Generation Mashup is Generation Distraction. And now you can media multitask on ski slopes with realski augmented reality technology. It's dangerous to use it while skiing, according to a statement on the company website. The GPS installed in many cars flashes a warning that it's dangerous to use it while driving. When else are you going to use it? It's installed in a car! HOWL.

*–Sharon Kleinman, November 2010*

**Point of View** See perspective

**Political Economy Studies** Cultural studies research that focuses on the relationships among media institutions and on how media conglomerates control cultural production in the news and entertainment industries and wield tremendous social, economic, and political power. See also cultural studies

**Political Tracker** Also called a tracker, someone who attends the public appearances of politicians and candidates for political office and records their speeches, attempting to document any unintentional contradictions, slips of the tongue, or other potentially embarrassing incidents. Trackers then publicize these incidents online or via traditional mass media. Trackers are paid by political parties and special interest groups. See also bleep out, blooper, malapropism, outtake, paparazzi

**Poll** Public opinion research that inquires about and measures people's opinions on a topic or topics, typically by contacting a large, randomly selected sample of people by telephone. The Quinnipiac University Polling Institute, for example, researches the opinions of registered voters in the United States who are 18-years-old or older on issues of public interest, for instance, concerning education, the environment, and taxes. See also inferential statistics, public opinion, questionnaire, random sample, spiral of silence, survey research

**Polysemic** Quality of having the potential for multiple meanings or interpretations. Members of an audience can interpret texts such as movies or songs differently. Interpretations of texts that differ from the creators' intention are called aberrant readings. A related term is polyvalence, which refers to another outcome of the audience interpretation of texts, specifically that people who interpret a text the same way might evaluate it differently. See also audience

**Popular Culture** Often shortened to pop culture, cultural products that appeal to a wide, mainstream audience. Also, the social environment, habits, beliefs, and activities that these products reflect as well as help to sustain. See also zeitgeist

**Popular Music** Music that appeals to a wide, mainstream audience.

**Population** In research, the group from which a sample is drawn. The term can refer to people, for instance, registered voters 18-years-old or older in Connecticut, or to other things, such as all of the full-page advertisements published in *Sports Illustrated* magazine from 2000 to 2010.

**Pop-Up Advertisement** Online advertisement that opens as users navigate a Web page, either when they click on a hyperlink or roll over a particular area, which is called a rollover or mouseover. It appears as a

window that is smaller than the background interface. The software for pop-up ads is called adware. Many Web users find pop-up ads annoying and quickly click the close or exit button. Pop-under ads are similar to pop-ups, but they appear in windows after the user leaves a Web page. A pop-up blocker, also called pop-up killer, is a program on a user's computer that automatically prevents pop-up windows from opening. Like anti-spam filters used for email systems, pop-up blockers sometimes filter out content that the user actually wants to view. Marketers sometimes use software that detects pop-up filters on users' computers and then converts ads into floating ads that pop-up blockers cannot filter out. See also pop-up window

**Pop-Up Window** A small square or rectangular graphic in the shape of a window that opens on a computer screen when the computer user clicks a hyperlink or rolls over a particular area, which is called a rollover or mouseover.

**Positive Appeal** Advertising strategy that focuses on why it is desirable to possess a certain product. A negative appeal stresses what consumers are missing by not owning the product that is being pitched. See also advertisement

**Postal Act of 1879** Act that refined the U.S. Postal Service's (USPS) mail classification system to prevent advertising circulars from being sent by second-class mail. Instead, senders of advertising materials had to pay the much more expensive third-class rate. Meanwhile, newspapers and magazines benefited from second-class postage rates, even though they increasingly included advertisements in them. This Act greatly enhanced the growth of the magazine industry in the United States in the late 19th century. See also advertisement

**Postcard** A small, stiff card that typically has an image on one side and is blank or mostly blank on the other, leaving space for the sender to write a concise message and the name and address of the intended recipient. In many places, including the United States, it is much cheaper to mail a postcard than to send a letter in an envelope. In the digital era, when many people communicate electronically, a handwritten postcard can make a big psychological impact on the recipient because of the thoughtfulness sending a postcard represents.

**Postcyberdisclosure Panic** (PCDP)  The anxiety experienced after communicating something confidential and potentially embarrassing via electronically mediated communication such as email or text message. People experience PCDP after they click the "send" button and realize that they have emailed the wrong person.

**Poster**  A large piece of paper that contains words, images, or both. Posters are commonly used to efficiently and relatively inexpensively advertise events, such as tag sales, concerts, and theatrical performances, as well as to communicate ideas, sentiments, or support for political candidates. People often hold up posters at rallies and protests. Some posters become highly collectible, such as movie posters and those that endorse political candidates. Some are affordable reproductions of famous art while others are works of art in their own right. In online contexts, a poster is a person who contributes something, such as a comment (or post) to a blog or discussion board. See also advertisement, billboard, typography

**PR**  See public relations

**Predator**  A blend of "producer" and "editor." A person capable of both producing and editing stories who works in a television newsroom. Like hiring so-called backpack reporters, employing predators is a cost cutting measure some news organizations are taking in today's highly competitive journalism market.

**Prequel**  A movie, novel, or play that tells the story of what happened before a story that has already been created. The audience of a prequel is already familiar with the characters and the world that they inhabit, as is the case with a sequel, which is the continuation of a story.

**Press**  A synonym for the field of journalism that also refers to the people who work in the profession. Good press refers to positive reporting about something while bad press is downbeat or harmful coverage. Press is also short for printing press. See also Fourth Estate, mass media, publicity

**Press Release**  Information summary sheet written in the format of a news article that is transmitted to members of the press so that the information can be integrated into broadcasts and journalistic reports. A press release is often written by a public relations professional working for a public relations agency or in the public affairs or media

relations department of an organization. The video equivalent of a press release is called a video news release (VNR). See also public relations, publicity

**Primary Research** Research conducted through first-hand investigation, such as an interview, content analysis, participant observation, or survey. It contrasts with secondary research, which draws on previous studies, synthesizing and analyzing other researchers' findings.

**Primary Source** See source

**Principle of Least Effort** See Zipf's Law

**Print Media** Category of mass media that includes newspapers, magazines, and books. Other media categories are electronic media, which includes radio, television, computers, video games, and the Internet, and photographic media, which includes movies and photographs.

**Printing Press** Mechanical printing machine with movable type that changed the way texts were produced and received. Movable type means that the individual characters can be put together to form words and sentences and then later reconfigured and reused. Printing presses with movable type were first developed in Asia in the 11th century. In the 15th century, German inventor Johann Gutenberg's (c. 1400–1468) printing press spread throughout the Western world, giving more people access to more information, new ideas, and knowledge than ever before in the scientific, religious, and literary domains. The printing press inspired a dramatic increase in literacy in the 15th century. German theology professor and priest Martin Luther's (1483–1546) Ninety-Five Theses (1517) was an influential text that was disseminated quickly, beginning in the Reformation. Within two weeks of publication it was distributed throughout Germany, and within two months it was distributed throughout Europe. The *Mayflower*, which sailed from England to America in 1642, had a printing press on board. See also book, Gutenberg Bible, information overload

**Probability Sampling** Survey technique that ensures that the sample selected represents the larger population from which it is drawn, typically by using a random selection technique. See also convenience sample, inferential statistics, snowball technique, survey research

**Producer**  In the music, movie, theater, television, and radio industries, the person who supervises a production, arranges the financing, and hires the director and/or other key personnel to work on the project. Actors sometimes produce and/or direct movie projects in which they act as well as those in which they do not appear on screen. Musicians sometimes produce their own records or records for others. People who create content for Web 2.0 are sometimes called prosumers, a blend of "producer" and "consumer." See also predator

**Product Placement**  The advertising practice of paying or bartering (trading goods or services) to have specific products appear in movies, television shows, and video games. It is estimated to be a $3.5 billion industry. In the age of technologies that enable viewers to fast-forward through commercials, product placement is a strategy for advertising products in a way that people do not even realize that they are being pitched to. Product placement is common in the U.S. media but it is regulated and restricted by government agencies in other parts of the world, including France and the U.K. This creates challenges for media productions that will have an international reach. Examples of the items restricted in various countries include alcoholic beverages, tobacco products, prescription and over-the-counter drugs, firearms, and, interestingly, infant formula. In the United States, cars, beer, and soft drinks are the most common products placed in television shows. The companies that did the most product placement in American television shows in the mid-2000s were Ford, Coca-Cola, Nike, the Boston Red Sox, and NetZero, according to Nielsen reports. Product placement fees are important revenue generators for media companies. Media critics argue that the ubiquity of product placement and other forms of advertising leads to a brand-obsessed consumerist culture. People see what is possible and available and then model their lives on the lifestyles and products they see in the media. Advertising and media productions are so intertwined and synergistic that sometimes they are almost indistinguishable. Product integration takes product placement to an even higher level. This strategy entails the intentional seamless integration of a product or brand into the storyline of a show. For instance, various models of Verizon phones used by the characters on the American television show *Gossip Girls* played key roles in the show. Whole episodes of the American television show *Friends* were constructed around particular products, including Dyson vacuum

cleaners and Nestlé Toll House cookies. Remarkably, more products were digitally placed in episodes of *Friends* for reruns and DVD versions. Television shows and movies as well as other media products, even cartoons, are entertainment, shopping catalogs that showcase trendy products, celebrity endorsement vehicles, and conveyers of materialistic values all rolled up into user-friendly advertainment packages aimed primarily at teens and young adults, who constitute an enormous consumer market. See also advertisement, brand, piracy

**Profile** See biography

**Program** In television, a show or broadcast. In computing, the instructions for a computer to follow, also called software or application. In performances such as concerts and plays, a brochure or pamphlet that lists information of interest to the audience, such as: performers' names and profiles, names and titles of production staff, title and synopsis of the piece(s) that will be performed, and sponsors. Performance programs sometimes include advertisements.

**Projector** A device that converts electronic signals into images of video, graphics, and text to make them viewable on screens. Projecting onto large screens allows for group viewing for entertainment (e.g., movies, rock concerts), education (e.g., college lectures, graduation ceremonies), civic involvement (e.g., political party conventions, social movement rallies), and business (e.g., shareholder meetings, corporate presentations). Projecting onto small screens allows for personal viewing or for viewing by a few people (e.g., television, home theater, video games). Projection systems are tailored to their intended usage contexts, taking into account the size of the room, audience, and screen; viewing distances; and image content. Different contexts require different image resolution levels to maximize the quality of the image. Various projection technologies (e.g., laser, light emitting diode [LED], lamp) can provide the appropriate resolution for different contexts. Large venues, such as multiplex cinemas with seating for 1,000 people, require a 12,000-lumen projector, while the largest movie theaters in the world, with seating for over 2,500 people, require a projector with very high output, about 30,000 lumens. Early projection inventions like the 17th-century magic lantern used candles for light and simple screens to exploit the persistence of vision phenomenon that makes a series of frames of still

pictures seem to move, allowing for the illusion of motion. By the 19th century, inventors from many different places working on different aspects of the project developed motion picture technology. By 1895, two brothers in France, Auguste (1862–1954) and Louis Lumière (1864–1948), had developed a portable hand-cranked camera that could also project films. Amusingly, *lumière* means "light" in French. The brothers exhibited their first film, *Workers Leaving the Lumière Factory*, to a private audience in France in 1895. In the United States, American inventor Woodville Latham (1837–1911) and his sons Gray and Otway projected films in a store in 1895. Around this time, American inventor Thomas Armat (1866–1948) demonstrated his motion picture projector in Richmond, Virginia, before selling it to American inventor and entrepreneur Thomas Edison (1847–1931). Several other American inventors also demonstrated their machines in the mid 1890s. The first official public exhibition of motion pictures to a paying audience in the United States was on April 23, 1896, at Koster and Bial's Music Hall, on 34th Street and Broadway in New York City. In the 21st century, there are two major socio-technological trends related to the capabilities of today's projectors: increasingly, people view and interact with media on very large screens as well as on very tiny screens. Moreover, they often do this simultaneously, which is called media multitasking. For example, someone watching a movie on television could also be checking email on a BlackBerry. Someone at a concert could also be recording the show with a Flip HD camcorder, viewing it on the device's three-inch-wide screen, and with the Flip connected to a laptop, emailing the video to friends and publishing it online to websites such as YouTube and Facebook. See also movie, silent film

**Prop** Short for property, which includes all of the movable items used on the set of a play or movie.

**Propaganda** Messages and information or intentional distortions and misinformation communicated strategically in order to influence, promote, or hurt an individual, group, organization, government, or doctrine. Labeling something as propaganda is typically pejorative (a negative put-down). See also culture jamming, optics, public relations, spin

**Prosumer** A blend of "producer" and "consumer" that describes people who participate in Web 2.0. The practice of creating and consuming user generated content (UGC) is called prosumption, a blend of "production" and "consumption." Prosumer was coined by American sociologists George Ritzer (1940–), known worldwide for his work on McDonaldization, and Nathan Jurgenson (1982–). See also Web 2.0

**Protocol** Technical standards, such as Transmission Control Protocol/Internet Protocol (TCP/IP), which enables computers to exchange information over the Internet. Each computer connected to the Internet has a unique IP address, a string of numbers, within its network. Each website also has a unique IP address, which is translated for usability purposes into a domain name, such as peterlang.com, through a domain name system (DNS) server.

**Provenance** The origin and history of a cultural artifact such as art, antiques, and literature, including who created it, where it came from, and who owned it.

**Proxemics** The study of the spatial proximity of human interactions and more broadly how people allocate and use space in their everyday lives. In diverse cultures and in different socioeconomic classes, various social norms have evolved that people typically adhere to in their interactions. Intercultural communication is fascinating and can be challenging because these social norms are anything but uniform around the world. For instance, in France it is appropriate to greet an acquaintance with a kiss to both sides of the face, while in Japan the traditional greeting is a bow from the waist. Haptics refers to how touch is used in human communication as well as how tactile (touch) sensation is used in video games, virtual reality environments, and on the touchscreens of a wide variety of electronic devices. Proxemics and haptics are both elements of nonverbal communication. See also chronemics, kinesics, vocalics

**Pseudo-Event** Also called a media event or staged news, a synthetic event contrived and staged for the purpose of gaining publicity. Six-year-old Falcon Heene's (a.k.a. Balloon Boy) fake flight in a runaway homemade helium balloon in October 2009 was a publicity stunt orchestrated by his father, American amateur scientist Richard Heene (1961–) and mother, Japanese-born Mayumi Heene. The two purportedly met in an acting class. The hoax turned into a media frenzy.

Millions of people in the United States watched coverage of the balloon flying high in the Colorado skies and worried about the boy's well-being. When the balloon finally landed no one was found in it so resources were deployed along the path it had traveled to search for the boy or his body. It was later revealed that Falcon had been hiding in the family's attic during this event and that the hoax was perpetrated because the boy's parents thought that the publicity would lead to a reality television show offer for the Heene family. The public and authorities were outraged at the parents' orchestration of this pseudo-event and at the cost of searching for the boy. The father was sentenced to 90 days in jail and 4 years of probation for the stunt. See also publicity

**Pseudonym** A fake name used to protect privacy and maintain anonymity often used in online contexts such as chat rooms. In research, investigators often assign pseudonyms to study participants even if they know the participants' real names in order to protect their privacy and maintain confidentiality. See also avatar, informed consent, pen name, persona

**Psychographics** Measurable psychological characteristics of potential consumers including their attitudes and lifestyles. Marketing and advertising professionals use this information to predict behaviors and design campaigns. See also demographics

**P2P** See peer-to-peer file sharing website

**Public Domain** Information and creative works that are not protected by copyright or patents. Works in the public domain can be used without paying royalties to anyone. A creative work whose copyright has expired is said to be "in the public domain."

**Public Opinion** The general attitude about something held by the people in a community, group, culture, or audience. Public opinion can be measured by a poll, which entails collecting and analyzing the responses to a survey of a representative sample of a population. See also agenda setting, spiral of silence, survey research

**Public Relations** (PR) Art and techniques of creating and portraying a positive image to the world and communicating effectively with stakeholders with the goal of raising awareness of something, such as a person or brand, maintaining or enhancing the reputation of

someone or something, and managing reputational risk. Public relations professionals use advertising, marketing, publicity, and networking events to achieve their goals. See also buzz, optics, press release, pseudo-event, publicity, spin, video news release

**Public Relations** (PR) **Campaign** A comprehensive, organized, researched plan for strategic communication about an issue, person, or entity that is developed by a public relations professional to support a client's specific objective or goal. See also buzz, press release, propaganda, pseudo-event, publicity, video news release

**Public Service Announcement** (PSA) *Pro bono* (voluntarily donated) advertisement produced in the United States by the Ad Council and carried for free by media outlets such as television networks and newspapers to support a cause of interest and benefit to the general public such as the prevention of drunk driving, drug addiction, and smoking. Often, celebrities or other well-known people are spokespersons in these announcements to make an even greater impact on the audience. See also advertisement, social marketing

**Publicity** Information that creates awareness of something, such as a product, brand, organization, or person. Negative publicity is unfavorable media exposure that can damage the reputation of something or someone, while positive publicity is favorable exposure. Positive publicity is typically information that has been designed and packaged skillfully to raise awareness about something and to enhance its reputation. Publicity is one of the tools that public relations (PR) practitioners use along with advertising and marketing to enhance the reputation of their clients. See also buzz, optics, press release, propaganda, pseudo-event, public relations, spin, video news release

**Publisher** Entity that produces printed material such as books, newspapers, or magazines or non-printed material such as software. Publishers are in the business of making things public. At some publications, the publisher is the chief executive while at others the publisher is in charge of certain business operations.

**Pundit** A commentator who authoritatively expresses her or his expert views and analysis in the media. However, just because a pundit said or wrote something does not mean that it is accurate. See also bias, media literacy, perspective

**Push Technology** Any system in which data is pushed to the user auto-matically rather than waiting for the user to request it, which is pull technology. In practice, users typically pre-select and authorize this data pushing in advance, for instance, by activating specific applica-tions on their computer or other Web-enabled device so that peri-odic weather, news, or stock market webcast updates appear on their screens as a screensaver, scrolling ticker, in a pop-up window, or in another presentation mode.

**Questionnaire** The written instrument of survey research. Questionnaires are sometimes used with other research methods such as experiments and participant observation to collect data. A questionnaire may contain open ended questions, closed ended questions, Likert scale questions, or a combination of some or all of these types. See also survey research

**Quiz Show** See game show

**Quotation** Also called a quote, an excerpt from a written work or speech used by a writer or speaker to make or support a point. Sometimes the quote is or becomes an aphorism, a frequently repeated adage, maxim, or proverb. In a printed piece, the name of the author of a quotation along with the date and other contextual information is usually provided so that readers can look up the source for further information. A quotation is typically marked by quotation marks at the beginning and end, like this: "Here is a saying worthy of quoting." Note that the period is placed inside of the close quote mark in this example. A comma, if that were the appropriate punctuation mark for this context because of the way that the sentence continued after the quotation, would also be placed inside of the close quote mark. However, a semicolon or colon would be placed outside. To complicate matters further, a question mark or an explanation point, which

is sometimes colorfully called a dog's cock, would be placed inside of a close quote mark if and only if it were part of the quoted material. Otherwise these two punchy punctuation marks would be placed outside of the close quote mark, like this: "Here is a saying worthy of quoting"! And, like this: "Here is a saying worthy of quoting"? A lengthy quotation is typically block indented in a separate paragraph from the rest of the piece and/or printed in a different typeface. In these cases, quotation marks are not used to mark the quote. Phew. See also informant, paraphrasing, retweet, sound bite, source

**QWERTY** The first six letters that appear on the top row of letters on the keyboard of most English language typewriters, personal computers (PC), and portable information and communication technologies (ICT) such as BlackBerry smartphones. Keyboards with this configuration are called QWERTY keyboards. Keyboards designed for users who write in other languages may have different configurations of the keys. For instance, on French keyboards the top row of letters begins with the letters AZERTY. See also BlackBerry, typewriter

**Raconteur** A compelling and skillful storyteller or public speaker.

**Radio** The first use of radio, then called wireless, was for ship-to-ship and ship-to-shore communication. Voice was first transmitted by radio waves in 1906. In 1919, the first radio station in the United States began broadcasting. American engineer Frank Conrad (1874–1941), who worked at the Westinghouse Electric and Manufacturing Company, founded Station KDKA, a homemade broadcast station, in his garage in Pittsburgh, Pennsylvania. At first Conrad broadcasted phonograph recordings twice a week. The first sponsored broadcasts began when Conrad ran out of his own records and started borrowing some from a local record store. He told his listening audience which store provided the records. Later he broadcasted amateur performers singing live. A local department store became the first advertiser. Conrad told listeners where they could purchase radio sets to listen to his broadcasts, and the model for commercial radio was born. In 2010, there were nearly 14,000 radio stations in the United States and 48 different radio station formats. Figure 6 on page 167 shows a contemporary radio. See also wireless communication

**Random Digit Dialing** A sampling technique used for polls and other types of research in which a computer generates the telephone numbers

FIGURE 6. A contemporary radio.

called to contact prospective respondents. See also public opinion, survey research

**Random Sample** A sample is a subset of a population. A random sample is one that is selected in such a way that all members of the population have an equal chance of being selected to be part of the sample.

**Rating System** Frameworks for categorizing the perceived appropriateness of movies, video games, and other media for viewing or use by people in various age groups based on the content. In response to some public calls for censorship and cleanup of the allegedly immoral content of movies, most movies produced for general audiences by major studios from the 1930s to 1968 adhered to the Hays code, which were movie industry production guidelines developed by American lawyer William H. Hays (1879–1954) for the movie industry to follow voluntarily so that there would not be a need for government censorship. The Hays code was abandoned when the Motion Picture Association of America (MPAA), composed of representatives from the world's largest media corporations such as Sony and Disney, developed a new rating system. The MPAA rating system now classifies movies into five categories:

**R**

G   General audiences. All ages admitted.

PG   Parental guidance suggested. Some material may not be suitable for children.

PG-13   Parents strongly cautioned. Some material may be inappropriate for children under 13.

R   Restricted. Children under 17 require accompanying parent or adult guardian.

NC-17   No one 17 and under admitted.

A movie or video game's rating helps determine where and how it is advertised, which ultimately influences the size of the potential audience. Some newspapers will not run advertisements for movies rated NC-17, for instance. Rating systems can be controversial because the way that they classify violent and sexual content is necessarily based on a limited number of people's viewpoints, that is, the viewpoints of the people who developed the system, and some constituencies disagree with the rating criteria. For example, in movies rated PG-13, it is acceptable to show almost all kinds of violence but unacceptable to show even the most innocent of sexual content. According to some critics of the MPAA rating system, it is makes no sense that in a PG-13 movie it is acceptable to show someone slashing a woman's breast with a knife, but it is unacceptable to show someone kissing a woman's breast. The Entertainment Software Rating Board (ESRB), a non-profit regulatory body for the gaming industry, has a two-part rating system for computer, Internet, and video games that includes a letter rating that indicates the ages for which the game is appropriate as well as standardized content descriptors, such as "blood and gore," "crude humor," "cartoon violence," "real gambling," "sexual violence," and "use of drugs." The ESRB rates games sold in North America in six categories based on their content:

EC   Early Childhood. Appropriate for people ages 3 and older.

E   Everyone. Appropriate for people ages 6 and older.

E10+   Everyone 10+. Appropriate for ages 10 and older.

T   Teen. Appropriate for ages 13 and older.

M   Mature. Appropriate for ages 17 and older.

AO   Adults Only.

Media research has shown that many video games rated E, appropriate for people ages 6 and older, contain significant violence. Media watchdogs urge parents and guardians to prescreen the media that their children view and use, including movies and video games. This good advice is a challenge to put into practice because video games are ubiquitous and children can play them in so many different contexts without parental supervision. Some Web browsers and televisions can restrict access to websites, movies, and other content based on ratings. This requires parents and guardians to enable access restriction settings on their computers and cable and satellite boxes. See also Arbitron ratings, Nielsen ratings

**Ratings** See Arbitron ratings, Nielsen ratings

**Read Receipt** An alert message activated by an email message sender so that the sender is informed when the recipient opened the email message. Of course, opening an email does not guarantee that it has been read. Some email applications give the recipient the option to return or not return the read receipt alert. In the latter case, the sender will not know if the message has been opened. See also delivery receipt

**Real Time** A synonym for synchronous, which means live as an event is actually occurring, as opposed to being recorded and then broadcast at a later time. The opposite of real time is asynchronous. Real-time communication includes: conventional or voice over Internet protocol (VoIP) calls (that is, speaking to someone on the other end of the line rather than leaving a voicemail); two-way amateur radio, also known as shortwave or ham radio; instant messaging (IM); Internet Relay Chat (IRC); short message service (SMS) texting, teleconferencing, and videoconferencing. The term real time is a retronym. See also placeshifting, retronym, timeshifting, twenty-four-hour news

**Reality Television** Television show genre in which non-professional actors who do not know one another from other contexts are brought together, typically in staged settings where they interact in a supposedly unscripted manner. Many more hours of raw footage are recorded for an episode of a reality show than for a scripted show, sometimes twice as many hours—200 hours of footage for a 44-minute-long reality show. The reason that so much footage is needed for reality shows is that the editor must splice scenes together to make the episode interesting enough to keep the audience's attention. In other words,

the editor must construct each episode of the show. Although reality shows are supposedly unscripted, they have planned storylines. For example, product placement/integration agreements with advertisers influence the brands and products that appear on the screen as well as the content of episodes. Examples of American reality shows include ABC's *Cops,* about the activities of actual police officers on-duty, and MTV's *The Real World,* which depicts the conversations and events that unfold when eight strangers live together in a house over an extended period of time while their lives are recorded. First broadcast in 1992, *The Real World* is currently the longest-running show on MTV. The genre of reality shows has proliferated because it costs less to produce these shows than other types of shows, which require larger budgets in order to pay professional actors and script writers. The popularity of the reality television format hinges on the fact that it offers the prospect of fame to ordinary people. In the digital age, media and communication technologies have made the documentation and broadcasting of everyday life up close and personal easy and commonplace. People seeking reality television fame have gone to outrageous lengths. The Balloon Boy hoax, a pseudo-event staged on October 15, 2009, in Fort Collins, Colorado, by the parents of the then-6-year-old Falcon Heene, is an example of the allure of fame in a culture that reveres celebrity. In many cases, people have become famous simply for being part of reality television shows and not because of any special talent that they have or special achievement or contribution that they have made. This phenomenon is called status conferral. In some cases, reality television programs have showcased people with genuine talent who have subsequently gone on to significant careers in the media or made significant social contributions. These achievements were at least partly bolstered by the fact that they had been exposed to a national or even international audience via reality television. See also celebrity

**Receiver** A person who receives a message, also called a recipient, or the component of a device such as a telephone or television set that receives communication messages or signals and transforms them into a perceptible format, such as audio or video.

**Record** Sounds recorded on a storage medium that can be played on a media player, such as an MP3 player like the iconic iPod, turntable,

compact disc (CD) player, or cassette tape recorder. In 1877, American inventor and entrepreneur Thomas Edison (1847–1931) thought his phonograph would be useful as a telephone answering machine. He did not anticipate that people would enjoy listening to pre-recorded music on mass-produced records. This illustrates that technology developers and proponents are often not the best predictors of how their technologies will be received, reshaped, and put to use by others. German-born American inventor Emile Berliner (1851–1929) made the first sound recordings on flat discs in 1888. By 1910, music players called Victrolas were replacing pianos as entertainment devices in people's living rooms. By the 1940s, magnetic tape technology developed in Germany allowed for the recording and mixing of multiple tracks of sounds on tape. Sound recording standards were established in 1953. Vinyl albums called LPs (for long-playing) turn at 33 $^1/_3$ rpm (revolutions per minute). Smaller vinyl discs that contained one song on each side, that are called singles or 45s, rotate at 45 rpm. Cassette tapes and portable tape recorders were introduced in the 1960s, followed by compact discs (CD) storing digital information on optical discs in the early 1980s, and MP3 files, which are compressed digital audio files, in 1999. In analog recordings, sound is captured on the grooves of a vinyl record or on a continuous band of magnetic tape. In contrast, in digital recordings, such as those on a CD and MP3 file, sound waves are translated into binary (on-off) pulses of numerical code. MP3 files can be played on computers as well as on many car audio systems, home audio systems, portable digital media players, and mobile phones. See also bootleg, dubbing, jukebox, piracy, taper

**Recording** A copy of something such as a lecture, music, or video stored on a memory device such as a vinyl album (LP), compact disc (CD), film, or DVD that can be archived and played at a later time. See also bootleg, dubbing, placeshifting, piracy, taper, timeshifting

**Recording Industry Association of America** (RIAA) Music label trade organization that is headquartered in Washington, D.C., whose mission is to protect the intellectual property and First Amendment rights of artists and music labels and fight music piracy though education, technological innovations, and legal means. The RIAA tracks music purchasing trends in the United States. Since 1958, the RIAA has

certified music recording sales achievements for gold records, those albums that have sold 500,000 copies. In 1976, it began honoring platinum records, those albums which have sold a million copies. In 1999, it began honoring diamond albums or singles, which have sold 10 million copies or more. See also bootleg, copyright, piracy, taper

**Reliability** In research, repeating the same study and achieving the same or close to the same results indicates that the findings are consistently accurate, that is, that the measures in the study have high reliability. If the findings from the repeated study are dissimilar, low reliability in the scales, tests, and/or measures is indicated. See also validity

**Remix** A blend of media, such as music, drawing on multiple sources to create a new work. See also mashup

**Rerun** The re-broadcast of a television show or other recorded event. See also evergreen, syndication

**Research Method** See method

**Research Question** Question that guides and underpins a research project. See also hypothesis

**Resolution** The level of detail in an image or communication signal. In printing and digital photography, on-screen image resolution is measured in the number of pixels per square inch (PPI). More pixels means more digital information and a sharper, better quality image. The printed output of images is measured in dots per inch (DPI). In analog video, the screen resolution is based on the number of horizontal lines. In digital audio, the sound resolution is based on the number of samples of sound per second.

**Respondent** A person who participates in a study such as a survey. See also survey research

**Response Bias** The concept that participants in research studies will often try to answer questions in the way that they think is most socially acceptable and/or the way that they think will please the researcher(s). Their answers may also be influenced by the context of the study or an external event. In other words, research participants do not always provide their most honest answers to questions. See also experimenter effect, observer effect

**Response Rate** Also called the completion rate or return rate, the proportion of people who respond to a survey. If 560 people complete a questionnaire that researchers sent to a sample of 1,000 people, the response rate would be 56%. It is calculated like this: 560 divided by 1,000 = 0.56 or 56%. See also survey research

**Retronym** Neologism (new term) created to differentiate the original version of a technology from a newer version. Rotary dial telephone (see Figure 7), snail mail, real time, manual typewriter, and acoustic guitar are retronyms. See also acronym, built-in obsolescence, pseudonym, synonym

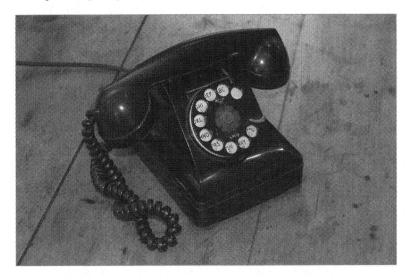

**FIGURE 7.** The author's 1937 rotary dial telephone made of Bakelite. This phone still works! Its non-adjustable ringer is exceptionally loud. If the handset were dropped on a person's toe, the toe would break, not the handset.

**Retweet** The practice of forwarding someone else's tweet to one's own Twitter followers. Also, the actual message forwarded. As is the case in most realms, there is retweeting etiquette. Twitter pros retweet discerningly; tag with the label "RT:" or "Retweeting:" or "Reading:"; credit the original author, as a retweet is a form of quotation; succinctly describe the content; and then add the hyperlink. See also netiquette, noise, spam, Twitter

**Reverberation** Also called reverb, in acoustics, how much time it takes a sound to stop bouncing off objects such as room walls. Reverb is a sound effect produced by a reverb unit, also called a delay unit, used by sound engineers to make audio recordings or live performances such as concerts sound fuller, that is, to make it seem like the sounds are happening in very large spaces.

**Rhetoric** The technique, art, and style of effective expression and persuasion through oral or written language that is logical, compelling, and geared to an intended audience. The roots of rhetoric go back to the ancient Greeks. See also persuasion

**RIAA** See Recording Industry Association of America

**Rough Cut** In moviemaking and sound recording, an early edited version that is not meant to be the final version. Various stakeholders in a media production such as the director and producer review and critique rough cuts and then suggest changes and enhancements for the editor to make. See also final cut

**Royalties** A percentage of the sales revenue per unit of an item sold that is paid to the creator of intellectual property or the copyright holder. Mechanical royalties are the fees paid to the publisher or writer of a song for each copy of the song sold. In the book industry, a publishing agreement, also called a book contract, between a publisher and author specifies the percentage of the net income from sales that the publisher will pay the author. In the music industry, the agreement between a record company and artist that specifies details about royalties, among other things, is called a record contract. See also advance, bootleg, copyright, intellectual property, piracy, taper

**RSS** Technology that automatically pushes Web content of RSS feeds to subscribers' computers or mobile devices. The acronym refers to several different technology standards, including: "RDF Site Summary" (RSS 0.9 and 1.0); "Rich Site Summary" (RSS 0.91 and 1.0); and "Really Simple Syndication" (RSS 2.0). See also push technology, user generated content, Web 2.0

**Sample** In research, a part of something that offers information about the whole that it comes from, which is referred to as the population, because it is representative of that whole. Even samples that are random samples will not yield absolutely perfect data. They have a degree of sampling error (SE), also called standard error, which is indicated in reports about the research findings as a plus or minus percentage margin of error, such as +/- 3%. Knowing the sampling error in a research report such as an Arbitron or Nielsen rating report or a public opinion poll is important because it indicates the degree to which people can be confident that the results of the study are not due to error or chance. In music, a sample is a sound clip from another piece of recorded music that is used to create a new work. See also descriptive statistics, inferential statistics, mashup, remix

**Sampling Plan** In research, the procedure for obtaining a sample, which is a subset of a population. The plan takes into account the expected response rate. See also descriptive statistics, inferential statistics, response rate

**Satellite** A craft launched into space that orbits the Earth. A communications satellite provides communication services such as television and radio broadcasts, microwave radio relay to complement underwater communication cables, and mobile communication to

vehicles such as cars, ships, and airplanes. Forty-four percent of the satellites launched now are for commercial uses. Most of the revenue that satellite companies earn is from television. See also broadband Internet, satellite radio

**Satellite Radio** Also known as Satellite Digital Audio Radio Service (SDARS), digital radio signals received directly from communications satellites that orbit the Earth or indirectly via Earth-based repeaters. Satellite radio programming can also be received through Internet connections. Compared to conventional land-based radio broadcasts, satellite radio signals are clearer (static-free) and can reach a wider geographic area. Using a business model similar to that of cable television, satellite radio requires a paid monthly subscription as well as a special receiver that is not yet a standard component in all or even most cars, homes, smartphones, or other devices or places. Satellite radio receivers are installed in many new cars. They are also available in some airplanes in the cockpit for pilots' use, especially for weather reports, as well as in the cabin for passenger entertainment. Satellite radio receivers can be purchased for home use. Many satellite radio channels are also accessible online to subscribers. XM and Sirius are the two satellite-based digital radio services available in the United States and Canada. Satellite radio channels transmit entertainment, music, news, weather, and, in contrast to conventional radio broadcasts, few commercials. XM and Sirius, which merged in 2008, are owned by Sirius XM Radio, Inc. See also AM/FM, subscription

**Satire** Caustic (biting) humor that deliberately employs exaggeration and irony to criticize, mock, or ridicule someone or something. Satire can backfire when it is interpreted literally, rather than as humor, because texts can have multiple meanings for audience members, a concept known as polysemy. Audiences have to be savvy enough to understand and appreciate the irony in a satire. Irony is a rhetorical strategy in which something ridiculous is said that is intended to mean something else that is typically the opposite. Sarcasm is a potent and often insulting form of irony. In the United States, the movies *Thank You for Smoking* (2005) and *Borat* (2006), television cartoons *The Simpsons* and *South Park,* and television programs *The Colbert Report* and *The Daily Show with Jon Stewart* are satirical. Parody is related to satire. A parody is a mocking imitation of something, such

as a television commercial, movie, or person. Parodies are also called spoofs or lampoons. The American television program *Saturday Night Live* parodies television commercials, news, celebrities, and politicians in skits. See also polysemic

**Scareware** Also called rogueware and fake antivirus software, scareware is malicious software that masquerades as antivirus software in order to trick people into revealing their credit card information to pay for a fraudulent service. Users are instructed to run the software to scan their computers. They are then told that their machines have a virus and that the software will clean their machines of the virus for a fee that needs to be paid by credit card. Scareware also removes legitimate antivirus software from infected machines. Computer security experts estimate that over three percent of all personal computers (PC) worldwide are infected with scareware every month, netting cybercriminals more than $400 million per year. See also adware, cracker, cybercrime, social engineering

**Scenery** The backdrop and decorations for a play, movie, television show, or other media production.

**Screenplay** Also called a master-scene script, a comprehensive blueprint for a movie or television show that describes all of the elements of the production and includes the dialogue. The terms script and screenplay are not interchangeable, though a screenplay is a form of a script. The word script is used in the media industries as well as in computing to describe a set of instructions.

**Screensucking** American psychiatrist Edward M. Hallowell (1949–) coined this term to describe the activity of aimlessly surfing the Internet or watching television. Screensucking refers to the sometimes unintentional as well as unnoticed wasting of time looking at large and small screens, including televisions, computers, and mobile phones. See also crackberry, Internet addiction disorder

**Script Doctor** Writer who improves the script of a media production that was written by someone else. See also ghost

**Search Engine** Computer program that scans and indexes computer databases and the Web in order to gather and report information on any topic that is keyword searched. Search engines generate reports with hyperlinks to the information of interest. Google has become

such a popular search engine on the Web that the term "to Google" something or someone has become synonymous with the activity of keyword searching online for information about something or someone, much the way that "to Xerox" something is a common way of referring to making a photocopy, even when a machine made by a company other than Xerox is used. Search engine optimization is the process of organizing a website to maximize the number of visits it will receive, for instance, by strategically embedding keywords in the Web pages so that they are likely to get indexed by search engines as they scan the Web over and over again, cataloguing its contents. See also genericized trademark, Google, Yahoo!

**Secondary Source** See source

**Selective Attention** The human tendency to not pay attention to messages and texts that conflict with prior held beliefs and values. See also selective exposure, selective retention

**Selective Exposure** The human tendency to pay attention to messages and texts that align with prior held beliefs and values. See also selective attention, selective retention

**Selective Retention** The human tendency to hold onto messages presented in media texts that align with prior held beliefs and values, thus reinforcing these ideas. In contrast, messages that conflict with prior held beliefs and values are typically not retained. See also selective attention, selective exposure

**Semiotics** Also called semiology, the study of all kinds of signs, which are verbal and nonverbal representations of things. French philosopher, social critic, and literary theorist Roland Barthes (1915–1980) and Italian philosopher, literary critic, and novelist Umberto Eco (1932–) are two seminal semioticians. See also code, cultural symbol, language, nonverbal communication, symbol

**Sender** A device or person that communicates a signal or message to a receiver or recipient.

**Sequel** See prequel

**Server** A host computer that other networked computers called clients connect to in order to access resources on it such as files, Web pages, and programs.

**SESAC** Performing rights organization formed in 1930 and headquartered in Nashville, Tennessee, that represents songwriters and publishers with the goal of making sure that they are compensated when music of which they are copyright holders is performed in public in the form of full-length songs, commercial jingles, and theme and background music on television shows and in movies. Performances of registered compositions are tracked by the organization and then the artists and creators are paid royalties. SESAC's original name was Society of European Stage Authors and Composers but SESAC is no longer an acronym. See also airplay; American Society of Composers, Authors and Publishers; bootleg; Broadcast Music, Incorporated; copyright; piracy

**Seven Dirty Words** American stand-up comic George Carlin's (1937–2008) "Filthy Words" comedy routine led to a public debate about censorship and was part of the landmark U.S. Supreme Court case in 1978 (FCC v. PACIFICA FOUNDATION, 438 U.S. 726) that established indecency regulation in U.S. television and radio broadcasting. The original seven dirty words in Carlin's comedy routine about what supposedly could never be said on television and radio were: shit, piss, fuck, cunt, cocksucker, motherfucker, and tits. See also censorship, obscenity

**Sexting** A blend of "sex" and "texting." The practice of exchanging flirty or lewd messages and/or nude or partially nude photographs via communication devices such as mobile phones. See also short message service

**Shareware** Copyright-protected proprietary software that is available for trial use without a charge for a limited time, typically 10 days to 2 months. Not all of the features are included in the trial version. Mechanisms in shareware make it inoperable after a certain time period. If users like the software and want to keep using it, they have to buy the license for it. See also freeware, software license

**Shield Laws** See journalist shield laws

**Short** In the movie industry, a brief film, typically less than 30 minutes long, that is not a feature film. In publishing, a brief magazine or newspaper article. In electronics, short is short for short circuit (s/c),

a faulty circuit, a potentially damaging and hazardous situation that is the opposite of an open circuit.

**Short List** In any competitive situation where different choices are available, the narrowed-down list of finalists. Actors selected by a casting director as finalists for a movie part, for example. Those that do not make a short list are said to have been "cut."

**Short Message Service** (SMS)  Also known as text messaging or texting, SMS was developed in the 1980s and has become an unanticipated worldwide mobile communication phenomenon. People in Japan were early adopters because a text message cost less than a phone call. Messages are limited to 140 characters so people invent and use a lot of abbreviations and acronyms like this: How r u? LOL. C u 2morrow. This translates to: "How are you? Laughing out loud. See you tomorrow." Text messages are of similar length to the typical postcard message. In the United States, the number of text messages sent daily now exceeds the number of telephone calls. Some people send thousands per day. Text-messaging technology is being used innovatively in a wide range of contexts. In addition to one-to-one interpersonal communication, text messages are used for mobile advertising. In one Massachusetts town, SMS technology was installed in trashcans in public places. Text messages notify public workers automatically when the cans are full, facilitating more efficient trash collection. Pharmacies have automated systems that text people when their prescriptions have been filled and are ready for pick up. Airlines send automated text messages to passengers when flight itineraries have been changed. Some banks send automated text messages to customers to alert them when accounts dip below a predetermined amount. Texting enables people to multitask—to eat with one hand and text with the other. It also allows people to send messages inconspicuously and quietly, for instance, while in a face-to-face (F2F) meeting or at a concert. Students sometimes send text messages to one another in class. It is the 21st-century equivalent to passing notes. When students are adept at texting, they do not need to look at the keys and can hold their phones under their desks, which may be out of the instructor's sight, but not necessarily out of the instructor's perception. An unintended consequence of texting is that it seems to be contributing to an increase in cyberbullying.

Another unintended consequence is the rise of sexting, which is the exchange of flirty or lewd messages and/or nude or partially nude photographs via communication devices such as mobile phones. Shockingly, nearly half of all teenagers reported in 2009 that they text while driving, which is leading to an increase in accidents caused by driving while intexticated, a form of distracted driving. See also acronym, Controlling the Assault of Non-Solicited Pornography and Marketing Act of 2003

**Shoulder Surfing** The practice of looking over someone's shoulder while the person accesses a computer system. A shoulder surfer can be close to the targeted person or far away, using binoculars or a camera with a zoom lens to watch the person's keystrokes as the user identification (ID) and personal identification number (PIN) are entered into a system. This information is stolen in order to gain unauthorized access to a computer system and/or the person's accounts. See also cracker, cybercrime

**Show Business** Sometimes shortened to show biz, a synonym for the entertainment industry, which includes music, film, radio, television, circuses, theater, and other types of performances.

**Sign Language** See American Sign Language

**Signal** Information transmitted using any type of communication channel, for example, a hand gesture made to catch a friend's attention across a crowded room, a ship-to-shore radio distress call using Morse code, or a television news broadcast.

**Signature File** A short text file created by an email user that is automatically appended at the end of email messages before they are sent. A signature file typically includes the user's full name, title, landline and/or mobile phone number, fax number, and website address (URL). Some people also include in the signature file an image, motto, or quotation after the contact information. Email systems allow users to create and label multiple signature files. Users can select which file, if any, to append to a specific email message before it is sent. For instance, a close friend probably does not need to receive a signature file containing the sender's full name and professional contact information, so the user might not select any signature file in this case.

**Silent Film** Until the 1920s, motion pictures were silent, but only in terms of spoken dialogue. They typically were accompanied by live or recorded music that accentuated the storyline, and they had subtitles, that is, the dialogue appeared in words at the bottom of the picture. The 1927 film, *The Jazz Singer,* starring Russian-born American singer, comedian, and actor Al Jolson (1886–1950), was the first full-length commercially successful motion picture with sound, known as a talkie. It ushered in a new era in the movie industry. Some successful silent film actors with unattractive voices were unable to transition to this new format with sound, and their acting careers fizzled. This parallels what happened later to some successful radio actors with the spread of television. While many were hired to work in the new medium, others were denigrated cruelly as having "faces for radio." See also movie, talkie

**Silhouette** In printing, to remove the background details from a half-tone cut.

**Silver Screen** A synonym for movie and the movie industry. See also Hollywood

**SIM Card** See subscriber identity module card

**Simulcast** A blend of "simultaneous" and "broadcast." A broadcast of something on more than one medium at the same time, such as television and radio. The content of simulcasts ranges from live political speeches to concerts to pre-recorded television shows.

**Skype** A peer-to-peer telephone and videoconference service that uses voice over Internet protocol (VoIP). The company was founded in 2003 by Swedish entrepreneur Niklas Zennström (1966–) and Danish entrepreneur Janus Friis (1976–). According to Skype officials, there were an estimated 560 million registered users at the end of June 2010. Skype allows users to make voice and video calls, including conference calls, as well as to send instant messages (IM), transfer files, and share screens with other users on the Skype network for free. Skype users can also call to and from landline telephones and mobile phones for a charge. As of 2011, Skype users could choose to pay as they talk for 2.3¢/minute in U.S. dollars, depending on where they were calling to and from, or pay less per minute with a Skype subscription of $1.09 per month. In 2010, on the days leading

up to Christmas, so many people connected to the service that the technology was overloaded, making it unavailable for millions of users around the world.

**Slander**  A malicious or defaming statement that is the spoken equivalent of libel, which is written.

**Sleeper**  A movie, book, album, or other media product that is not an immediate commercial success but that later becomes popular to an unexpected degree.

**Sleeper Effect**  A media effect that emerges after exposure to a media message but not immediately afterward. It is a delayed reaction.

**Slogan**  A succinct, memorable phrase used in a message or advertisement, such as Nike's "Just do it," which captures the essence of the product or brand being sold. Slogans are also used in political campaigns to galvanize supporters. The slogan "Yes we can" was used in U.S. President Barack Obama's (1961–) 2008 presidential campaign. A proposed marketing slogan for the practice of embedding radio frequency identification (RFID) technology in people's bodies was "It's hip to be chipped."

**Smartphone**  A Web-enabled, handheld, battery-operated device that can be used as a telephone and also for many other purposes, including for using Internet and Web-based applications. Smartphones can do so much more than the earliest mobile phones, which could only be used for voice telephone calls, that they have become the Swiss Army knife of life in the 21st century for many people worldwide. The BlackBerry and iPhone are iconic smartphones. See also application, augmented reality technology, global positioning system, jailbreak, location-based applications, mobile phone

**Smiley**  :-) and many more typed characters used creatively in text-based messages such as email to convey facial expressions and emotions. See also emoticon

**Smishing**  Short for short message service (SMS) phishing. When cybercriminals send deceptive text messages to people asking for private information with the intention of perpetrating fraud against the intended victims. The messages are designed to appear as if they are

from legitimate businesses, organizations, or government agencies. See also cybercrime, social engineering, vishing

**Snail Mail** A letter or other communiqué sent in a physical format through the postal service in contrast to a letter or other text sent practically instantaneously in an electronic format over the Internet via email or over telephone lines via a fax. The term humorously underscores that it is much slower to communicate by sending messages via the postal service than by electronic means. Snail mail is a retronym.

**Snowball Technique** Also called snowball sample or snowball sampling, an approach for recruiting people to participate in a study that entails asking each participant to recommend one or more people for the researcher to try to recruit, and so on, until a sufficient number of participants have been recruited.

**Soap Opera** Serial dramatic show genre first popularized in the 1930s in the United States on the radio, which ran five or six days a week in 15-minute episodes. The genre was adopted by television in the 1950s. The storylines are typically open ended, which allows for long-running series. One soap opera, *Guiding Light,* began as a radio show in 1937 and then successfully migrated to television in 1952. The name of the genre refers to the early sponsors, soap companies. These shows are also called daytime dramas, because they were originally broadcast during the day. Housewives were the target audience of the early soaps in the United States, but over the years various programs in the United States and in different countries have been aimed at more diverse audiences in terms of gender, age, race, socioeconomic status, and ethnicity. Critics have pointed to the low production values in many soap operas, including amateurish acting and inexpensive sets. Nevertheless, soap operas remain a popular television genre worldwide because of the real-life psychological, medical, and social problems that the characters in the shows confront. Soap operas focus on relationships among characters rather than on action-packed plots. This genre tends to have loyal fans who feel remarkably connected to the characters in the shows that they watch and tune in five days a week, or as often as the shows are broadcast, year after year. Researchers call these types of connections, that members of an audience develop with television characters, parasocial relationships. See also fan

**Social Engineering** The art of subtly manipulating or conning people. With social engineering, people are nudged in a certain direction so that they take certain actions, such as clicking on a link on a website in order to view a video about a product. See also adware, cybercrime, phishing, scareware, vishing

**Social Learning Theory** Theory tested and popularized by Canadian psychologist Albert Bandura (1925–) that argues that people observe and imitate what they see, learning values, how to behave, and how to react by observing others, in the case of children, especially by observing adults. Proponents of this theory argue that there is a link between viewing media violence and aggressive behavior. Critics argue the opposite, saying that if there were a link, there would be a lot more violence than there is, based on the proliferation of violence depicted in television shows, movies, video games, and so forth. Further, some critics of this theory suggest that there may be a catharsis effect of viewing violence in the media, that is, that vicariously experiencing mediated violence might help some people to purge themselves of violent emotions. See also theory

**Social Marketing** Communication endeavors that draw on the techniques of marketing and social science in order to persuade people to make beneficial long-term behavioral changes. Social marketing campaigns focus on issues such as wearing sunscreen to reduce the risk of skin cancer and not smoking. Social marketing and social media marketing are not the same things. See also social media marketing

**Social Media** Any medium that encourages users to interact with it and other users. Examples include blogs, YouTube, Wikipedia, Facebook, and Twitter. See also social networking website, Web 2.0

**Social Media Marketing** The practice of creating a buzz about a person, brand, or product through social media such as blogs and the microblogging service Twitter. If the message (or links to it) spreads quickly from person to person to person, in other words, if it "goes viral," the marketing impact can be tremendous. This marketing approach costs little or no investment of marketing dollars and resources. Social media marketing is not the same thing as social marketing, though social marketing campaigns sometimes leverage the power of social media to spread their messages. In some corporations, sales associates

are encouraged to use social media to promote their company or store to attract customers. See also social marketing, social media

**Social Media Presence** Just as having an online presence means that an entity has a website, having social media presence means that an entity participates in social media such as the social networking website Facebook and the microblogging service Twitter. More and more businesses, organizations, news outlets, celebrities, and everyday folks are developing their own social media presence.

**Social Networking Website** A Web-based service that allows individuals to develop and post profiles, which can be accessible to the public or by invitation only, to post a list of their associates, and to connect with other users of the website with whom they share a connection. The earliest were developed in the late 1990s. Specialized social networking websites are aimed at different communities and designed for diverse purposes: people of specific ethnicities, nationalities, sexual orientations; fans of a particular band; even people with the same illness who share intimate details about symptoms, diagnoses, treatments, and biometric data, crowdsourcing information and support from other patients like them. People use social networking websites for community building, maintaining friendships, professional networking, information seeking, and dating. LinkedIn, for example, is aimed at professionals who want to share business contacts with other professionals. Many businesses, organizations, and news media use social networking websites, especially the highly popular Facebook, which surpassed 500 million registered members in 2010, to promote their endeavors and connect with their constituencies. See also Facebook, Facebook stalker

**Soft News** See news

**Software** The programs that direct what computers do, as contrasted with the physical computer machinery, components, and peripherals such as mice, keyboards, external hard drives, and so forth, which are hardware. See also application

**Software License** Also known as an end user license agreement (EULA), a legal agreement between the creator or publisher of software and the user that stipulates that the person can use the software as long as the conditions in the EULA are followed. See also copyright

**Soldier**  Slang for an explanation point!

**SOS**  International emergency distress call that is sometimes said to be an acronym for "save our ship" or "save our souls," though it actually does not stand for any particular phrase. Rather, SOS was selected because the letters are easily signaled in Morse code like this: ". . . --- . . ." See also code, telegraph, wireless communication

**Sound Bite**  The spoken equivalent of a written quotation in a newspaper or magazine. Radio and television news broadcasts typically incorporate short sound bites into stories. See also quotation

**Soundtrack**  All of the dialogue, sounds, songs, and background music in a movie or other type of media production.

**Source**  In research and journalism, the person or resource, such as a written document, that supplies information, ideas, or quotations. More generally in communication, the originator of any message. A primary source is a historical document or a creative work such as a novel or movie that a researcher could analyze and interpret. A secondary source is a work that draws on and discusses primary sources, for example, a biography that uses and analyzes a person's diary. An original source is the first version of something, as opposed to a copy. Source credibility is the perceived expertise and trustworthiness of a source. It influences how people respond to and interpret messages and information from a source. See also interview, journalist shield laws, peer reviewed journal, quotation, trade publication

**Source Code**  The underlying programming instructions of a computer program. See also application, freeware, open source software, shareware

**Spam**  Unsolicited bulk email (UBE) that often tries to advertise or sell something to recipients. At its best, spam is an annoyance because it clogs email inboxes and wastes people's time as they sift through and delete it. At its worst, spam can contain a damaging computer virus. A spam filter, also called anti-spam filter, is software that automatically inspects all incoming email messages, assessing them based on certain criteria to see if they are likely to be legitimate or not before they are placed in the recipient's email inbox. Messages suspected to be spam are quarantined or placed into the junk mail folder or destroyed, depending on the type of spam filter used. But spammers often cleverly use spamouflage such as intentional

typographical errors to bypass spam filters. Because spam filters are not 100% reliable, legitimate messages are sometimes sent to junk mail folders by mistake, and spam sometimes makes its way to the inbox. For this reason, it is important for email users to periodically review the contents of their junk mail folder to search for legitimate messages that do not belong there and add legitimate senders to their whitelist. Also, email addresses that send spam messages undetected by the filter can be added to the user's blacklist for future filtering. Some spam deceptively uses email spoofing of the header information so that the message appears to have been sent by someone or by an entity, other than the actual sender, that would look familiar to the recipient. If the email recipient recognizes the supposed sender's name or organization in the header, she or he is likely to open the message and possibly even comply with its instructions, even if those instructions specify that the recipient needs to click on a link and then provide private information, such as passwords and account numbers. It is relatively easy for criminals to perpetrate scams online because many people are inclined to follow instructions unquestioningly if they perceive them as coming from legitimate organizations or from people in authority positions. See also blacklist, Controlling the Assault of Non-Solicited Pornography and Marketing Act of 2003, junk mail folder, social engineering, spoof website, whitelist

**Spamouflage** See spam

**Speakerphone** A telephone feature on many landline and mobile phones that allows people to have conversations over the phone without holding a handset or wearing a headset.

**Special Effects** Enhancements to movie images and sounds and photographs that creators use to help tell the story they want to tell. Three-dimensional (3-D) images are an example. They provide viewers with a realistic perception of depth.

**Specs** Short for specifications. A detailed, often technical description of something.

**Spin** The practice of presenting information from a particular point of view strategically in order to achieve certain goals. Public relations (PR) professionals are sometimes called spin doctors. To put a spin on something, whether it is a tennis ball or a news story, means

manipulating it to alter its trajectory. Disc jockeys spin (play) records on radio shows and at parties, weddings, dances, clubs, and raves. See also optics, propaganda, public relations

**Spin-Off** In television, a program derived from an existing or earlier show that incorporates one or more characters from the existing show. Spun-off shows sometimes spin-off additional shows. *Dr. Phil* is a spin-off from *Oprah. Bionic Woman* was a spin-off from *Six Million Dollar Man. Frasier* was a spin-off from *Cheers. Maude, Archie Bunker's Place, Gloria,* and *The Jefferson's* were all spin-offs from *All in the Family.* See also dingbat

**Spiral of Silence** German political scientist Elisabeth Noelle-Neumann's (1916–2010) 1974 model of public opinion that explains how people who believe that they hold opinions on controversial issues that are deviant from the majority norm will be disinclined to voice their minority views, and/or will change their views to conform to the dominant opinion out of fear of isolation because of nonconformity. As dominant views are repeatedly expressed and reinforced in the mass media, people with opposing viewpoints become increasingly quiet about their opinions. Moreover, when the media portray and reinforce viewpoints that are not majority viewpoints they can create false majorities while actual majority positions remain unexpressed. See also public opinion, theory

**Spoof** See parody, satire, spoof website

**Spoof Website** A website that deceivingly mimics the website of a legitimate organization, business, or agency. Spoof websites are often used in phishing scams to obtain personal information from people such as social security numbers, user identification (ID) numbers, and passwords for use in cybercrimes. Phishing emails and smishing text messages often contain hyperlinks to spoof websites. A spoof website can also be one that satirically lampoons a legitimate website for the fun of it rather than for a malicious reason. See also cybercrime, social engineering

**Spyware** Software that Internet users unknowingly download to their computers that collects data about users and their browsing behavior for advertisers or other interested parties. See also cybercrime

**Status Conferral** See reality television

**Status Update** Using Twitter, Facebook, and other social software applications, individuals post messages called status updates to instantly communicate with many people, including friends, acquaintances, and total strangers, their whereabouts, what they are doing, and what they are thinking. On the microblogging service Twitter, these messages are known as tweets and are limited to 140 characters. Because social software applications make it easier than ever for interested parties to literally follow a target's every move in order to monitor, harass, or cause physical or emotional harm, concerns have been raised about the reduction of personal privacy and enhanced ease of cyberstalking. On a more benign level, if a group of friends are constantly reading real-time updates online about what everyone is doing, there will be no new news for them to share with one another when they meet face-to-face (F2F). See also Facebook, Facebook stalker, short message service, Twitter

**Stereotype** An oversimplified and sometimes inaccurate representation of any social identity group, which could be based on race, ethnicity, gender, socioeconomic status, religion, sexual orientation, physical appearance, profession, or other characteristic. Humor often leverages stereotypes, sometimes in a cruel way; think of all the jokes about blonde women, for example.

**Streaming Media** A compressed audio or video file that plays in real time as it is decompressed and downloaded, rather than requiring the user to download the entire file before it can be played. The software, hardware, or a combination of both that compresses and decompresses data is known by an acronym, codec, which stands for "compression/decompression." Streaming media can originate from recorded files or from live broadcast feeds. Media players, which can be part of Web browsers or plug-in programs, are required for playing streaming audio or video. In October 2010, movie rental giant Netflix announced that its approximately 17 million subscribers were streaming more media content (movies, television shows, and so forth) than they were obtaining on DVD by mail. This recent shift marks the concluding stages, but certainly not the complete extinction, of DVD usage. More and more Internet companies will join the streaming video rental business to serve consumers' desire for instant access to an even wider range of media content than Netflix

offers. But because everyone does not yet have access to a reliable broadband Internet connection, which is needed to support streaming media, there will continue to be a DVD market.

**Strong Password** In computer systems, a logon code that a computer or human cannot easily guess or decipher. A strong password typically includes a combination of uppercase and lowercase letters, numbers, and symbols and is changed periodically for enhanced security. When organizations enforce the use of a strong password to increase computer security, it is a form of password hardening. Other password hardening strategies include the use of biopasswords and biometric verification. Other means for protecting against online security breaches and fraud include two-way authentication, also called mutual authentication, a technical process in which a user's computer and a network server check one another to determine if they have a trusted connection before the user is permitted to continue to use the system. See also biometric verification, cracker, cybercrime, firewall, shoulder surfing, spyware

**Subculture** A subgroup of a population whose members are distinguished from the rest of society, based on their shared values, beliefs, ideas, interests, behaviors, language, or characteristics. See also Beat Generation, cultural symbol, fan, vernacular

**Subliminal Message** See advertisement

**Subscriber Identity Module** (SIM) **Card** Portable data storage card for a mobile phone or smartphone that holds information such as the subscriber's identity, phone number, user preferences, network authorization data, personal security keys, contact list, and text messages. A SIM card can be removed from one device and installed in another for the sake of convenience if the user's device runs out of battery power or if the user wants to switch to a new phone. A traveler can temporarily remove the original SIM card from a phone and install a prepaid SIM card with a phone number that is local to the destination he or she is visiting. Swapping the prepaid card for the original is relatively easy if the manufacturer of the device has not locked (married) the device to a specific network service provider. Businesses that provide unlocking services have sprouted up to meet this consumer need. See also jailbreak

**Subscription** Fees paid to media providers such as newspapers and cable television services in order to receive their products on a regular basis.

**Subtitles** Movie or television program dialogue that appears in written words superimposed onto the picture screen, typically at the bottom. In the United States, movies in which there is dialogue in languages other than English typically have subtitles in English. Subtitles have a long history. Many silent films had them. In print media, a sub-title is a short explanatory phrase or sentence that is often used as a secondary title after the main title of a book or article. For instance, in the book called *The Culture of Efficiency: Technology in Everyday Life* (2009), the part that comes after the colon is the subtitle. See also caption, silent film

**Supermarket Tabloid** See tabloid

**SuperSpeed USB** See Universal Serial Bus

**Surfing** Surfing the Web refers to navigating online from website to website. Ego surfing is the practice of entering your own name into a search engine. Channel surfing describes the activity of skipping from channel to channel on the television using a remote control. Shoulder surfing is peering over someone's shoulder either up close or at a distance using binoculars or a camera with a zoom lens in order to watch the keystrokes of the person's user identification (ID) and personal identification number (PIN) with the intent to steal this valuable information and gain unauthorized access to a system and/or the person's accounts. See also screensucking

**Surround Sound** Sound technology that simulates the acoustical experience of real life in which sounds are heard from all directions. Surround sound systems have multiple speakers that can be positioned to encircle listeners so that they experience the sounds from a surround sound encoded soundtrack in a more authentic way than if they listened to them from just two speakers in a stereo system. Surround sound is used in cinemas and in home and car audio and entertainment systems.

**Survey Research** Quantitative research method used to collect data directly from respondents about their beliefs, attitudes, ideologies, and behaviors through a series of strategically worded questions. Survey researchers use sampling procedures so that respondents' answers to

the survey questions are representative of the population from which the sample is drawn, for instance, all registered voters 18-years-old and older in the State of Connecticut. A random sample ensures that all potential respondents to the survey have an equal chance of being selected to participate. There are other sampling approaches used in survey research for a variety of reasons, depending on the circumstances of the research. Researchers analyze survey data in order to answer research questions. This analysis can reveal correlations (relationships or associations) between variables but cannot explain cause and effect. Written surveys are called questionnaires. The list of questions that comprise a survey is called the survey instrument or instrument. Surveys are conducted face-to-face (F2F), on the telephone, or via email or snail mail. See also response rate

**Symbol** The representation of one thing by another to stimulate meaning. A symbol can be an image, word, or gesture. An example is the White House representing the U.S. Government. See also cultural symbol, icon

**Synchronous Communication** When the sender and receiver of messages are communicating in real time, rather than timeshifting, which refers to their accessing of each other's messages at different times. Instant messaging (IM) is an example of synchronous communication, and email is an example of asynchronous.

**Syndication** Creating and providing media content for publication or reuse in media outlets as part of a paid subscription service. For example, newspapers obtain some of the news that they publish from the wire services to which they subscribe. Feature syndicates provide content such as cartoons and well-known writers' newspaper columns. Online content syndication is a growing media arena. Wire services provide content to print media and, increasingly, to websites. Television and radio shows are also syndicated. For broadcasts abroad, a new soundtrack is often dubbed with the dialogue spoken in the local language.

**Synonym** A word with the same or nearly the same meaning as another word. Here are several pairs of synonyms: carefree and lighthearted; grand and magnificent; and pal and friend. An antonym is a word that has the opposite meaning of another word. For example: wide and narrow; hard and soft; and warm and cool. A homonym is a

word that is pronounced the same way as another word or words, but is spelled differently and has a different meaning. For example: ad and add; ant and aunt; ark and arc; base and bass; and fishing and phishing. A heteronym is a word that has one spelling but different meanings depending on how it is pronounced. For example: bass (fish) and bass (musical instrument); lead (metallic element) and lead (to guide); produce (to bring forth) and produce (vegetables). Heteronyms are particularly challenging words for non-native English speakers to differentiate when reading. See also acronym, eponym, neologism, pseudonym, retronym

**Tabloid** Popular magazines printed on newsprint paper so they look like newspapers. Tabloids are descendants of the sensationalistic and sometimes unscrupulous yellow press of the late 19th century. They are also called supermarket tabloids, because they are staples on supermarket check-out line shelves where customers waiting in line scan the shocking headlines and bizarre photos on the front page and are enticed to buy the tabloid on impulse. Tabloids lure readers with scandalous, fake, and grotesque stories about celebrities, aliens, and tragedies as well as sensationalistic, bogus, and manipulated photographs. The first modern tabloid in the United States was *The National Enquirer,* founded by American newspaper mogul William Randolph Hearst (1863–1951) in 1926. Tabloids are formatted on half of a 17x22 inch broadsheet. A broadsheet is the standard size of paper used for newspapers. See also paparazzi, yellow journalism

**Talk Radio** Popular radio format in which a host discusses topics of public interest, conducts interviews, and engages in on-air conversations with members of the listening audience. See also agenda setting, audience, opinion piece, public opinion, pundit, spiral of silence

**Talkie** Slang for a movie with sound. The term was primarily used in the late 1920s and early 1930s, which were the early days of motion pictures with sound. See also silent film

**Taper** Person who makes recordings of live concerts, typically with performers' and copyright holders' permission, and shares them with other tapers. Performers grant this permission because they benefit from the exposure that they and their music get when the music is shared. People who hear tapers' recordings might buy tickets to the artists' concerts or purchase the artists' "merch" (merchandise), including official releases (manufacturer recordings on compact disc [CD] and MP3), clothing with the artists' names or logos on it, and so forth. The iconic American jam band *Grateful Dead,* which performed approximately 2,300 concerts from 1965 to 1995, pioneered the practice of arranging special taper areas in concert venues where people with tickets that designated them as tapers could set up their microphones near the sound board and could sometimes even plug into it, which yielded especially clear recordings.

**Target Audience** The intended audience for a message or media product.

**TCP/IP** See protocol

**Teaser** A compelling preview of something, such as a movie or television news broadcast, musical composition, or business proposal, that makes people want to see, hear, or read more. The abstract of a written work can be a teaser for a reader. See also abstract, pitch, trailer

**Technological Determinism** The idea that technology inevitably causes things to happen in society. From this perspective, it is technological factors that push human development and large scale social trends rather than the other way around. Another point of view argues that there is a mutual shaping of people and technology, with people creating, adopting, hacking, and modifying technologies of all sorts in unanticipated ways, and then those technologies altering people's lives, also in unanticipated ways, over and over again. See also hacker, jailbreak, modder, phreak

**Technology** See information and communication technology

**Technophobe** See diffusion of innovations

**Telecommuting** Working at home, in public settings, or on-the-go, that often entails the use of computers and/or mobile devices, rather than working in a traditional business setting. See also mobile communication, Wi-Fi hotspot

**Telegraph** Communication device developed in the mid-19th century by American artist and inventor Samuel Morse (1791–1872), that uses a series of short and long electric signals to communicate in code the letters of the alphabet, numerals, and punctuation marks in order to spell out the words and sentences of messages. "What hath God wrought" was Samuel Morse's first official telegraphed message in 1844. The diffusion of the telegraph revolutionized how news and information, both public and private, were spread and how business, politics, and even military actions were conducted. In his pivotal book *Communication as Culture: Essays on Media and Society* (1988), communication theorist James W. Carey (1934–2006) explains the vast social transformations brought on by the telegraph. For the first time in history, communication was decoupled from transportation; messages did not need to be transported from place to place by foot, horse, ship, or railroad. The telegraph is cleverly hailed the Victorian Internet by British writer and journalist Tom Standage (1969–) in his book, *The Victorian Internet: The Remarkable Story of the Telegraph and the Nineteenth Century's On-line Pioneers* (1998), because the wide-reaching and unanticipated impacts of connecting geographically dispersed people via the telegraph in the 19th century parallel some of the impacts of the Internet in the 20th century (and beyond). The development of telegraph technology laid the groundwork for the development of the telephone. See also Morse code

**Telemarketer** Person who solicits or sells something on behalf of a company or organization over the telephone, often through the use of cold calling techniques, which means that the people who are called did not ask to be contacted. Telemarketing phone calls are the verbal equivalent of email spam messages, unwelcome intrusions that greedily suck up a recipient's time. In the United States, individuals can permanently register their home and mobile phone numbers on the national "do not call registry."

**Telephone** A handheld communication device containing a transmitter and receiver that is used for sending voice, facsimile (fax), and other data over a telecommunications network. After years of experimentation, on March 10, 1876, Scottish-born American scientist, engineer, and educator of the deaf Alexander Graham Bell (1847–1922) spoke the first words that would be heard over a phone, calling his

assistant: "Mr. Watson—come here—I need you." Bell received the first U.S. patent for the telephone in 1876. See also Bakelite, mobile phone, smartphone

**Teleprompter** A device displaying text that a person can read from as they are recorded on camera. The device cannot be seen by the audience on television.

**Television** A communication machine developed in the 1920s that gained widespread popularity in the 1950s. In 1936, American marketing research pioneer Arthur Charles Nielsen, Sr. (1897–1980) developed his first television audience measurement method. At the time, there were only about 200 televisions worldwide. Today, three-quarters of all American households have three or more television sets. In the typical American home, a television is turned on for eight or more hours a day. In the United States, there are 565 satellite-delivered networks. There are 1,353 HDTV satellite channels in the world today. By 2013, that number is expected to grow an astounding 350 percent. In addition to watching and/or listening to television shows for entertainment and information, people now also interact with television sets to play video games. Unlike many other communication technologies, including computers, there are no special skills required to use a television. An individual does not even need to know how to read to use one. In contemporary society, television is the primary storyteller. Parents sometimes call it the electronic babysitter. Critics have derided it as the idiot box and the boob tube. Yet there are educational content and high-quality programs on television mixed in with shows of mediocre quality. Until recently, in some countries, including France, people had to pay a special tax every year based on the number of television sets they owned; having multiple sets in a household was a sign of economic wealth. Compelling and nearly universally available, television is a powerful institution of socialization and education. People can learn about the world and about people from different and distant cultures and subcultures through television without leaving their homes, and can view shows on-the-go using mobile devices like the iPad. Television reflects and defines reality and what is "normal" for many viewers, provides mediated experiences of reality, and offers opportunities to escape from reality. Its ability to fulfill many roles is why it has maintained a widespread

appeal among people of all demographic groups for the last 60 years, even as newer technologies such as computers and the Internet have permeated the media landscape. See also cultivation theory, cultural indicators project, mean world syndrome, Nielsen ratings

**Tempo** In speech and music, the speed of individual sounds.

**Temporal** Having to do with time. See also asynchronous, timeshifting

**Text** Anything that people can read, in the broadest sense of the word read, and critically analyze, such as: books, newspapers, websites, letters, postcards, photographs, movies, YouTube videos, cartoons, billboards, bumper sticker slogans, and, of course, short message service (SMS) text messages.

**Text Messaging** See short message service

**Theory** A well-explored conceptualization expressed in words about why specific variables are related in a certain way. Successful theories have predictive power regarding new phenomena and/or suggest further lines of research. "There is nothing so practical as a good theory," as German-born American psychologist Kurt Lewin (1890–1947) famously observed. Examples of media and communication theories include: agenda setting, diffusion of innovations, spiral of silence, two-step flow theory, and uses and gratifications. See also empirical, hypothesis

**There's An App For That** Slogan that Apple first used in a television commercial promoting the iPhone in 2009. In October 2010, the U.S. Patent and Trademark Office granted Apple a trademark for this succinct celebration of the more than 250,000 applications for the iPhone, iPad, and iPod available from the Apple App Store, preventing competitors from using the phrase in marketing and advertising for their own products. Computing and media enthusiasts, technical writers, and corporations have spoofed and lampooned this slogan in jokes, articles, and commercials. See also Apple, iPad, iPhone, iPod, slogan, trademark

**Thesis** In speaking and writing, a proposition or argument that is developed and supported with evidence.

**Thick Descriptions** Detailed notes that a researcher takes when conducting a participant observation study or an ethnography.

**Think Piece** Also called a background story, a journalistic article that provides historical contextualization and analysis to supplement a current news story.

**Third Person Effect** Common belief of people that they are not affected personally by media messages, including advertisements, but other people are.

**Thumbnail** A mini version of a larger image that loads more quickly on a computer screen than the full size version. Because of their small size, typically about the size of a thumbnail, many of these can fit onto and be viewed on a screen at once. When the user clicks on a thumbnail, the full size version opens for viewing.

**Tie-In** Merchandise such as a candy, toy action figure, or another media product such as a novel based on a movie script that helps to publicize the release of a movie. Sometimes books are reissued when the story is made into a play, movie, or television show. These are called tie-in reissues. See also advertisement, claymation, product placement

**Timeshifting** The practice of viewing a media product such as a movie or television show at the audience members' convenience, rather than when it is broadcast, by making a recording of it for later playback. Similarly, podcasts of radio shows allow audience members to time-shift and listen at their own convenience as well as to fast forward, pause, or review portions or the whole show as many times as they like. A related practice is placeshifting, which is accomplished with a device such as a Slingbox that allows users to view satellite or cable television shows available on their home television sets on a computer located elsewhere that is connected to the Internet with a broadband Internet connection. Placeshifting is a popular practice among college students and vacation homeowners, because it eliminates the need to pay for an additional cable or satellite television subscription. Placeshifting is also a useful practice for travelers who can access broadband connections in hotel rooms or via Wi-Fi hotspots. Intriguingly, the home television set does not need to be turned on for the user to access its programming remotely with placeshifting technology, because it uses programs stored on the recording device and not the television itself. See also podcast

**Tinseltown** Slang for Hollywood, California, connoting its glitzy, glittering aura.

**Touchpad** Cursor control device integrated into a computer that was first popularized on Apple laptop computers in 1994. A touchpad responds to the user's finger pressure on it and finger movements across it to perform the same functions as a mouse. Usually integrated into a laptop or portable computer, a touchpad makes a mouse unnecessary, though many people continue to use a mouse.

**Touchscreen** A combination of a computer display screen and a computer input device. The user touches words, icons, or images on the screen and the device senses the user's finger pressure on a specific location and responds by executing the user's selected commands. Touchscreens eliminate the need for a mouse or keyboard, but these input devices are still sometimes used as supplements to touchscreens.

**Tracker** See political tracker

**Trade Publication** Periodical whose target audience is composed of people who work within a specific field or industry, for instance, *PC Magazine* for information technology (IT) professionals and *PR Week Magazine* for public relations (PR) professionals. See also magazine, peer reviewed journal

**Trademark** Legal mechanism companies use to protect words or symbols that identify their goods in a distinctive manner. Trademarks appear on companies' products and in their advertising and marketing materials. Apple Corporation's apple is an example. According to the U.S. Code, Title 15, Chapter 22, Subchapter III, § 1127, a trademark "includes any word, name, symbol, or device, or any combination thereof—(1) used by a person, or (2) which a person has a bona fide intention to use in commerce and applies to register on the principal register established by this chapter, to identify and distinguish his or her goods, including a unique product, from those manufactured or sold by others and to indicate the source of the goods, even if that source is unknown." See also copyright, genericized trademark, logo, slogan, symbol

**Traffic** See website traffic

**Trailer** Also called a preview, compelling movie clips shown before another movie, played in television advertisements for a movie, or aired during television programs in which the movie is discussed, in order to encourage people to see the movie. Trailers are also used to promote television programs, plays, and other media productions. See also advertisement, clip, teaser

**Transcription** In music, the notation of a musical composition on paper. In journalism, law, social research, medicine, and market research, the word-for-word written record of spoken dialogue from an interview, focus group, legal proceeding, medical report, or other context. An exact transcription is *verbatim et literatim,* the Latin expression for "word-for-word," which is usually shortened to *verbatim.*

**Treatment Group** In experimental research, the group of people that receives the intervention, as opposed to the control group, which does not. At the end of an experiment the results from the two groups are compared to determine the effect, if any, of the experimental treatment. In a double-blind experiment, neither the investigator(s) nor the participants know which group is the treatment group and which is the control group.

**Triangulation** In media research, employing more than one type of research method such as a survey and interviews to investigate a topic. This is also called a mixed-methods approach. Congruencies as well as discrepancies in findings from different methods can provide valuable information to researchers.

**Triple Threat** In the entertainment industry, a performer who is accomplished at singing, dancing, and acting.

**Trojan Horse** In computing, malicious and potentially damaging software that pretends to be something else, such as a video game or email attachment, in order to lure an unsuspecting person to download and run it to cause harm to the computer like a virus would. See also cybercrime, social engineering

**Turntable** Also called a phonograph or record player, a device with a rotating component that is used to play analog LPs (long playing albums) and 45s. In the 21st century, compact disc (CD) and MP3 players have largely replaced turntables, but some audiophiles (music lovers) continue to collect and listen to records on turntables.

**Tweaching** See online education

**Tweak** To adjust, fine tune, or modify something.

**Tweet** A message posted to the real-time microblogging service Twitter, so called because it is a short burst. Also, a high-pitched chirping sound. See also retweet, Twitter

**Twenty-Four-Hour News** Genre of continuous television coverage of worldwide news. This format requires a breakneck pace of reporting in which live action is emphasized. Events like natural disasters, wars, terrorist actions, and election results are shown in real time to global audiences. Stories are broadcast in a rolling format so that viewers can tune in for a few minutes to catch the latest breaking news or stay tuned hour after hour continuously mesmerized. In the 21st century, television news is ubiquitous. People watch news channels in homes, elevators, highway rest stops, offices, school cafeterias, airports, airplanes, and also on mobile devices such as smartphones. Turner Broadcasting System (TBS), a Time Warner Company, pioneered 24-hour-news coverage with the launch of Cable News Network (CNN) in 1980. In 2010, CNN reached approximately a billion people. There are approximately 100 other 24-hour-news channels worldwide, including CNBC World (U.S.), Canal 24 Horas (Spain), LCI (France), Al Jazeera (Qatar), Antena 3 (Romania), and CCTV News Channel (China). See also journalism, video journalist

**Twenty-Four/Seven** (24/7) Short for twenty-four hours a day, seven days a week, meaning continuous operations. Cable News Network (CNN) pioneered around the clock news coverage in 1980. Mobile communication devices connect people to their loved ones, friends, colleagues, associates, and workplaces 24/7. See also information overload

**Twitter** A real-time microblogging Web service that allows people to send short messages, up to 140 characters long, to an audience of subscribers known as followers. Twitter posts are called tweets, highlighting that they are short bursts. The act of posting messages to Twitter is called tweeting or twittering. Using Twitter for instruction is called tweaching. This term was coined by American online education specialist and neologist Brian Salerno (1980–) in 2009, while he was an instructional designer at Quinnipiac University. Tweets can be sent and received instantaneously via computers or portable mobile

devices such as mobile phones. Unlike instant messaging (IM), tweets are archived and accessible on the Twitter website. Public is the default setting on Twitter, which means that anyone can follow anyone on Twitter unless the tweeters have changed the settings on their accounts to protect their profiles and limit who has access to their tweets. According to a December 2010 report from the Pew Research Center for the People and the Press, an independent, non-partisan public opinion research organization, 6% of all U.S. adults use Twitter. This number represents 8% of all adult Internet users in the United States. See also blog, retweet, status update

**Twittersphere** The universe of people who use the Twitter microblog online application to read others' messages, called tweets, and/or to contribute their own tweets. See blog, lurker, retweet

**Two-Step Flow Theory** Communication theory that argues that media such as television news shows influence people known as opinion leaders who then influence other people via interpersonal communication. See also opinion leader, theory

**Typewriter** A device designed in the late 18th century for typing letters on paper. It was developed initially to help blind people write. Typing on the earliest manual (non-electric) typewriters was slower than writing by hand. In the 19th century, a variety of machines were designed that could type more rapidly than writing by hand. Some versions had keyboards on which the keys of the most commonly used letters were positioned nearest to people's fastest fingers to optimize the speed of typing. The keys of letters commonly used together in English were positioned away from one another so that the typewriter's metal rods with individual letters on the ends of them would not crash together and jam the machine when those keys were pressed in rapid succession. Electric typewriters were developed by 1901, initially to be connected to telegraph machines. By the 1930s, IBM had invested more than $1 million to enhance the electric typewriter. By the end of the 20th century, affordable computers and printers made typewriters virtually obsolete. However, some writers and self-professed neo-luddites who eschew computers use manual or electric typewriters, or write by hand in what is appropriately called longhand. Because computer printed documents are ubiquitous in the 21st century, a handwritten letter or note can have enormous

impact on the recipient. A century ago, a typewritten letter would have been the exception and would have had similar impact. See also font, QWERTY, typography

**Typo** Short for typographical error, which means a typing mis*t*eAk. Oops. See also font, typography

**Typography** The art and activity of arranging letters through the use of particular styles and sizes of fonts in order to enhance the communication of messages. Graphic designers, typesetters, compositors, art directors, typographers, comic book artists, graffiti artists, and writers all strategically use typography.

**Uniform Resource Locator** (URL)  The distinct address of a particular file or website on the Internet. When a URL is typed into a Web browser's address bar, the browser brings up the requested page of a website. For example, the URL "http://www.peterlang.com" will bring up the home page for the website of Peter Lang Publishing. A URL has two parts. The first part, "http://", specifies the networking protocol, HyperText Transfer Protocol, the common protocol for transferring hypermedia files on the Internet. If the first part were "https://", it would specify a secured transfer protocol, using encryption. The second part of the URL in this example, "www.peterlang.com", indicates where the files should be retrieved from. Sometimes URLs have a third part, which identifies specific pages within a website. URLs are not case sensitive. It is helpful to use plain letters rather than language-specific letters in a URL, so that it can be typed from any computer in the world. In 2008, the Google search engine indexed one trillion URLs. The acronym URI, for "uniform resource identifier," is sometimes used instead of URL. There is a slight distinction, however. A URI identifies an online resource, and a URL provides all the information needed to retrieve it. See also Google, Yahoo!

**Universal Plug-And-Play** (UPnP)  An open industry standard that uses Internet protocols (IP) to enable a device that is plugged into a computer network to seamlessly and instantaneously configure itself, acquire a Transmission Control Protocol/Internet Protocol (TCP/IP) address, and inform other devices on the network that it is connected. See also plug-and-play

**Universal Serial Bus** (USB)  Device connection plug that has become the connection standard for computer peripherals such as printers, monitors, external hard drives, mice, scanners, and flash drives as well as other digital devices, such as portable digital media players and digital cameras (see Figure 8). SuperSpeed USB, also known as USB 3.0, which can read and write data at the same time, is the latest upgrade to USB technology. It is 10 times faster than USB 2.0.

FIGURE 8. Universal Serial Bus (USB) cables.

**Universal Service**  U.S. Federal Communications Commission (FCC) goal to make affordable telecommunications services such as telephone and Internet connections available to people in all regions of the country. The FCC administers initiatives that promote service for everyone. See also digital divide, Federal Communications Commission

**Unlocked Mobile Device**  See jailbreak

**Unobtrusive Observation** Research conducted in a public place or online in a way that the people being studied are not aware that they are being watched, and they have not given their informed consent. This approach has led to some ethically controversial research. See also informed consent

**Unsolicited Bulk Email** (UBE) See spam

**Untitled** The non-title conventionally used in place of a name for a musical composition or for a work of art that is on display in a gallery or museum when there is no known title for the piece. In a clever reference to this convention, a zany, satirical movie about gallery owners, art collectors, and avant-garde music released in 2009 is titled *(Untitled)*.

**Upgrade** A newer version of something such as a mobile phone or piece of software that has enhanced and/or added features and capabilities as compared to the earlier version. See also built-in obsolescence, neo-luddite

**Uploading** The process of transferring any form of data, such as text files, MP3 audio files, video clips, movies, or computer software, from a personal computer (PC), smartphone, or other device onto another device or system, typically a server, for others to use. For example, people upload videos onto the YouTube website for any Internet user to view, and individuals upload vacation pictures onto their Facebook page to share with their family and friends. Downloading is the reverse process: obtaining any form of data from one device or system, typically a server, and putting it onto another device or system, typically a personal computer or smartphone, for "disconnected" usage. For example, people download songs from the iTunes website onto their iPods for their personal listening. See also prosumer, Web 2.0

**Urban Communication Foundation** (UCF) A not-for-profit organization founded in 2007 that promotes interdisciplinary research in urban communication, sponsors seminars, and encourages civic and social engagement. Urban communication concerns the roles of mediated and face-to-face (F2F) communication and their impacts on urban life. Urban journalism specialist and philanthropist Gene Burd (c. 1931–), associate professor of journalism at the University of Texas at Austin, was the founding benefactor of the UCF.

**URL** See Uniform Resource Locator

**Usability Testing** A technique for evaluating a product or interactive system in which someone who might be an actual or potential user of it is observed by a researcher, developer, or usability engineer as the person performs tasks with a product or a prototype of it. The goal of usability testing is to see how real users interact with a product and hear how they evaluate it in order to find ways to improve it. Usability testing is sometimes conducted unobtrusively, which means that the observer tries not to guide, enhance, or interfere with the user's experience in any way. An opposite approach is obtrusive observation, in which the observer engages with the user, answering and asking questions and providing information. Often both approaches are combined in order to glean as much information as possible about the ease of use and usefulness of the product being tested. Usability testing is an integral part of user centered design, which aims to maximally enhance the user experience and meet users' needs. The bottom line is that happy users become repeat customers. See also observer effect, response bias, user centered design, user interface

**USB** See Universal Serial Bus

**User Centered Design** A design philosophy and practice that incorporates the user, sometimes called the end-user, of a product or technology into multiple stages of the development process in order to ensure that users' needs and desires are reflected appropriately in a product. User centered design is employed in a variety of contexts, including software development and website design. It typically entails multiple rounds of usability testing.

**User Generated Content** (UGC)  Media content created by members of the audience, such as the amateur video that is commonly uploaded to the video hosting website YouTube. News organizations are increasingly requesting and airing user generated content ranging from nonprofessionally produced video clips to email messages and Twitter tweets. See also prosumer, Web 2.0

**User Interface** Also called graphical user interface (GUI), the location where a person using a technology and the technology meet. In personal computers, the Windows desktop is the user interface. On a smartphone, it is the keypad and screen. The interface is also known

as the front-end, while the software and technology supporting it is known as the back-end. Also in computing, a client computer is at the front-end while the server computer is at the back-end. See also user centered design, World Wide Web

**Uses and Gratifications**  Communication theory that argues that audiences actively choose and use media to satisfy their personal needs for entertainment and information. Uses and gratifications research focuses on the functions of media usage for individuals rather than on the effects and implications of media on society. See also theory

**Utopia**  In literature, movies, and political philosophy, an ideal or envisioned perfect situation and place. See also dystopia

**Validity** Research concept that describes whether a measure or instrument, such as a survey, is actually measuring what it is intended to measure. See also reliability

**Validity Effect** Concept that describes what happens when something is repeated so many times in the media that people believe it is true, whether it is or not, because they have heard it often.

**Venting** Explosively communicating something orally or in writing, such as recounting an incident and/or expressing emotions about something. Venting can be done face-to-face (F2F), on the telephone, or via another form of mediated communication. It can occur as one-to-one or one-to-many communication. See also flame

**Verbose** Too wordy. Enough said. See also information overload, jargon

**Vernacular** Informal everyday language of people in a region or characteristic of people within a certain group. See also idiom, jargon, subculture

**Vertical Integration** When a business controls many stages of the supply chain for its product. For instance, a book publisher that owns printing presses and bookstores or a movie studio that owns production companies, movie distribution companies, and movie theaters. Extensive vertical integration in an industry can leads to an oligopoly,

when a few key companies control most of an industry, as has been the case in the movie industry in the United States, even after the Paramount Decision of 1948, when the U.S. Supreme Court forced movie companies to sell their theaters but not their distribution companies. See also concentration of media ownership, horizontal integration, political economy studies

**Video** Moving images recorded and displayed electronically as compared to those captured and displayed mechanically on film.

**Video Blog** (Vlog) A blog containing visual material. Video blogs are an example of user generated content (UGC), also called DIY (do-it-yourself) media on Web 2.0. Vloggers upload their creations to the Internet quickly and easily, especially to video sharing websites such as YouTube. Vloggers use video blogs as tools for self-expression. Video blogs often blur the lines between private and public both in terms of their content and their accessibility; vloggers can leverage privacy functions of vlog technology to control access to their vlogs. The part of the blogosphere devoted to vlogs is called the vlogosphere. See also blog, podcast, RSS

**Video Clip** See clip

**Video Game** Phrase that refers to a computer controlled game device as well as the games that are played on it. This entertainment category includes computer games played on personal computers (PC), console games played on specific devices that are connected to television sets to play the game, game applications on mobile phones, handheld game devices, and arcade games that are played on machines in public places like malls and hotels where patrons pay per game played. To play a video game, one or more players follow rules and interact with the game device and sometimes also with other players face-to-face (F2F) or online. Video gaming is the largest media industry in the world, with revenue exceeding movie industry revenue. Amazingly, in 2009, revenue from video games was approximately $1 billion per month. Video games have progressed from being text-only to highly graphical immersive experiences with sound effects in which people play in imaginary worlds that they co-create. The range of input devices that gamers use to play games has expanded from keyboards and joysticks to handheld controllers to sensor technologies such as those in the Nintendo Wii system. The Entertainment Software

Rating Board (ESRB), a non-profit regulatory body for the gaming industry, has a two-part rating system for video games that includes a letter rating that indicates the ages for which the game is appropriate as well as standardized content descriptors, such as "blood and gore," "crude humor," "cartoon violence," "real gambling," "sexual violence," and "use of drugs." The ESRB rates games sold in North America in six categories based on their content:

EC Early Childhood. Appropriate for people ages 3 and older.

E Everyone. Appropriate for people ages 6 and older.

E10+ Everyone 10+. Appropriate for ages 10 and older.

T Teen. Appropriate for ages 13 and older.

M Mature. Appropriate for ages 17 and older.

AO Adults Only.

Media research has shown that many video games rated E, appropriate for people ages 6 and older, contain significant violence. Media watchdogs urge parents and guardians to prescreen their children's video games. This is good advice that is a challenge to put into practice because video games are ubiquitous and children can play them in so many different contexts without adult supervision. Some Web browsers can restrict access to websites and other content based on ratings. This requires parents and guardians to enable access restriction settings on their children's computers. See also diagetic space, haptics

**Video Journalist** Also called a backpack reporter or mobile journalist (Mo-Jo), a professional reporter capable of using digital photography and video as well as writing to report a story, often working alone or with just a small team. Some industry insiders compare video journalists to "one-man-bands." They are increasingly being deployed for news gathering as part of the cost-cutting measures many media organizations have taken in the last few years. See also citizen journalism, journalism, news

**Video News Release** (VNR) Video version of a press release that is typically produced by a public relations (PR) firm, by the public affairs office of an organization, or by the Advertising Council. A VNR

provides prepackaged information about an issue, event, product, or company. It is crafted like a news report so that it can be aired on television. See also buzz, press release, pseudo-event, public service announcement, publicity

**Video On-Demand** (VOD)  A multimedia content delivery service that makes content available to viewers immediately upon request, often for a fee per use but sometimes "for free" as part of a monthly subscription. Multimedia products are delivered in digital formats. Video on-demand services allow users to view in real time, pause, rewind, and fast forward digital content such as movies and television shows as well as to save the content for viewing up to 24 to 48 hours later, which is called timeshifting. Video on-demand services can be accessed via a television set-top box, Internet-connected computer, or mobile device. See also pay-per-view, placeshifting, subscription

**Videocassette Recorder** (VCR)  A machine developed in the 1960s for recording and playing back video and audio on cassettes containing magnetic tape. Two major formats were VHS (Video Home System) and Betamax. Each was developed by a different Japanese company and available for purchase by the early 1970s. A format war in the 1980s and 1990s led to the obsolescence of Betamax. Since then, the DVD with its superior versatility and storage capacity has eclipsed VHS. See also built-in obsolescence, diffusion of innovations

**Viral Marketing**  A marketing technique that leverages the power of the Internet and social media to rapidly reach an exponentially growing number of people in order to publicize something and generate a buzz about it. Someone who receives a message via email or who reads it on a blog or views it on a video hosting website such as YouTube might forward the message or link to friends who forward it to their friends, and so on. Viral marketing is also called referral marketing, buzz marketing, grassroots marketing, and, cleverly, word of mouse, but of course viral messages can be sent and received by mouseless electronic devices. See also advertisement, astroturfing, public relations, publicity, social media

**Virgule**  Also called shilling bar, slant bar, solidus, and, most commonly, slash, a fancy name for a diagonal slash punctuation mark used in writing, mathematical notation, and computing. Virgules are often

called forward slash (/) and back slash (\) to differentiate between the two.

**Virtual Reality** An immersive, computer-simulated three-dimensional interactive environment such as that created in a flight simulator. See also augmented reality technology

**Virus** See computer virus

**Vishing** A blend of "voice" and "phishing." A scam technique in which people are conned into revealing their private information for fraudulent purposes, such as bank account numbers or computer passwords, over a landline, mobile, or voice over Internet protocol (VoIP) telephone. Targeted people are often instructed by a synthesized voice to call a certain phone number and enter their personal information when prompted. See also cracker, cybercrime, phishing, social engineering

**Visual** Pertaining to sight or something that can be seen. For instance, a pitch for an advertising campaign might include visual aids such as illustrations, graphs, and charts for a client to evaluate. See also audiovisual/information technology integration, eye candy, persistence of vision, poster, video

**Vita** See curriculum vitae

**Vlog** See video blog

**VNR** See video news release

**Vocalics** Study of how voice is used in communication. See also chronemics, haptics, proxemics, nonverbal communication

**Voice Identification** See biometric verification

**Voice Over Internet Protocol** (VoIP) Data transmission technologies that enable voice and multimedia data communication over the Internet via a broadband Internet connection instead of an analog telephone line. Individuals, businesses, organizations, and government agencies are switching to VoIP because it reduces infrastructure costs. Organizations with multiple locations and travelling employees use VoIP phone systems in which each employee has her or his own VoIP device and phone number and can plug in at any organization location to make and receive phone calls. VoIP customers can avoid paying for both broadband and a traditional landline telephone connection. VoIP

does not necessarily offer all of the features of a traditional landline. For instance, not all VoIP services enable users to call 9-1-1 to connect to emergency services. And, not all VoIP services offer directory assistance. Moreover, different services offer different features. Some require additional equipment such as a special telephone or adapter. Some have limitations on which locations or users can be called with the service. For instance, only other users of the service, or only domestic calls. Skype is a well-known VoIP service. It allows users to make voice and video calls, including conference calls, as well as to send instant messages, transfer files, and share screens with other users on the Skype network for free. Skype users can also call to and from landline telephones and mobile phones for a charge. In 2011, Skype users could choose to pay as they talked for 2.3¢/minute in U.S. dollars, depending on where they were calling to and from, or to pay less per minute with a Skype subscription of $1.09 per month. A drawback to VoIP is that cybercriminals can eavesdrop on VoIP calls more easily than on phone calls over conventional telephones through the use of technology that intercepts calls before they are encrypted. Moreover, cybercriminals can activate the speakerphone feature of an Internet Protocol (IP) telephone remotely and undetectably, capturing the sounds and conversations in the room where the phone is located without the people in the room being aware of it. Similarly and sinisterly, microphones integrated in computers or attached to them can be enabled remotely as eavesdropping devices. See also cracker, cybercrime, hacker

**Voicemail** Voice message recorded on a telephone answering machine or on a telephone message service system, which answers the call automatically, that is stored for later playback and/or forwarding. See also placeshifting, timeshifting

**Voiceover** A technique used in documentaries, movies, plays, and television shows in which the voices of characters from the story or unseen narrators are used to convey information to the audience. See also dubbing, lip sync, narrator

**VoIP** See voice over Internet protocol

**Walt Disney Company** See Disney

**Wardrobe Malfunction** Euphemism describing the unintentional exposure of body parts because clothing or a costume fails to provide cover in the manner intended. This term gained traction because of the highly sensational coverage (no pun intended) of the infamous incident that occurred during the 2004 Super Bowl football game half-time show that aired on CBS television stations. American pop singer Janet Jackson's (1966–) breast was accidently exposed for 9/16th of a second as she performed with American pop singer Justin Timberlake (1981–). The Federal Communications Commission (FCC), which regulates radio and television broadcasting, fined CBS $550,000 for airing the segment, a decision that was subsequently overturned by an appeals court in 2008, and then reviewed again by an appeals court in 2010, which ultimately ruled in favor of CBS. See also censorship, euphemism, First Amendment, obscenity

**Wayback Machine** Archive of the World Wide Web (WWW) from 1996 to the present available for browsing and historical research at the website http://web.archive.org. See also archive, World Wide Web

**Weak Password** See strong password

**Web**  Short for World Wide Web (WWW). See also Internet, Web 1.0, Web 2.0

**Web 1.0**  During the first decade of the World Wide Web (WWW), sometimes referred to as Web 1.0 to indicate that it was the first version of the Web, most websites communicated information to users in a top-down, one-way manner. In contrast, most websites built today in the era of Web 2.0 have areas where users can contribute, participate, and interact with members of the entities sponsoring the websites via features such as real-time chat and blogs. Interactivity is now the norm rather than the exception on the Web today, but some websites that are purely informational still use Web 1.0 techniques for content generation. See also Internet

**Web 2.0**  Today's World Wide Web, where users are empowered content producers who actively participate in the creation and consumption of Web content and interact with online media and with one another in a wide variety of online contexts that support social computing, as contrasted with personal computing, including: blogs, wikis, video games, RSS, and social networking websites. See also crowdsourcing, independent media, Internet, participatory media, prosumer, Web 1.0, YouTube

**Web Archive**  See Wayback Machine

**Web Browser**  Web navigation software with a user-friendly graphical user interface (GUI). The first Web browser was developed in the 1990s. It made the Internet accessible to non-computer experts. Examples of Web browsers include: Internet Explorer, Safari, Firefox, Flocks, Lynx, and Opera. Websites do not necessarily look or function identically when accessed using different browsers. While website developers aim for as much consistency as possible in the appearance and functionality of their products across browsers, cross-browser compatibility is difficult to achieve completely. For this reason, if a website looks goofy or is not working as expected, opening it with a different browser sometimes resolves the problem. A mobile browser is designed for mobile devices such as smartphones that typically have small viewing screens and limited memory. Some mobile browsers can display regular HTML websites while others only work with websites developed specifically for viewing on mobile devices. The latter are predominantly text-based and/or low graphic websites.

**Webcam** Video camera embedded in a computer or attached to it capable of transmitting digital images over the Internet in real time. See also Skype, user generated content, voice over Internet protocol, YouTube

**Webcasting** See push technology

**Web-Enabled** A handheld device that has Internet capabilities. Web-enabled mobile phones are called smartphones.

**Webinar** An online seminar accessible to participants in real time. Webinars leverage the power of the Internet to facilitate virtual meetings, alleviating the need for people to travel physically in order to convene for educational or corporate meetings.

**Webmaster** Person who creates and manages the content of a website.

**Website** A collection of Web pages with user-friendly graphical user interfaces (GUI) that can be accessed using a computer program called a Web browser by typing an address, also called uniform resource locator (URL), into the browser's navigation bar at the top of the screen. Web pages are linked via hyperlinks. The top page of a website, which is usually the root or landing page that visitors view first, is called the home page. In 1990, British engineer and computer scientist Sir Timothy John Berners-Lee (1955–) built the first website at CERN (*Organisation Européenne pour la Recherche Nucléaire,* which is French for European Organization for Nuclear Research) in Geneva, Switzerland. He used Hypertext Markup Language (HTML), a computer language that he and his colleagues had developed to link hypertext documents on the Internet. HTML defines the layout of individual Web pages and the functions embedded within them. HTML made the World Wide Web (WWW) possible and remains the basic language of the Web, though many websites today use several other languages as well, such as CSS, Javascript, and Flash. The visual design of a website is called the front-end, while the back-end technology runs on a server computer behind the scenes, supplying the website's information and supporting its functionality. Web developers attempt to build into their websites as much cross-browser compatibility as possible so that websites appear and function close to identically when accessed using different Web browsers. But this is challenging to achieve. So, if a website looks goofy or if a feature on

it is not working as expected, opening it with another Web browser sometimes resolves the issue. See also Web browser

**Website Traffic** Number of website visits that can be automatically tracked and analyzed. Each time a file is requested for viewing on a Web page, including individual images on a Web page, it is counted as a hit. Website owners often want to know information about the number of unique visitors to their website, users' activities on the website, users' points of entry and exit, external links that brought visitors to the website, countries of origin, and so forth so that they can better get to know their audience and discern if the website is doing what it is intended to do, such as inform website visitors about a certain topic or sell products or services. People who advertise on the Web are interested in the number of ad views, also called views and impressions.

**Weekly** Magazine or newspaper that is published every week. See also dailies

**White Hat** The quintessential good guy in the American western movie genre. Hackers are sometimes called white hats, drawing on the symbolism of westerns in which the good guy wears a white hat and the bad guy wears a black hat. See also hacker, hacktivist

**Whitelist** List of email addresses that a user wants to make sure will not be banned from her or his mailbox. These email addresses should not be automatically routed to the junk mail folder. See also blacklist

**Widget** In computing, a component of a graphical user interface (GUI) such as an icon, scroll bar, or pull-down menu as well as the modifiable back-end programming that details how the component looks and directs how it functions. In life, a generic name for any doohickey whose proper name is unknown, obscure, or forgotten.

**Wi-Fi** See wireless fidelity

**Wi-Fi Hotspot** Geographic area where people with devices that support wireless Internet connections, such as laptop computers with wireless cards, can access the Internet via high-speed broadband Internet connections either for free, for an hourly charge, or by paying a monthly subscription fee. Hotspots are access points where many people can connect to the Internet simultaneously via radio waves rather than cables. Many public places such as parks, restaurants, and hotel lobbies are Wi-Fi hotspots. See also wireless fidelity

**Wiki** Hawaiian word for quick that is used to refer to collectively written websites in which readers can edit or augment the content others have contributed. The first wiki was created by American computer programmer Howard Cunningham (1949–) in 1995 to serve as a collaboratively organized repository of computer programming patterns. Wikis are self-indexing, and contributors serve as volunteer participants, contributing to them, and housekeepers of them, introducing innovations in wiki features. Wikipedia is the most well-known wiki. See also discussion board, Wikipedia, wikiscrubbing

**WikiLeaks** An independent, not-for-profit media organization launched in 2007. It publishes confidential, sensitive, and restricted documents from governments and corporations that are submitted anonymously, using encryption techniques and other means to protect the sources. It is a highly controversial organization due to the nature of the information that it makes public. Submissions are reviewed and fact checked by WikiLeaks staff and external journalists before the original source material is published on the WikiLeaks website along with news articles about it written by WikiLeaks journalists. WikiLeaks is not actually a wiki because unlike on Wikipedia, for example, information published on its website cannot be altered by anyone at anytime. WikiLeaks receives funding from organizations and private individuals. See also citizen journalism, exposé, freedom of information, wire service

**Wikipedia** Collectively authored online encyclopedia of human knowledge created by American Internet entrepreneur Jimmy Wales (1966–) and American philosopher Lawrence Sanger (1968–) in 2001. Wikipedia has been subject to criticism by some academics as being systematically biased and unreliable because anyone can edit entries. Proponents argue that the collective and on-going peer review of entries makes Wikipedia a reliable source of information because it is being improved and updated all the time; therefore, it is self-correcting in a way and to a degree that a print encyclopedia cannot be. Wikipedia entries are supposed to be based on and cite credible sources of information. Experts say that it should not serve as a primary source for authoritative information on a topic, but rather as an enhancing secondary source that can be useful as an adjunct to primary source information. See also blog, crowdsourcing, participatory media, prosumer, user generated content, Web 2.0, wiki, wikiscrubbing

**Wikiscrubbing** Wiki housekeeping practice that entails correcting mistakes, refuting falsehoods, and documenting or debunking unsupported statements in the entries of a collectively written wiki such as Wikipedia. See also crowdsourcing, user generated content, Web 2.0, wiki, Wikipedia

**Wi-Max** See worldwide interoperability for microwave access

**Wingding** See dingbat

**Wire Service** A national or international news service that provides to subscribers news dispatches gathered by its correspondents. Wire services are news wholesalers, meaning that they do not broadcast information directly to an audience but rather distribute it to news provider organizations. The first wire service was the Associated Press (AP), a cooperative newsgathering organization formed in 1848 by representatives from six New York papers for the purpose of sharing news stories so that they could provide the readers of their papers with wider coverage at a time when newsgathering was much more time consuming and challenging than it is now. Today, wireless mobile technologies can record and transmit photographs, video, audio, and text, providing video journalists (also called mobile journalists or Mo-Jo's) anytime, anywhere connectivity for their work. In contrast, in the mid-19th century, news was transmitted by telegraph. With the diffusion of the telegraph, news became a saleable commodity, and telegraph companies were beginning to sell news or were developing plans to sell news, competition that threatened newspaper revenue. Soon after the AP's formation, two newspapers outside of New York became the AP's first paying clients, *The Baltimore Sun* and *The Philadelphia Public Ledger.* Today there are many different wire services. Some provide their subscribers with news collected and analyzed about specific geographic regions and others focus on particular topics, such as business, religion, or the environment. Examples of wire services include: United Press International (UPI), Reuters, Bloomberg Business News, Canadian Press, Religion News Service, PR Newswire, Environmental News Network, and *Agence France Presse* (AFP).

**Wireless Communication** Communicating electronically without physical connections between devices. The signal is transmitted over electromagnetic waves for all or part of the communication route. Italian

inventor Guglielmo Marconi (1874–1937) was one of the key figures who ushered in the age of wireless communication. His work in wireless telegraphy was integral to the development of radio and television. In 1895, he created a system for ringing a bell by striking a telegraph key that transmitted electromagnetic waves without wires across two rooms. Soon after, he was the first to send messages over large distances wirelessly using Morse code. In 1897, he demonstrated his invention to the British Navy, and wireless systems were subsequently installed in many warships and steamships, including the *Titanic*. Marconi established wireless communication between England and France across the 32-mile English Channel in 1899. Two years later, his wireless system was the first to transmit signals 2,100 miles across the Atlantic, the letter "s" several times. Building on Marconi's systems, on Christmas Eve in 1906, Canadian electrical engineer Reginald Fessenden (1866–1932) showed that continuous radio waves could transmit voice and music. His invention was called radiotelephony, or radio. Today, many devices communicate wirelessly, including mobile phones, microphones, garage door openers, two-way radios, global positioning systems (GPS), baby monitors, and computer peripherals such as printers and mice. See also bluetooth, Morse code, Wi-Fi hotspot, wireless fidelity

**Wireless Fidelity** (Wi-Fi) Wireless networking technology that enables one or more computers to connect simultaneously to the Internet without cables via a local area network (LAN). Businesses, especially restaurants and coffee shops, often provide free Wi-Fi access or access for a nominal hourly fee, paid by credit card, in order to entice customers to visit them and spend time there. In the United States and elsewhere in the world, free Wi-Fi access is available in some public parks and plazas. These access points are called Wi-Fi hotspots. Wi-Fi uses particular engineering specifications (standards) developed by the Institute of Electrical and Electronics Engineers (IEEE). There have been other technologies developed since Wi-Fi that use different engineering standards, such as Wi-Max, which stands for "worldwide interoperability for microwave access." However, Wi-Fi is now typically used generically to describe wireless broadband Internet access.

**Wireless Number Portability** Process in which a user of a mobile device switches to a different mobile service provider or to a different mobile device and retains the same telephone number. This saves time,

effort, and money that would be spent notifying contacts about a new telephone number. Likewise, a customer can transfer a landline number to a mobile device.

**World Wide Web** (WWW)  Also called the Web, the set of protocols (technical standards) that enables anyone with Internet access to publish, view, and navigate multimedia Web pages using Web browsers such as Safari and Firefox. The Web is part of the Internet, which is sometimes called the net, a global network of interconnected computers that communicate with one another using Transmission Control Protocol/Internet Protocol (TCP/IP). Although the words Web and Internet are sometimes used interchangeably, they are not equivalent terms because the Internet includes other elements in addition to the Web, such as File Transfer Protocol (FTP) and email. In a sense, the Internet is the platform on which the Web functions. See also network neutrality

**Worldwide Interoperability for Microwave Access** (Wi-Max)  A wireless data network that can provide mobile high-speed broadband Internet access to multiple simultaneous users as well as other services such as voice over Internet protocol (VoIP). Wi-Max transmits data over the Internet rather than through radio broadcasts, satellite signals, or cable television lines, so this technology can supplement or supplant digital subscriber line (DSL), cable, and telephone services. See also wireless fidelity

**Writing**  Inscribing letters or other symbols onto a medium, such as paper, or keying letters or other symbols into a device, such as a smartphone, in order to record and/or communicate facts, thoughts, feelings, or ideas. Because writing well is a challenging endeavor even for the most experienced writers, some people report that they hate to write. Some of those same people say that they love to have written. Good writing requires great editing. Enough said. See also code, editor, font, jargon, journalism, language, printing press, publisher, typewriter, typography, vernacular

**WYSIWYG**  In printing and computing, this acronym for "what you see is what you get" was popularized during the early stages of desktop publishing in the 1980s when the content that appeared on a computer screen, especially fonts, often looked different when printed on paper.

**Xerox** Trademark for the output of a document photocopier that uses the xerography process. The Xerox corporation protected this trademark from genericide, that is, from becoming a genericized trademark, by launching a public relations (PR) campaign that encouraged everyone to say "photocopy" rather than "Xerox" when referring to the duplication of documents. Xerox also specializes in printers and document management systems. Xerox has 12,500 employees worldwide. In 2009, the company's revenue was $15 billion, with net income of $485 million. See also genericized trademark, trademark

**Yahoo!** American online media company founded by Taiwan-born American computer engineer and entrepreneur Jerry Yang (1968–) and American computer engineer and entrepreneur David Filo (1966–) in 1994 that provided the first searchable, hierarchical directory catalog of the Web. Yahoo! is now a major corporation headquartered in Sunnyvale, California, that offers its users and clients a diverse array of technology services and solutions. Yahoo! has 13,900 employees and offices in 25 countries. Most of the company's products are available in 25 languages. Its 2009 revenue was $6.5 billion, with net income of $598 million.

**Yak Shaving** A colorful idiom that describes the unanticipated series of steps that may be or appear to be pointless or ridiculous that are undertaken by someone in the process of accomplishing a project. Detours, roundabouts, and workarounds are integral parts of life when trying to get from point A to point Z. See also screensucking

**Y-Coordinate** On a two-dimensional graph or layout, a vertical location on the y-axis. On a two-dimensional graph or layout, a horizontal location is called an x-coordinate, which is on the x-axis. When representing a point in a three-dimensional context, a z-coordinate on a z-axis is also used. This system for specifying the location of any point in a two-dimensional plane, or in a three-dimensional space, a

four-dimensional space, or an even higher number dimension, using fixed axes as reference lines, was developed in the 17th century by French mathematician and philosopher René Descartes (1596–1650), and it is named eponymously the Cartesian coordinate system.

**Yellow Journalism** Sensationalistic style of journalism that has roots in the United States in newspaper reporting from the late 1800s, when papers competing in the same market used shocking and exaggerated stories, large banner headlines, phony or doctored photographs, comic strips, as well as other promotional strategies to appeal to readers in order to sell papers. The term yellow journalism draws on an element of the first hit comic strip, *Hogan's Alley,* created by American cartoonist Richard Outcault (1863–1928). The comic featured a character named Mickey Dugan who lived in city slums, wore an oversized yellow nightshirt, and appealed to the masses. Dugan became widely known as Yellow Kid because of his shirt and was probably the first cartoon character used for merchandise tie-ins such as candy and toys. Outcault later created the popular Buster Brown cartoon character that led a middle class lifestyle and was designed to appeal to middle class audiences. Today's tabloid newspapers, which are printed on newsprint paper but considered magazines by the industry experts that track circulation, are descendants of the sensationalistic and sometimes unscrupulous yellow press of the late 19th century. They are also called supermarket tabloids, because they are staples at supermarket check-out lines where customers waiting in line scan the shocking headlines and bizarre photographs on the front page and are sometimes enticed to buy the papers on impulse.

**YouTube** The world's largest video file sharing website. People watch more than 2 billion videos a day and upload hundreds of thousands of user generated videos to the website daily. YouTube is supported by advertising and has strategic partnerships with media companies worldwide that make some of their content available on YouTube. The company was founded by American Internet entrepreneur Chad Hurley (1977–), Taiwan-born American Internet entrepreneur Steve Chen (1978–), and German-born American Internet entrepreneur Jawed Karim (1979–), three former PayPal employees, in 2005. It was funded by $11.5 million from the private equity and venture capital firm Sequoia Capital. YouTube was purchased by Google about a

year later, in 2006, for $1.65 billion. It serves as an ever-expanding repository of amateur videos of original content and mashups of original or existing content, as well as an archive of popular culture in the form of movie clips, music videos, television clips, television commercials, political speeches, and anything else that people have recorded and uploaded to the site for free public consumption. YouTube is an example of the power of Web 2.0. Its user generated and/or user uploaded content is leveraged by individuals, political groups, and organizations to communicate inexpensively and easily with potentially huge audiences. YouTube enables anyone to be a producer. An important part of the allure of YouTube, and the many other video and photography file sharing websites on Web 2.0., is that the possibility of celebrity comes with self-broadcasting. This allure is similar to that of reality television. YouTube is popular because people are amused by spectacles, and it offers an endless supply. See also prosumer, user generated content, Web 2.0

**Z-Coordinate** When representing a point in a three-dimensional context, fixed axes are used as reference lines, the x, y, and z axes. The z-coordinate is a point on a z-axis. The system for specifying the location of any point in a two-dimensional plane, a three-dimensional space, a four-dimensional space, or an even higher number dimension, using fixed axes as reference lines, was developed in the 17th century by French mathematician and philosopher René Descartes (1596–1650), and it is named eponymously the Cartesian coordinate system.

**Zebra Stripes** Diagonal stripes that appear in the viewfinder of professional cameras to indicate over-exposed parts of the picture to the camera operator. These stripes are not recorded on the picture.

**Zeitgeist** German for the "spirit of the age." The trends, fashions, and ideas of a particular era that define the times and are characteristic of it. See also popular culture

**Zinger** An outstanding person or thing. This term is often used to describe a remark that is strikingly caustic or humorous.

**Zipf's Law** An explanation of the seemingly innate human tendency to communicate as efficiently as possible by compressing phrases into acronyms and words into abbreviated utterances (vocal sounds). Moreover, the most frequently used words in a language are also the

shortest. In English, consider the length of articles such as "the" and prepositions such as "of." Zipf's Law is an eponym. American linguist George Kingsley Zipf (1902–1950) identified the phenomenon in the 1930s. He called this tendency the Principle of Least Effort. It is surprising that the principle is not referred to as POLE! See also acronym, code, idiom, short message service, Twitter, vernacular

**Zoom** In photography and cinematography, changing the focal length of an optical zoom lens on a camera, which has a movable component, so that the object or scene that is being shot looks either closer to the camera for a close-up or farther away for a wide-angle, long shot. An extremely fast zoom shot is called a crash zoom. On some camcorders, a zoom microphone is linked to a zoom lens. The microphone's sensitivity to foreground sounds and directional characteristics are increased when zoomed in, for instance, to ensure the clarity of dialogue and reduce ambient noise. In contrast, when zoomed out, ambient sounds are picked up more clearly. In computing, users can zoom in to magnify what is on their computer screen, for instance, when more detail is needed while looking at a Google Earth map. The user would zoom out to view a greater area of the surroundings on the map. See also ambiance

# Index

**Digital Formations**

*General Editor: Steve Jones*

Digital Formations is an essential source for critical, high-quality books on digital technologies and modern life. Volumes in the series break new ground by emphasizing multiple methodological and theoretical approaches to deeply probe the formation and reformation of lived experience as it is refracted through digital interaction. Digital Formations pushes forward our understanding of the intersections—and corresponding implications—between the digital technologies and everyday life. The series emphasizes critical studies in the context of emergent and existing digital technologies.

Other recent titles include:

Felicia Wu Song
  *Virtual Communities: Bowling Alone, Online Together*

Edited by Sharon Kleinman
  *The Culture of Efficiency: Technology in Everyday Life*

Edward Lee Lamoureux, Steven L. Baron, & Claire Stewart
  *Intellectual Property Law and Interactive Media: Free for a Fee*

Edited by Adrienne Russell & Nabil Echchaibi
  *International Blogging: Identity, Politics and Networked Publics*

Edited by Don Heider
  *Living Virtually: Researching New Worlds*

Edited by Judith Burnett, Peter Senker & Kathy Walker
  *The Myths of Technology: Innovation and Inequality*

Edited by Knut Lundby
  *Digital Storytelling, Mediatized Stories: Self-representations in New Media*

Theresa M. Senft
  *Camgirls: Celebrity and Community in the Age of Social Networks*

Edited by Chris Paterson & David Domingo
  *Making Online News: The Ethnography of New Media Production*

To order other books in this series please contact our Customer Service Department:
(800) 770-LANG (within the US)

(212) 647-7706 (outside the US)
(212) 647-7707 FAX

To find out more about the series or browse a full list of titles, please visit our website:
WWW.PETERLANG.COM